To Ben:
from Murphy
'68...

# The Splendors of Asia

# The Splendors

India

Thailand

Japan

# of Asia

Photographs by DOROTHY HALES GARY

Text by ROBERT PAYNE

A Studio Book    THE VIKING PRESS    New York

First published in 1965 by The Viking Press, Inc.
625 Madison Avenue, New York, N. Y. 10022

Published simultaneously in Canada by
The Macmillan Company of Canada Limited

Library of Congress catalog card number: 65-20777

Produced in collaboration with Paul Steiner, Inc.
Printed by Amilcare Pizzi, S.P.A., Milano, Italy

To Ilonka Karasz

*who understands…*

With deep gratitude for years of friendship

D.H.G.

# Contents

*India*  11

Plates following pages 14, 32, 52

*Thailand*  65

Plates following pages 68, 88

*Japan*  103

Plates following pages 106, 140

# Black and White

for Dorothy Hales Gary

I love the bright light that gives back the dark image
the fretted edge of a carved rock, the temple-bell –
a cool brow under the curdled foliage
the sun-slashed alleys & the ribbed waters
the eyes of a child forever intent.

I wander with you through the opal vistas of India
the terraced hills of Thailand, the frothing torrents
and come to rest in the holy gardens of Japan.
Visions that trembled in the crystal eye
are suddenly clear and still.

I stand on the threshold of darkness
redeemed & forever delighted.

Herbert Read.

# India

*H*E STANDS THERE IN HIS NAKEDNESS AND PRIDE, AND AT FIRST YOU MIGHT TAKE HIM FOR one of those carved archaic Apollos which can still be seen in the Greek islands. He has an Apollonian grace, and there is so much strength in him, so much resolution and gentleness, that he seems to belong to one of those ages when men possessed an enviable self-assurance. He has thrown off his imperial robes, but in his nakedness he wears an imperial grandeur. One does not think of him as stone but as living flesh. He stands on his mountaintop like a conqueror who has accomplished everything he set out to do, and now there remains only the contemplation of his conquests. No sculptor has ever carved a more imperious figure.

It is worth while to examine him closely because he is among the supreme achievements of the sculptor's art and because he represents an attitude of mind which is wholly foreign to the West. As we see him standing against the skyline in the power and immensity of his youth, he seems to be the embodiment of heroic endeavor; and so he is, but it is an endeavor far removed from our normal preoccupations. Nearly sixty feet high, carved out of the living rock and dominating the landscape for miles around, he represents to the Indian mind nothing so irrelevant as conquest. It is in fact the portrait of a Jaina saint who has wholly renounced the world.

In this portrait sanctity has been given heroic shape: the towering youthful figure is emblematic of power, but it is the power of renunciation, of total withdrawal from the world. He has ordered the world to be still, to come to an end, and he is himself living in a hushed stillness, and he has himself come to an end. His eyes are open but unseeing. His arms are twined with creeping vines, for he is so lost in contemplation that he is completely unaware of the events of this world, which continues to exist in spite of his demand for total renunciation and silence. Nature remains; the flesh remains; the world goes on, while he dreams the long dream of annihilation. If his nakedness is an attribute of his divinity, it is also an attribute of his earthliness and sensuous beauty. So very gradually we come to realize that he belongs both to the

world of men and the world of the gods, and through him the two worlds are held in a precarious balance.

One should look at him very carefully because he represents an essential element in the Indian imagination, which does not obey the canons of the West. For us, asceticism and sensuality stand at opposite poles, irreconcileable. We, too, have our fleshly saints, our Saint Sebastians smiling languorously at their wounds, but we recognize them for what they are: they are no more than beautiful youths performing in a charade, having no relation to our profoundest beliefs. We do not believe it is possible to be simultaneously sensual and ascetic, to love life and to reject it. Reason tells us that we cannot step twice into the same river and that we cannot do two things at the same time, and still less can we believe two contrary things. The Indian mind, more generous and adaptable, sets no limit to belief. It can believe in the one god, Brahma, and simultaneously it can believe that the air is peopled with gods, and that every tree and lake and flower is a meeting place for its attendant divinities. The Indian imagination, hovering between the extremes of flesh and the extremes of spirit, teems with images of fecundity. The tree is forever putting forth leaves; it cannot stop. There is no end to the number of the Indian gods, because there is no end to the Indian imagination.

The youth who stands in his superb nakedness on the mountaintop at Sravana Belgola, not far from Mysore, is himself a god, receiving all the honors due to a god. His title is *tirthankara*, meaning "the maker of the river crossing," for he has passed across the river into another land, and leads the way for those who come after him. Once every twelve years a huge scaffolding is erected around him, and to the chanting of the priests water, ghee, coconut meal, honey, fruits, gold and silver coins, and even jewels are poured over him, running down from the crown of his head to his feet. It is a ceremony comparable with the ritual clothing of the gods in ancient Greece and Rome. The milk and jewels form his earthly attire, signifying that he has taken up his abode on earth, but only for a little while. Soon he will return to his nakedness and his interrupted meditations, gazing down at the world from his mountaintop, smiling his eternal meditative half-smile which is itself the sign of his authority over the world.

Yet when we examine him more closely, we discover that there is nothing simple about him and he is far from being what we expect him to be. In the beginning he was not a god, not even a saint. Indeed to call him a saint is to grant him qualities he scarcely possesses, since the word has Christian overtones and he belongs wholly to the East. Unlike Apollo, whom he otherwise resembles, he was born of earthly parents, and acquired his divinity in later life. His name was Gomateswara, and he was a soldier.

How it came about that a soldier should be represented naked on a mountaintop— without arms, without armor, with nothing to identify him as soldier—is an instructive story and goes some way toward explaining the molten core of the Indian imagination. For this soldier was no ordinary soldier. He had won victories and rejoiced in them, and then quite suddenly, while he was still young, he had realized the vanity

of his triumphs and the evil he had done. As an act of penance he had sworn to stand in motionless meditation to the end of his life. The huge monolithic statue, the largest figure ever cut from stone, depicts him in the glory of his young manhood as he performs his lifelong penance.

The flowering vines twining around his thighs and arms are therefore not merely decorative; they symbolize his entire absorption in the act of penance. He remains unmoving while the vines grow over him. He is so sunk in meditation that he is totally unaware of the ant hills at his feet and the serpents issuing from them. He stands in the posture of meditation known as *kayotsarga*, legs planted firmly on the earth and arms hanging limp at his sides, not touching his body. It is not so much that he is wholly immersed in his meditations as that he is rapt: his soul is almost set free from the trammels of matter and he is about to set out for the journey to Nirvana, the land of eternal and instantaneous joy which lies somewhere to the north of the universe.

The Jains, who carved this statue about the year 980 A.D., were well aware that Gomateswara had been a soldier, and therefore represented everything that was most repellent to them. At the heart of the Jaina doctrine lies an exquisite tenderness and reverence for all living things. Since life in all its manifestations is holy, nothing must be killed, nothing must be hurt. The Jains will mask the flame of a lamp to prevent insects from falling into it, and strain their drinking water to preserve the lives of animalculae. They carry feather dusters to brush ants and other insects from their path, to save them from being trampled upon, and some, the more extreme, wear bandages over their mouths to prevent them from inhaling flies and other airy creatures. Agriculture is forbidden to them, because plowing the land involves the dissolution of life and the extinction of living elements in the soil. From the time of Vardhamana Mahavira, the founder of the religion, who was born about 540 B.C., to the present day, the Jaina doctrine has revolved around the holiness of life in all its forms, and for those who follow the doctrine there is almost nothing on earth which is not alive. Rivers and winds are alive, and so are rocks. The years and the ages are alive. Clouds, seas, the vast spaces of the heavens, all have the breath of God in them.

Vardhamana Mahavira was the exact contemporary of Gautama Buddha. Indeed, they were rivals and seem to have known one another and to have fought bitter doctrinal battles against one another. But though Gautama Buddha left deeper traces on the course of Indian art, it was Vardhamana Mahavira who left the deeper traces among the Indian people, for his religion survived in India long after Buddhism had moved on to the countries of southeast Asia and to China and Japan.

Yet the two sprang from the same springs and traveled a long way together. Their similarities were perhaps greater than their differences; both Buddhism and Jainism demand from their devotees an unyielding reverence for life, an infinite tenderness. They differ only in their conception of the purposes life fulfills.

The doctrine of *ahimsa*, or nonviolence, is as old as India: so old, so deeply ingrained in the Indian consciousness, that it can scarcely be called a doctrine at all. It is something the Indian drinks with his mother's milk. Out of Hinduism it came to feed into

# Plates

page

15 Statue of Gomateswara, Jain saint, at Sravana Belgola, Mysore.

16 Miniature of the above statue, showing ant hills and serpents, set between the feet of the colossus.

17 Wooden gate set with horseshoes, Fatehpur Sikri.

18–19 Within the walls of the twelfth-century Varadaraja temple, Kanchipuram, Madras.

20, 21 Courtyard, Fatehpur Sikri.

22 Venu-Gopala Vishnu, Halebid, Mysore.

23 Carved pillars in a temple, Kanchipuram.

24 Detail of frieze, Hoysalesvara temple, Halebid.

25 One of the many *goporanas*, or ornamental towers, erected at Kanchipuram.

26, 27 Bathing ghats, Benares.

28–29 Temple of Kishava, built 1268 A.D. in the Hoysala style, at Somnathpur, Mysore.

30 *Goporana*, Kanchipuram.

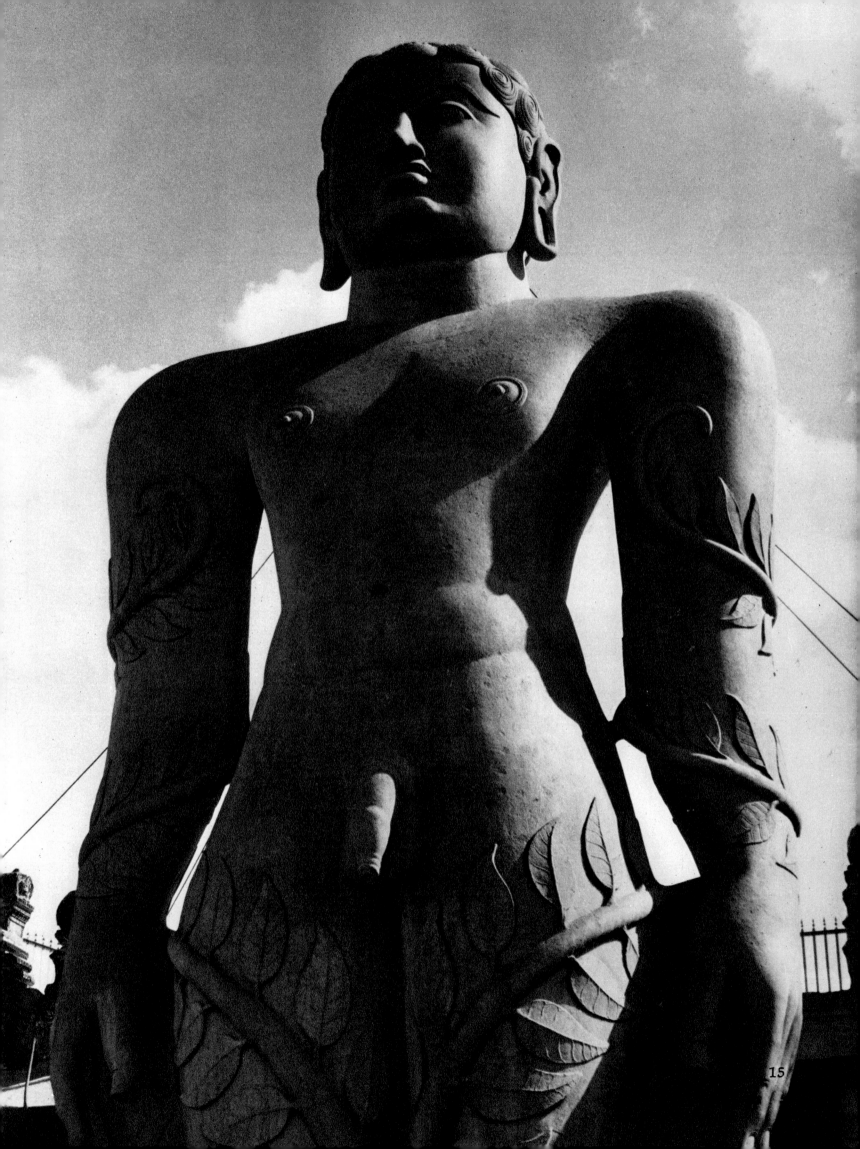

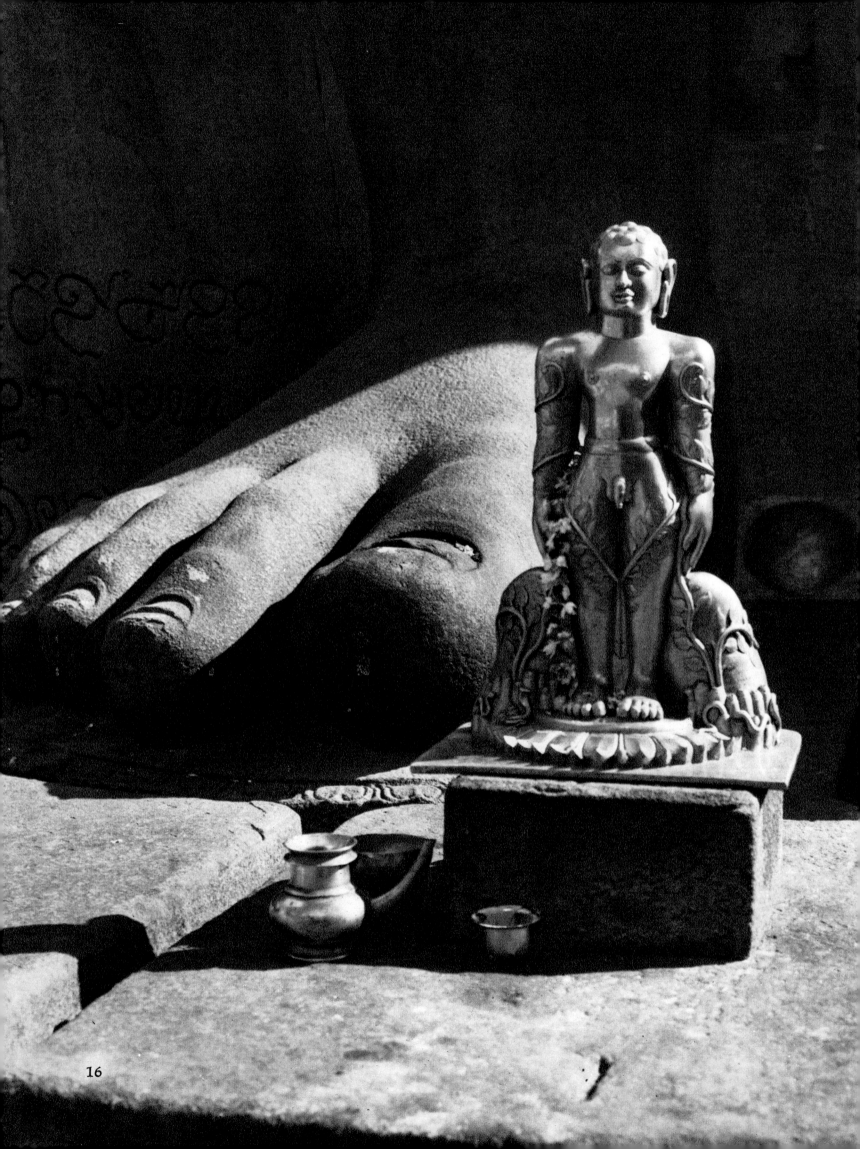

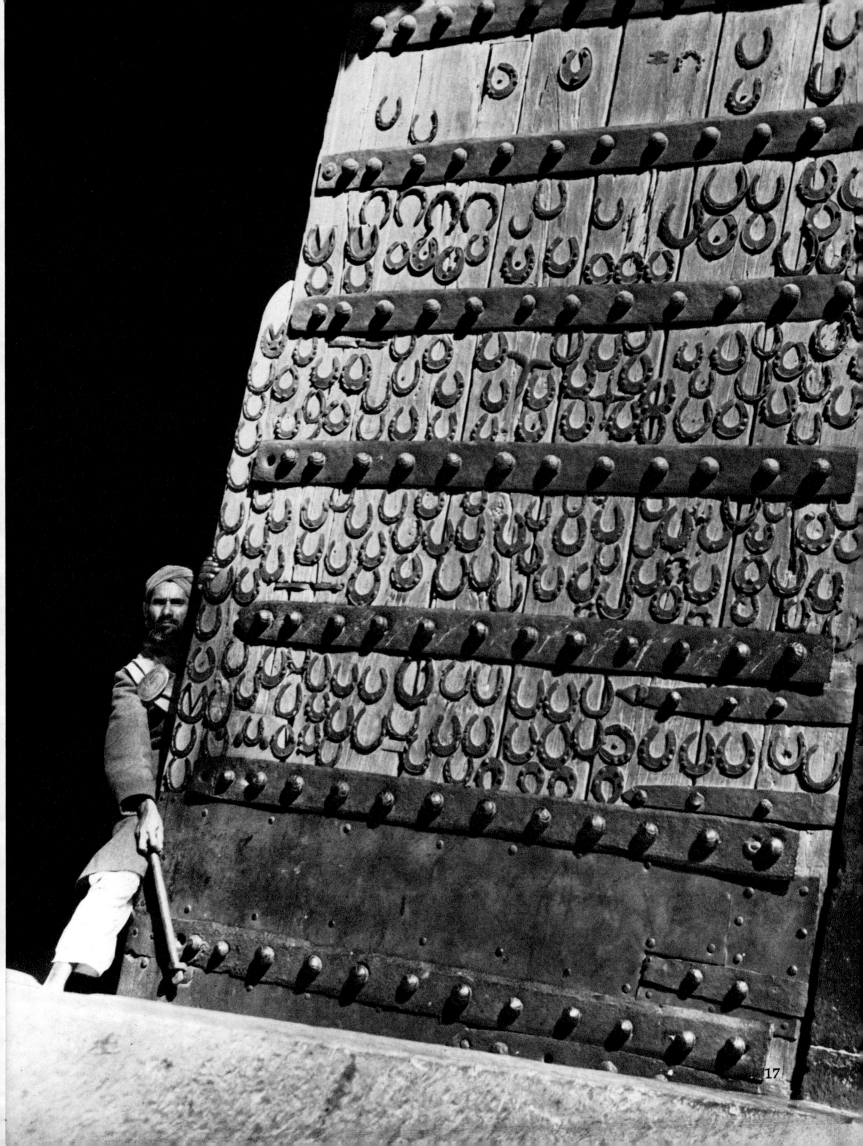

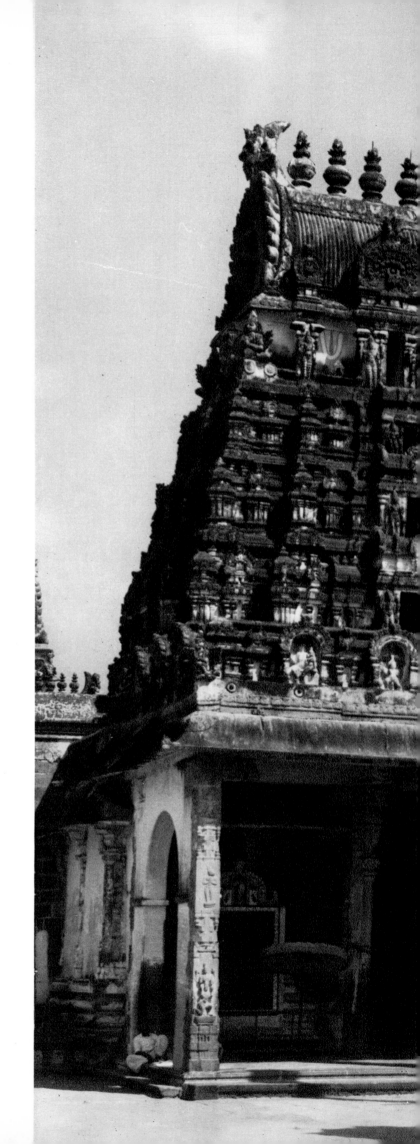

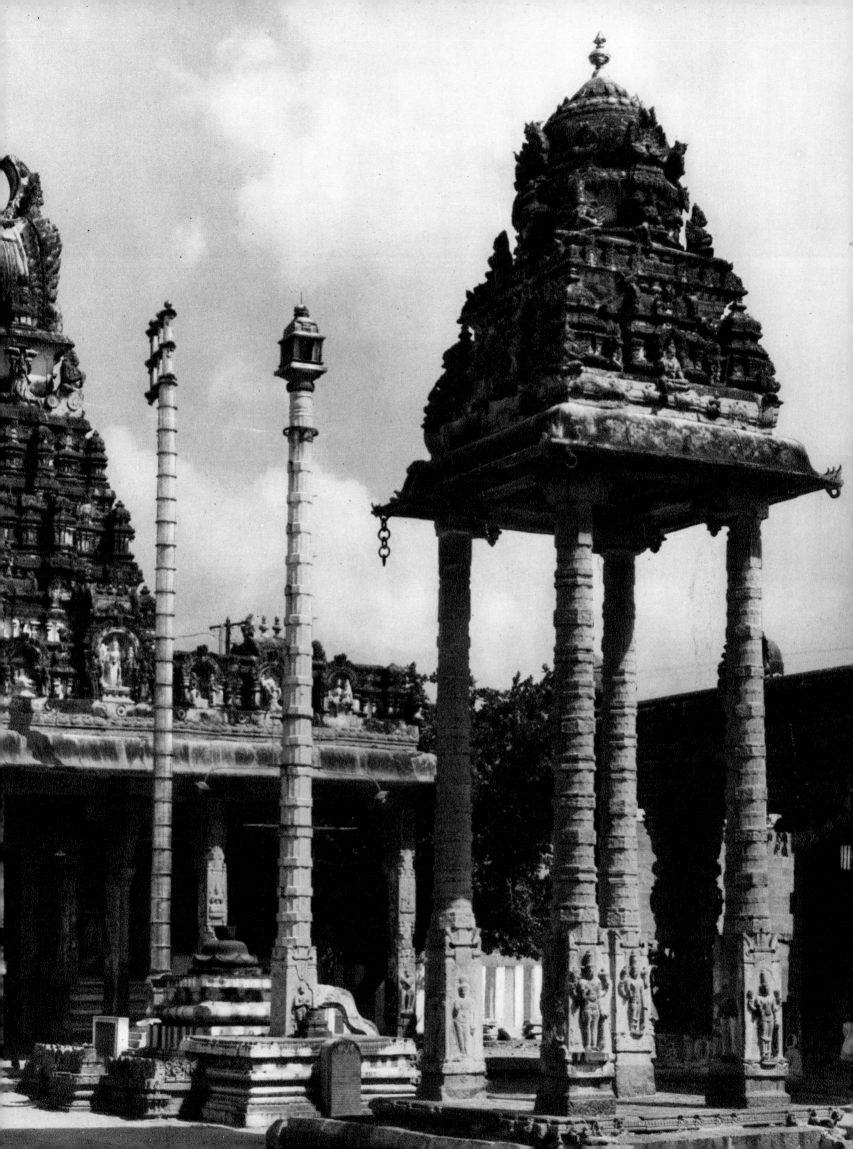

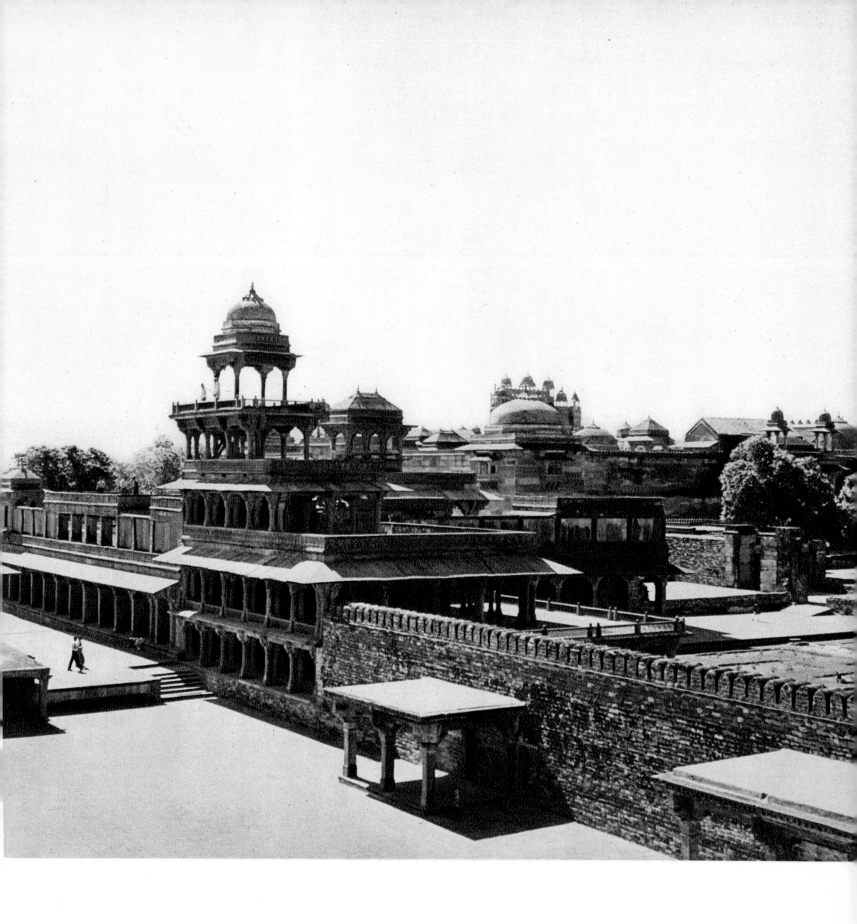

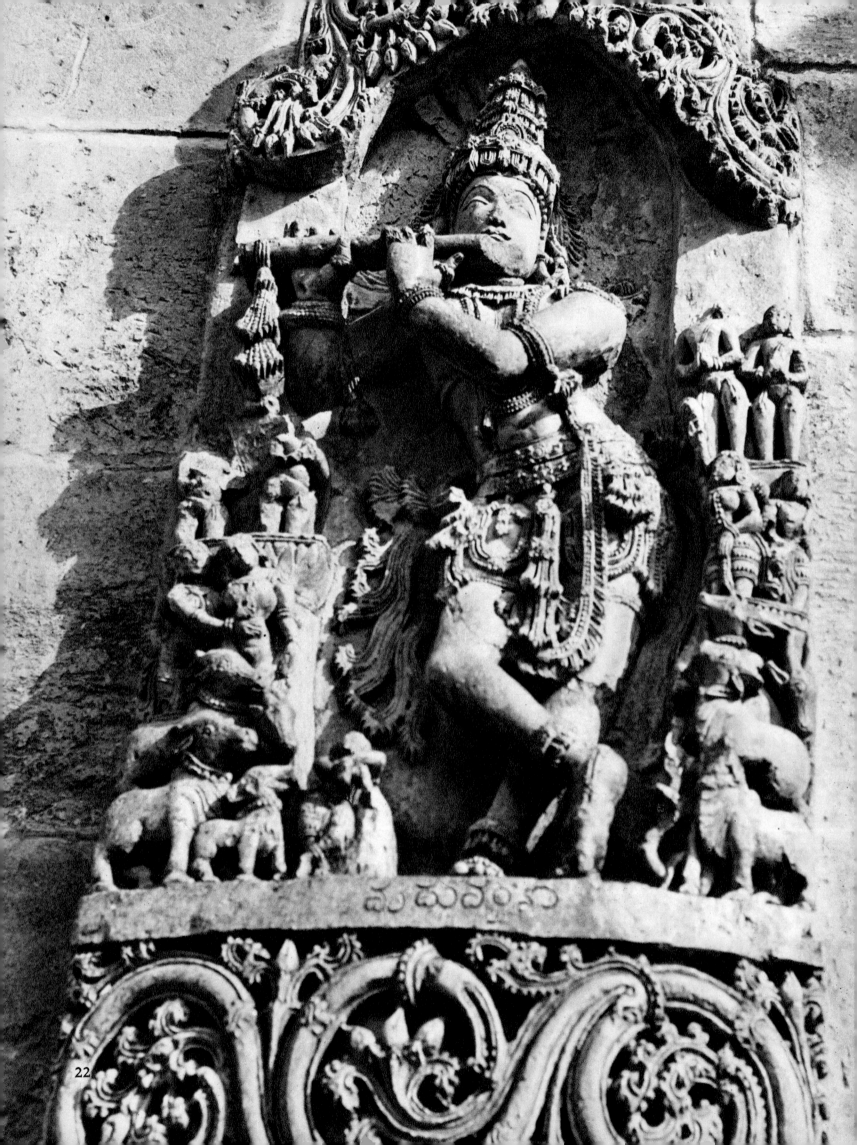

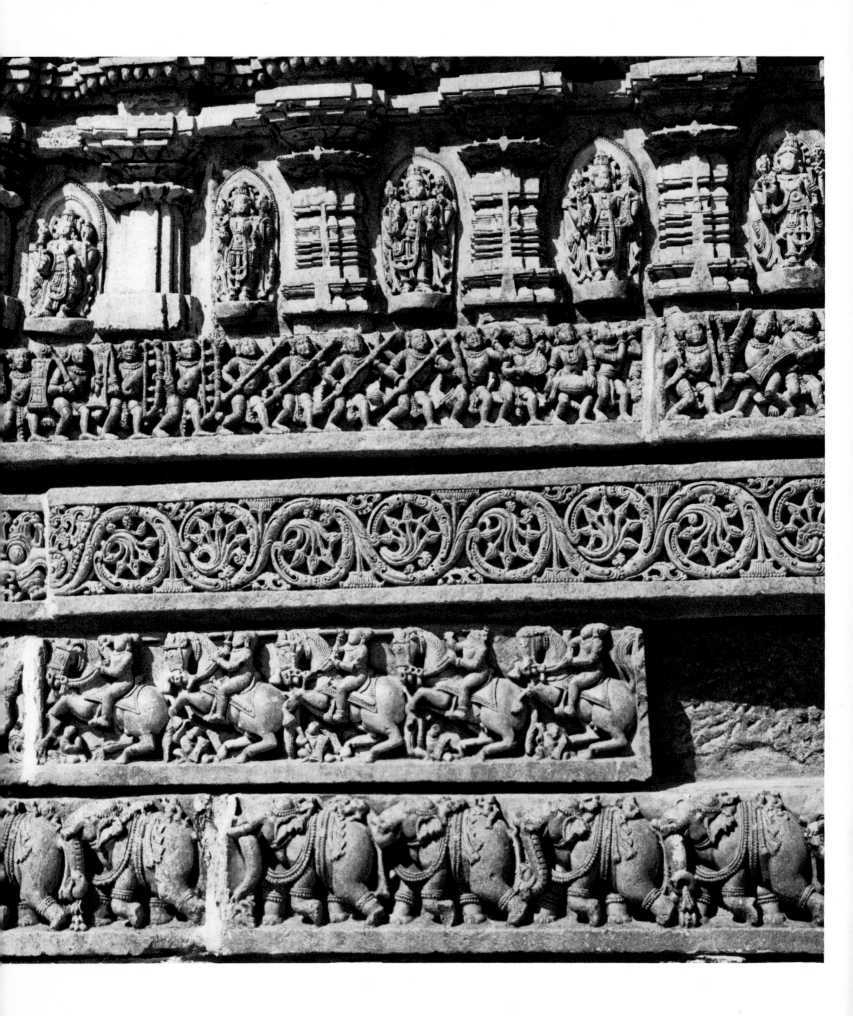

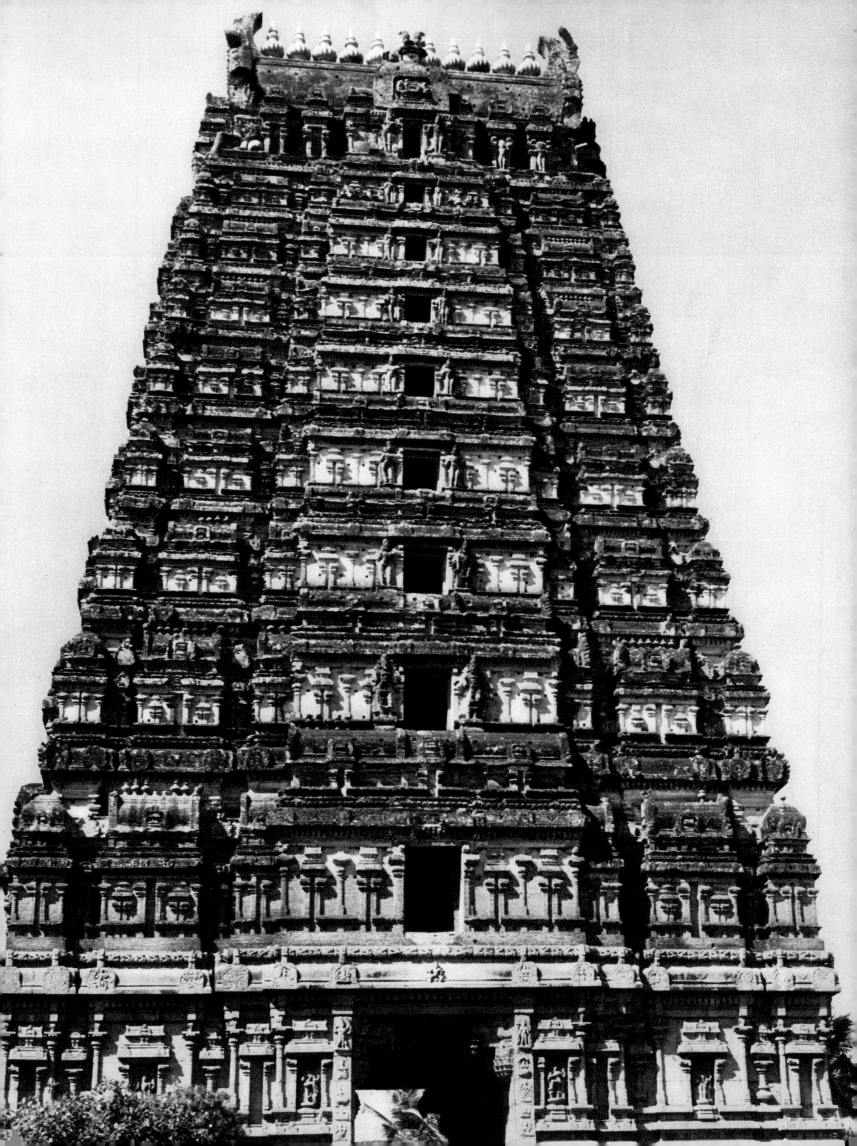

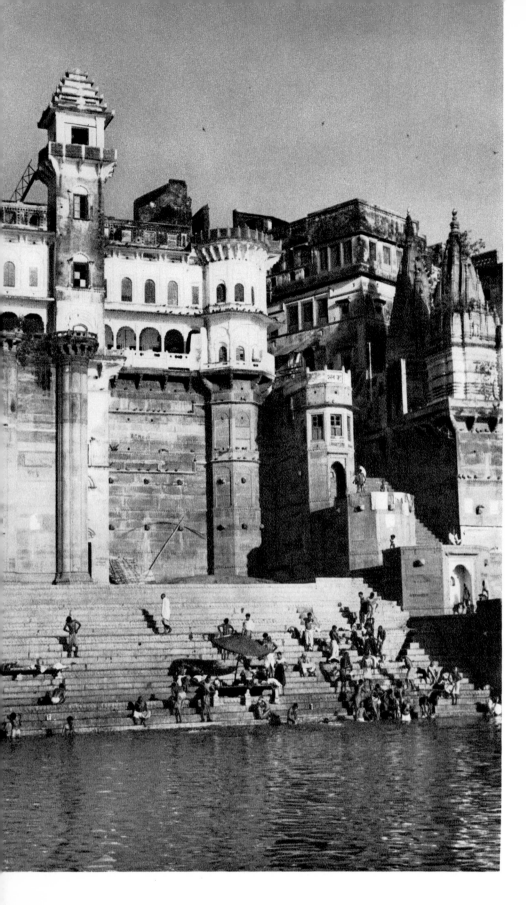

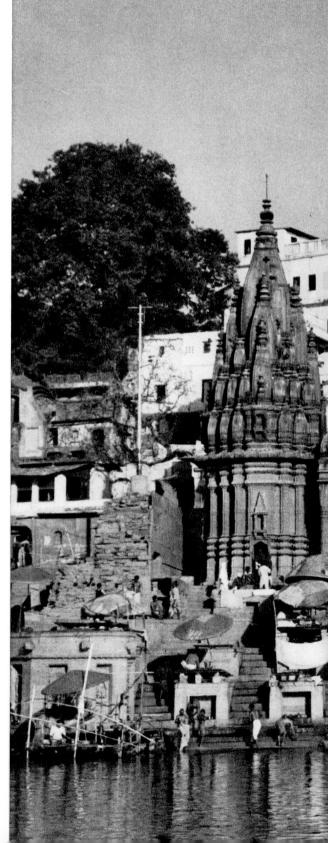

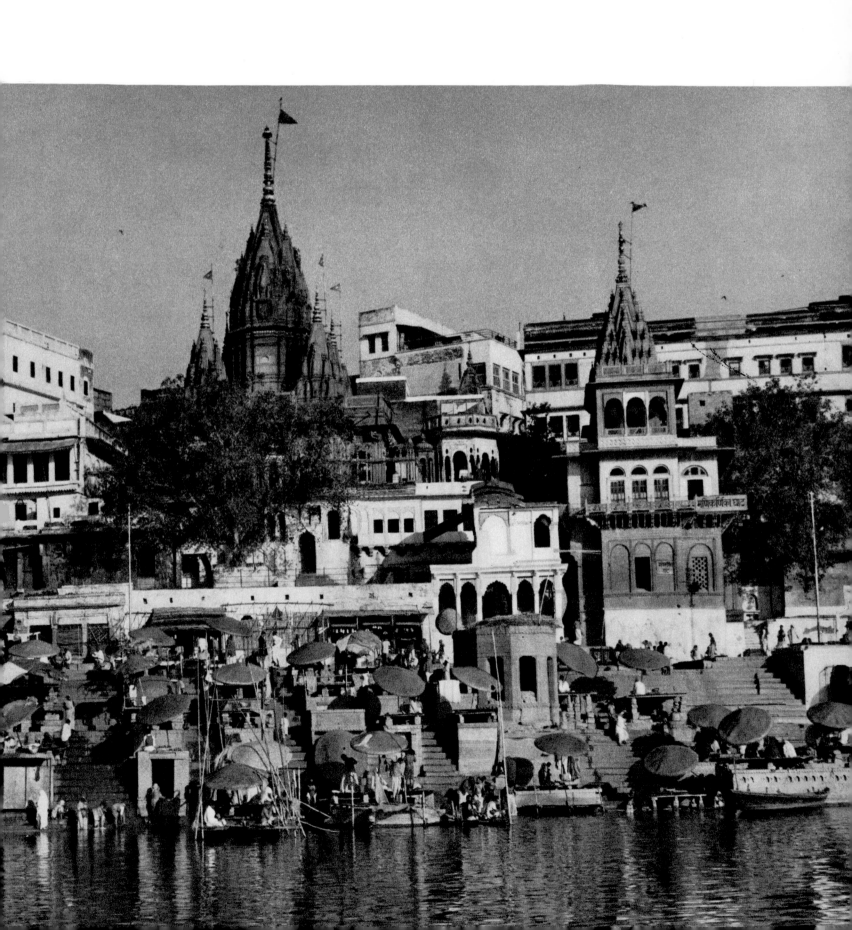

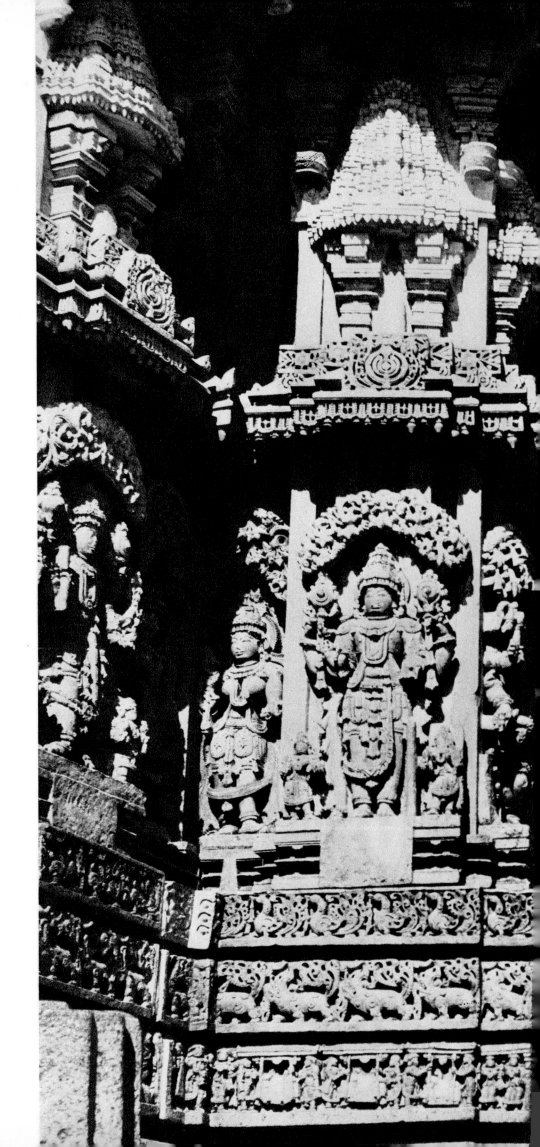

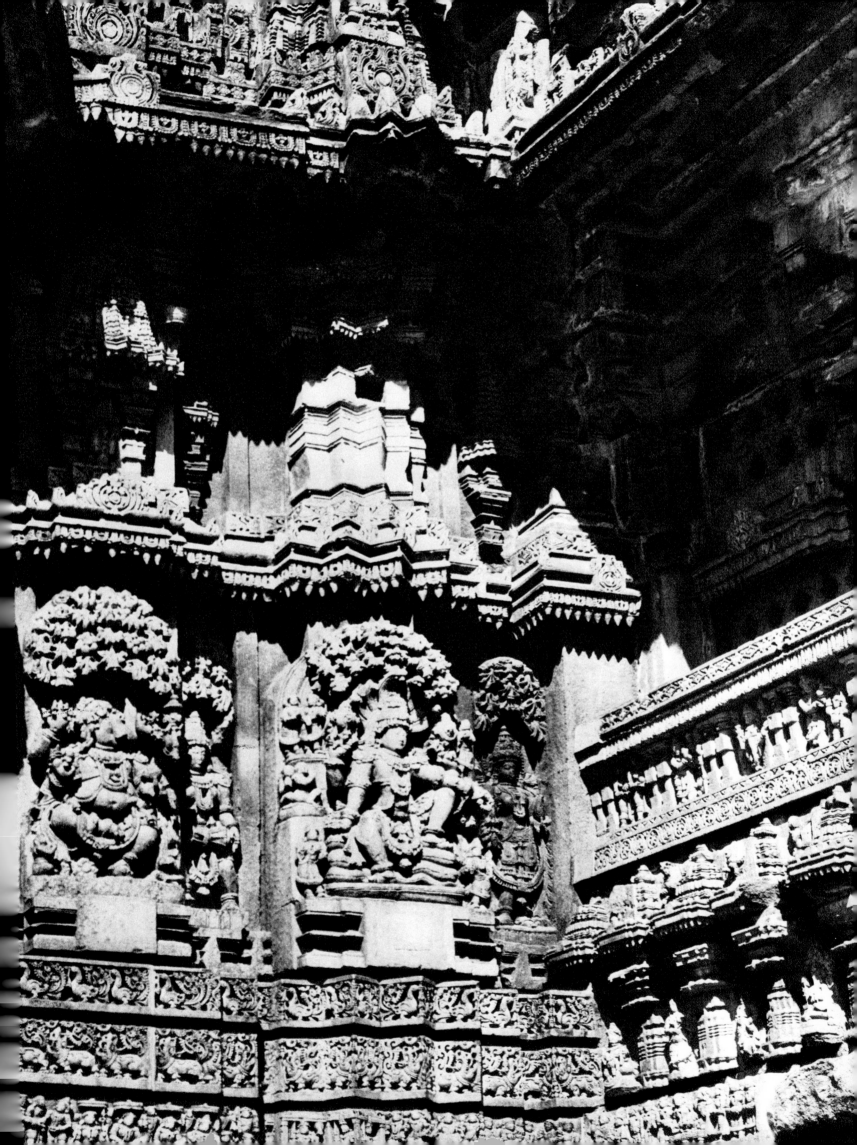

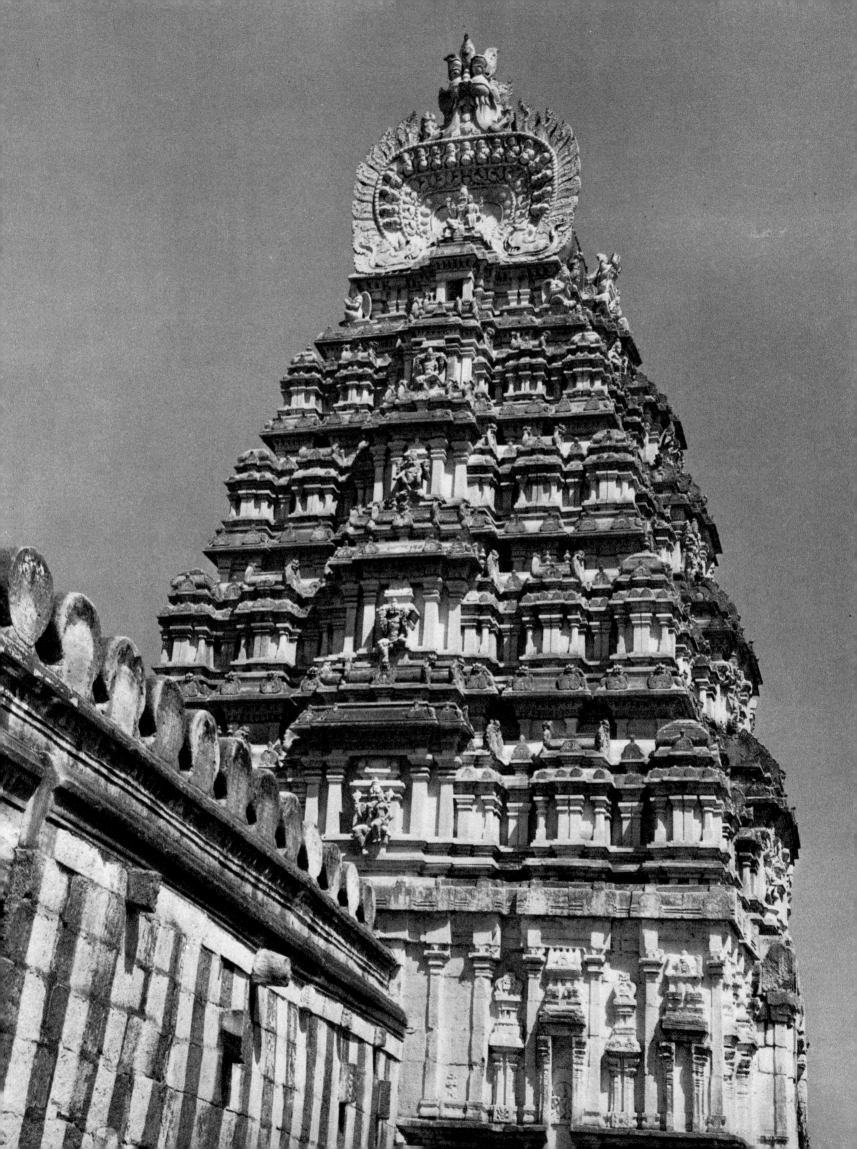

a thousand sects. Only the Jains seem to have held more tightly to it, making it the central article of their faith. So the naked Gomateswara throws his armor and weapons away, to stand in meditation while the vines grow over him.

From time immemorial armies have wound across the Indian plains, plundering and burning. The cities went up in flames, the rivers were swollen with the dead. A people who loved peace and reverenced life found themselves inevitably involved in wars. Not all were Gomateswaras, renouncing their victories in silence and penance.

The heroic tradition of the original Aryan invaders found its most powerful defense in the *Bhagavad Gita*, where Krishna, an incarnation of Vishnu, gives his blessing to the warrior Arjuna: "Thou hast sorrowed, Arjuna, for whom thou shouldst not sorrow....The wise mourn neither for the dead nor for the living....Never was there a time when I did not exist, nor thou. Only the unreal does not exist; the changeless one is imperishable, no one can destroy the essential spirit. The unborn, the permanent, the eternal is not slain when the body is slain. Pleasure and pain, gain and loss, victory and defeat—hold them all equal. So gird thyself and fight, O Arjuna!"

In this way the warriors acquired divine sanction for their wars, but among the millions of peasants quietly tilling their fields there were few who believed that the sanction was justified. Popular imagination decreed that even Arjuna must perform a penance. So we discover among the rock temples at Mamallapuram, not far from Pondicherry, a vast relief carved on a boulder which is popularly described as "Arjuna's Penance."

This relief is among the wonders of the Indian world, a thing vibrant with energy, conceived on a massive scale by artists of astonishing power. Here on the seashore, at some time during the seventh century A.D., a master sculptor attached to the palace of a Pallava prince depicted nothing less than the creation of the world. He could not have worked alone; some ten or fifteen assistants must have helped him to carve those innumerable figures from the solid granite, but there is the sense of a single unifying imagination at work. We do not know the name of the sculptor, and we do not know exactly when he carved the relief, the largest in the world, for it is ninety feet long and thirty feet high.

"Arjuna's Penance" occupies only a small part of the relief—if indeed Arjuna is present at all. The central characters are the god Shiva, the royal hermit Bhagiratha, and the heavenly Ganges, which is represented by a natural fault in the rock. Through the prayers and fastings of the royal hermit, the world is about to come into being. For untold centuries he has practiced austerities, and now at last his reward is to be given to him. We see him praying beside the temple where Shiva is standing mysteriously in the shadows; and when Shiva emerges into the full sunlight, the grace is accomplished, the world is born, the heavenly Ganges flows across the plains, and every living thing rejoices. We see the naga-king rising to the surface, trailing his coiled serpentine tail, and followed by the naga-queen. On the upper register we see Bhagiratha again, standing on one leg with his arms raised above his head, while Shiva,

# *Plates*

*page*

33  Durga temple, Benares, built in the eighteenth century by Rani Bhawani of Natore.

34  Detail from Hoysalesvara temple, Halebid.

35  Ganesa crowned, Halebid.

36  One of the "Seven Pagodas," Mamallapuram, Madras.

37  Sculptured elephant of the Pallava period, Mamallapuram.

38, 39  Two segments of "Arjuna's Penance," or "The Descent of the Ganges," Mamallapuram.

40  Monkeys, Mamallapuram.

41  Nandi, the Sacred Bull of Shiva, Chamundi Hill, Mysore.

42–43  Pallava pagoda, Mamallapuram.

44  One of many stone cows surrounding a shore temple at Mamallapuram.

45  Vishnu, Mamallapuram.

46–47  The Taj Mahal, Agra, built by Shah Jahan, 1631-1653 A.D.

48  View of Kanchipuram, Madras.

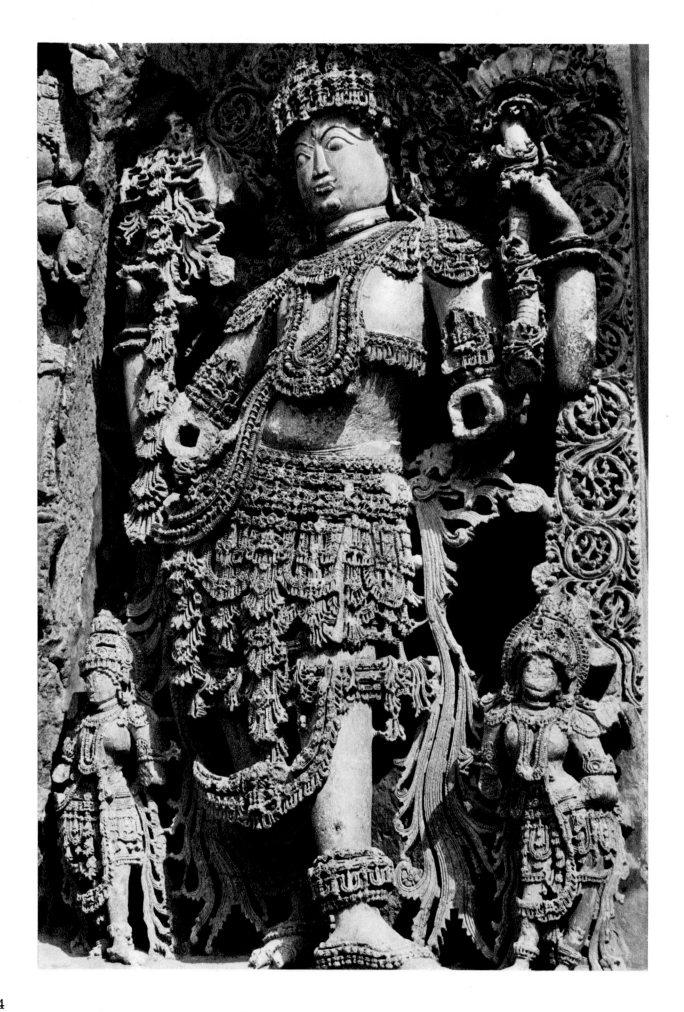

34

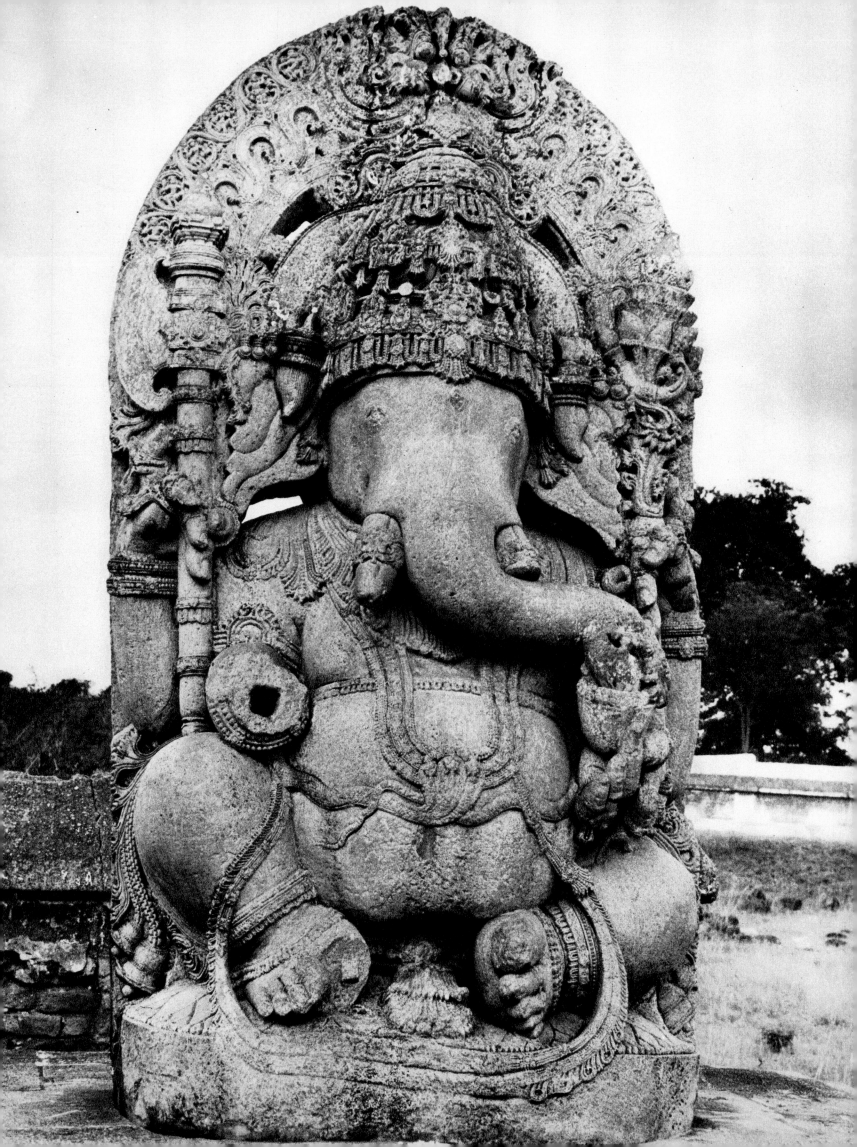

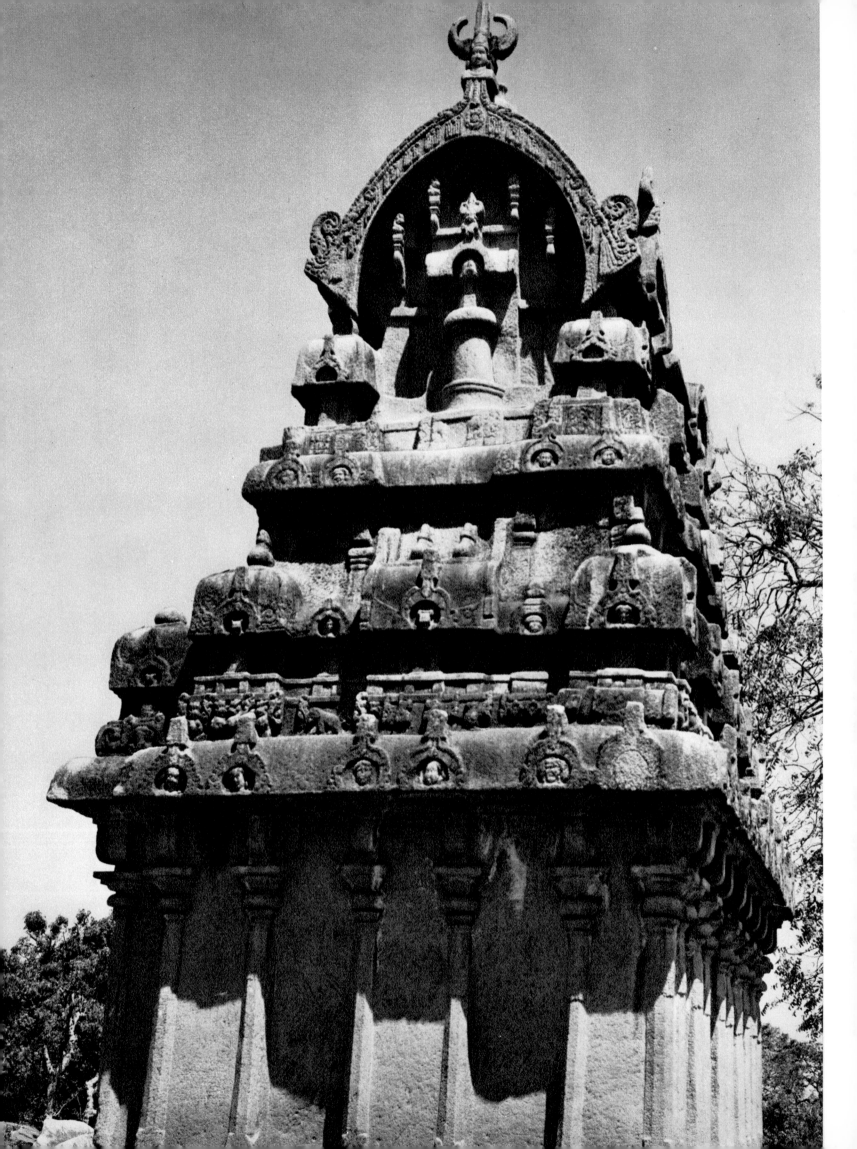

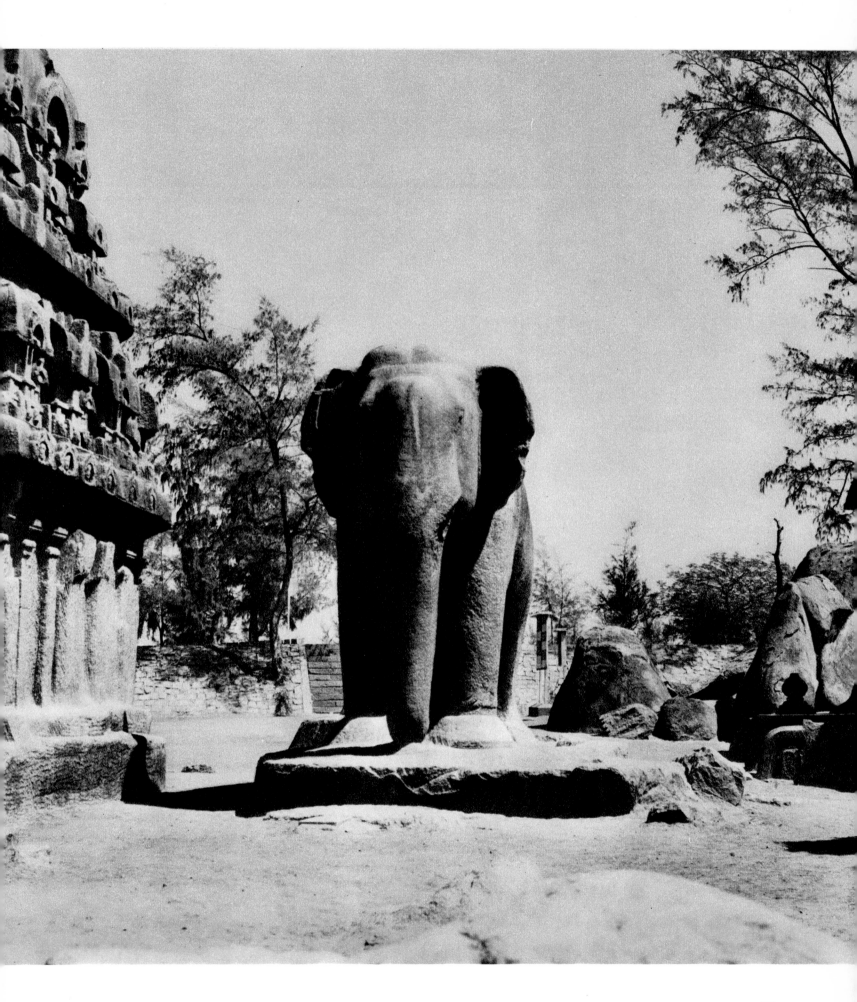

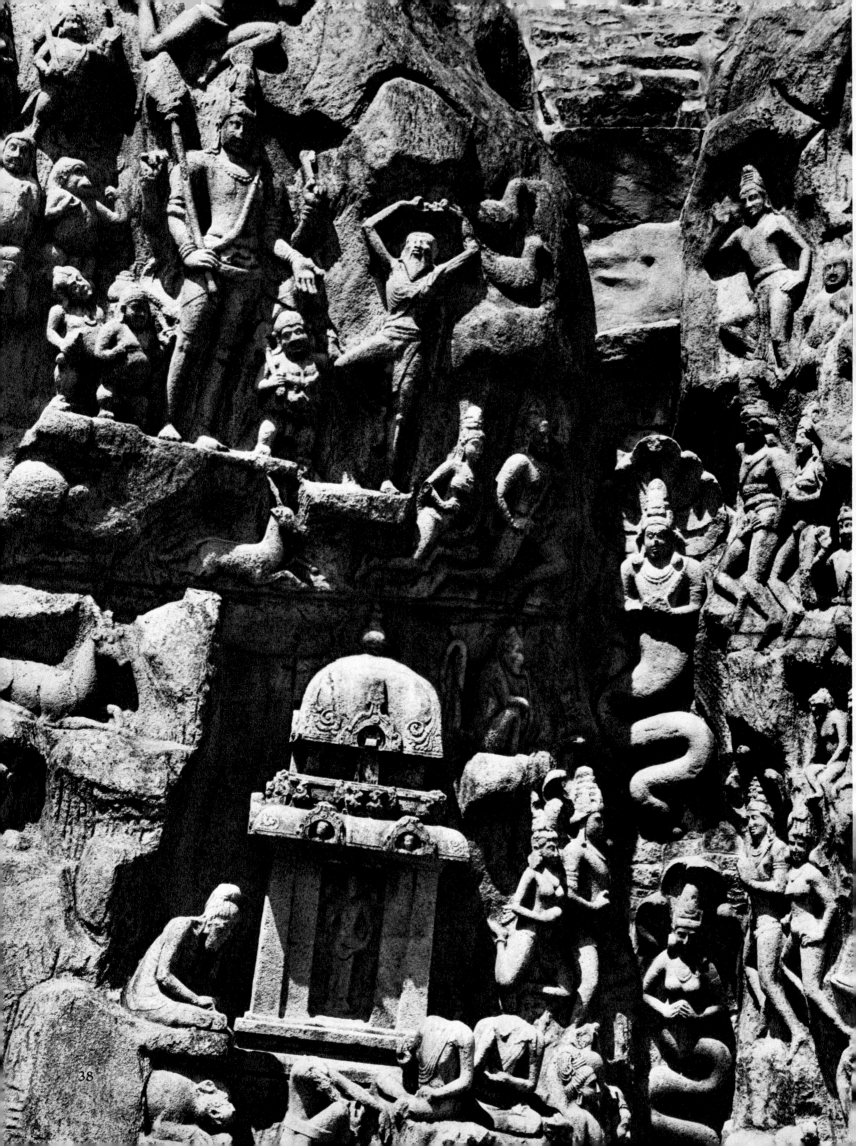

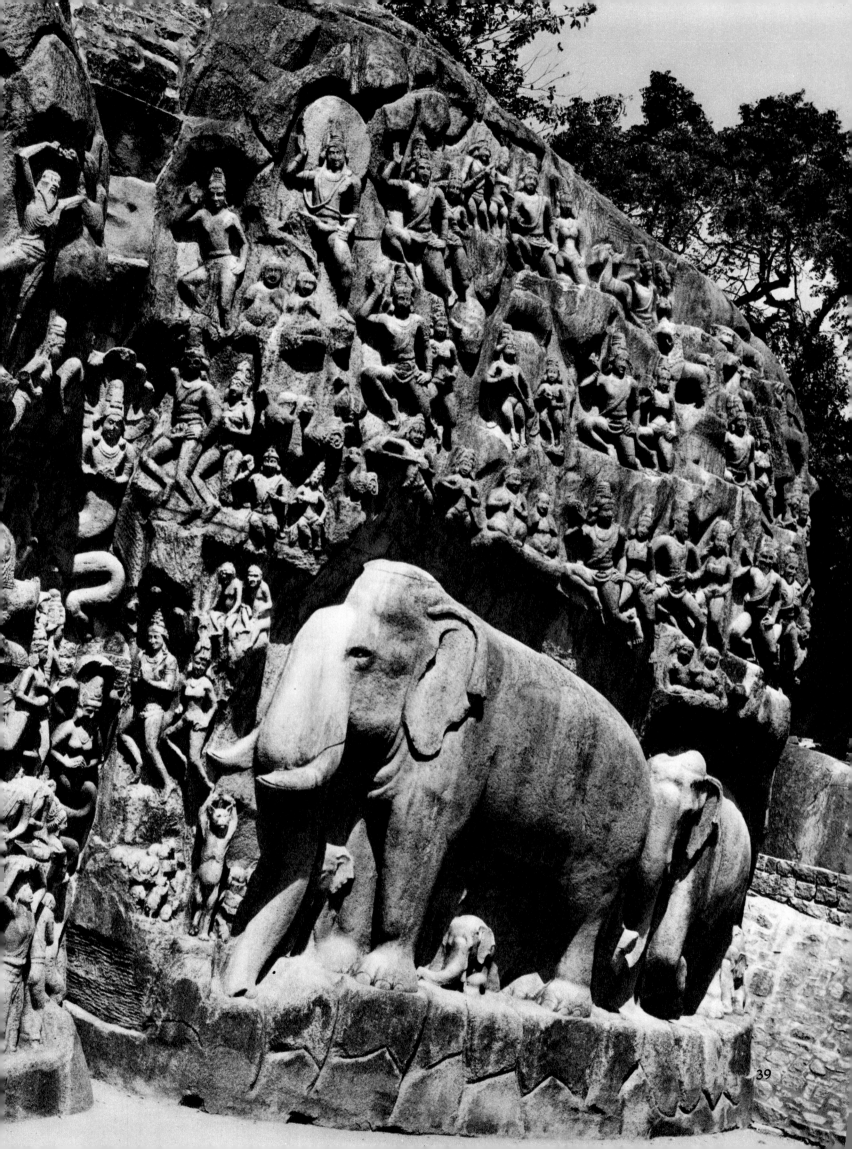

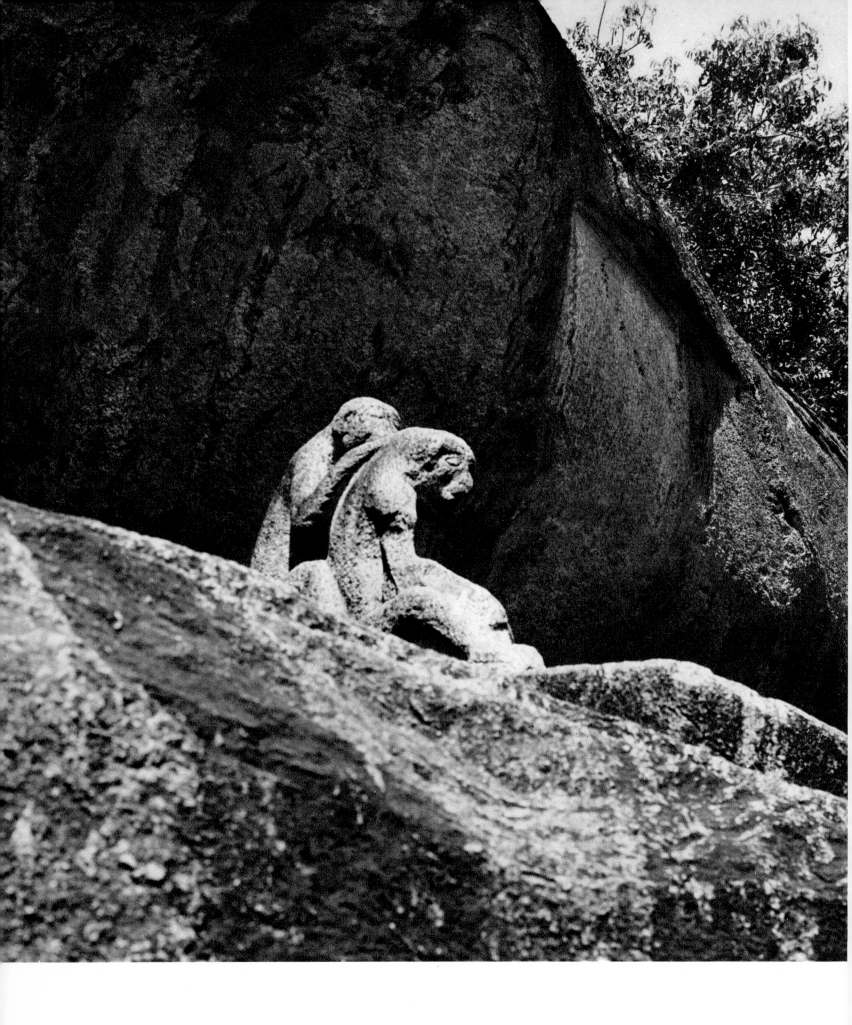

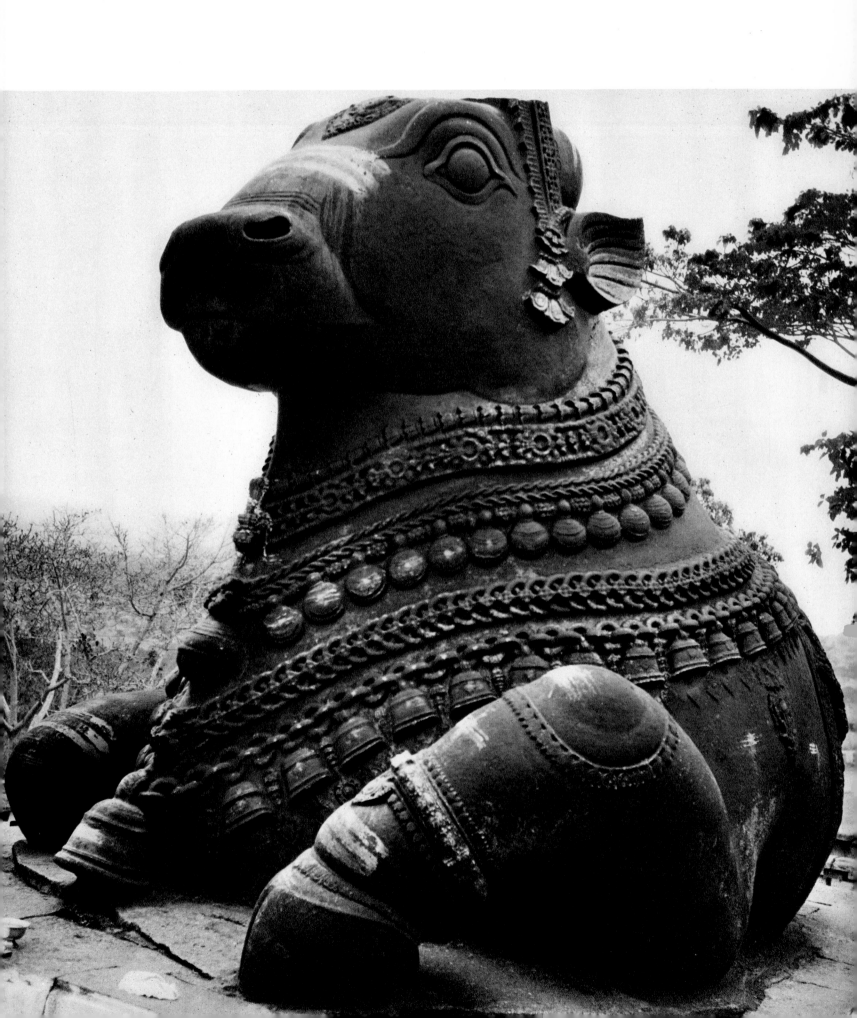

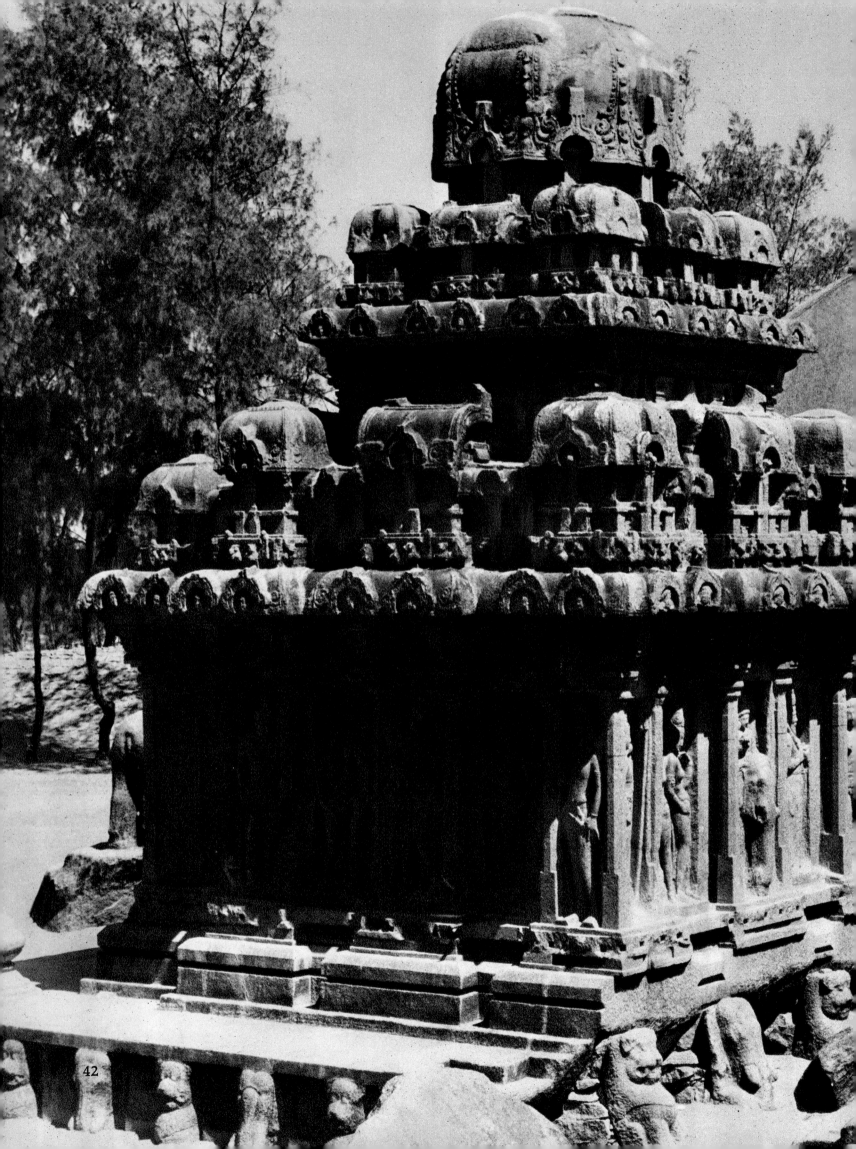

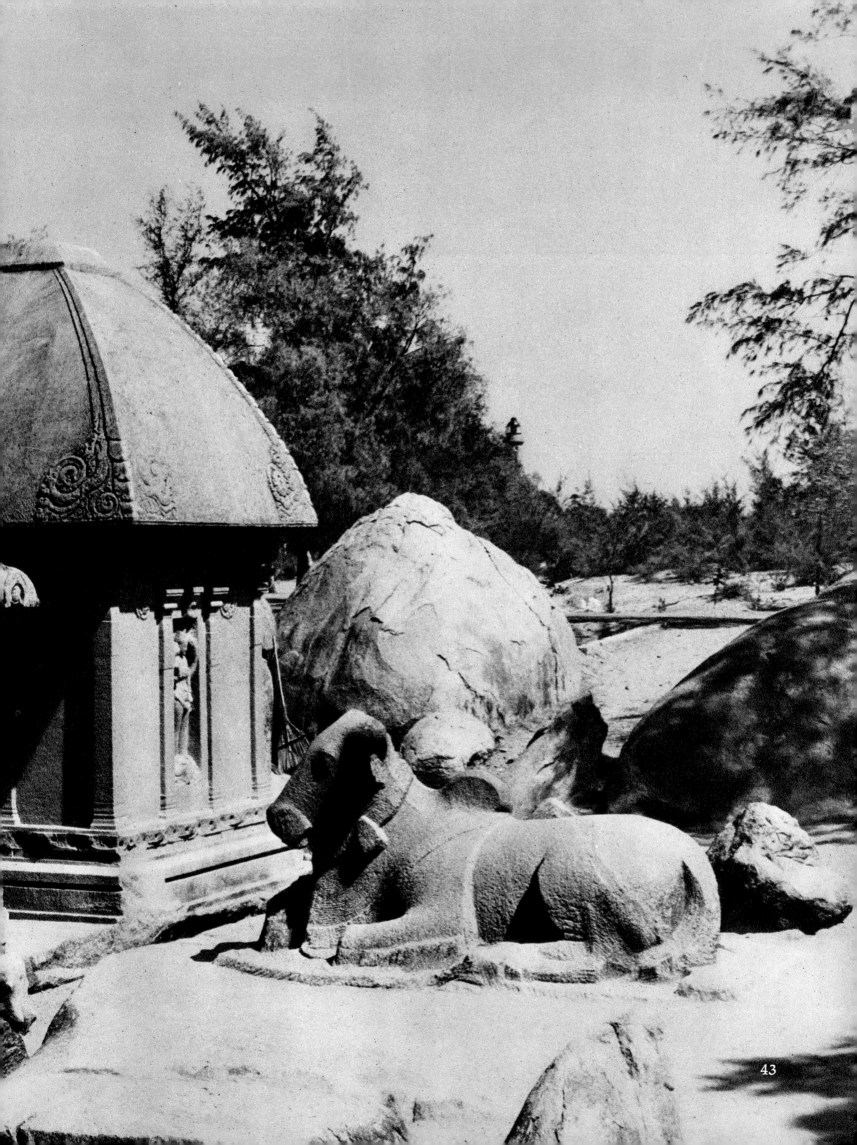

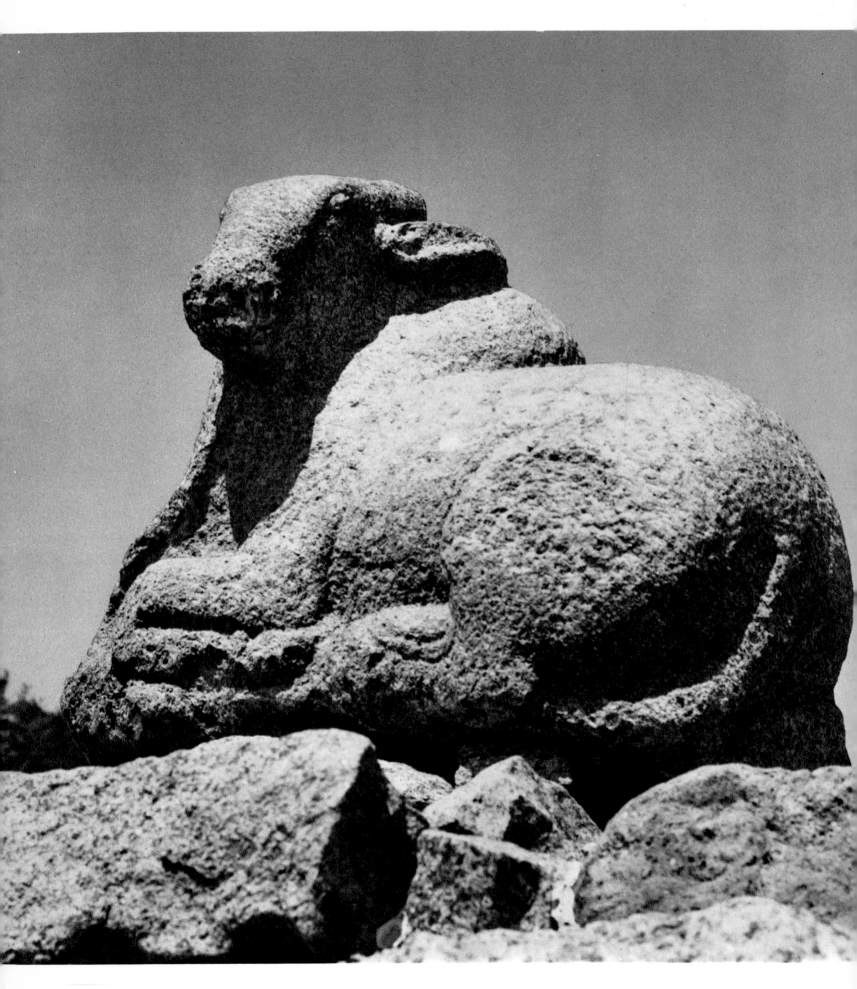

44

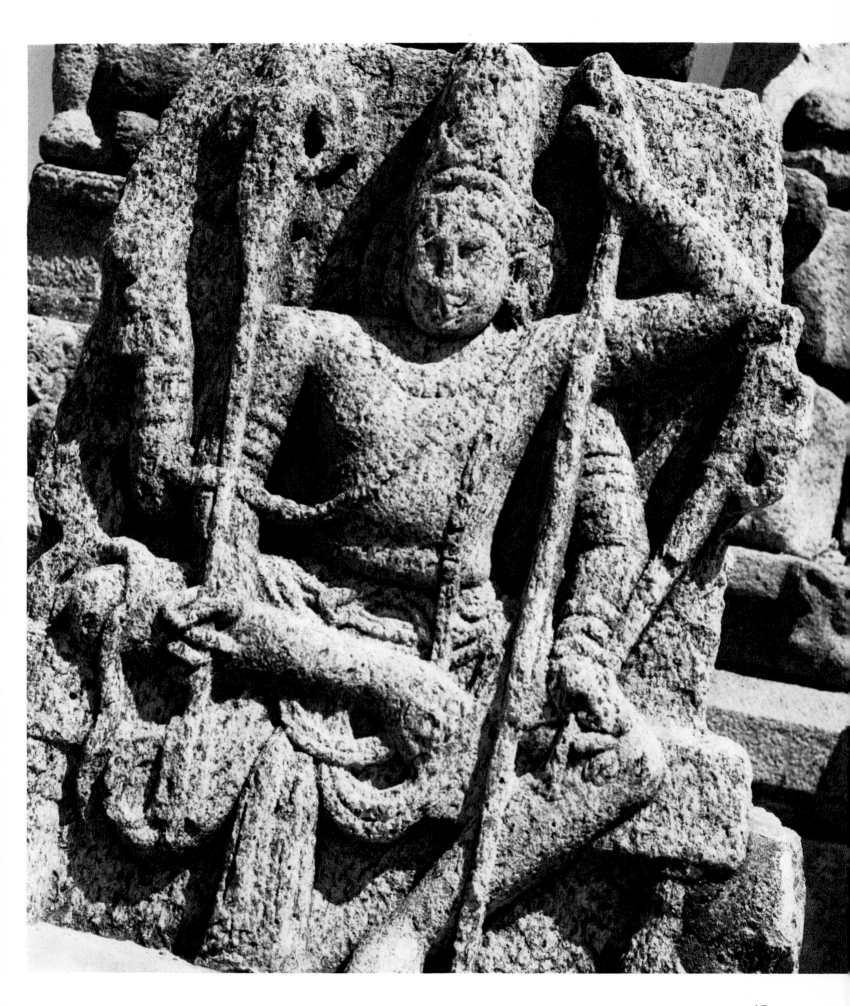

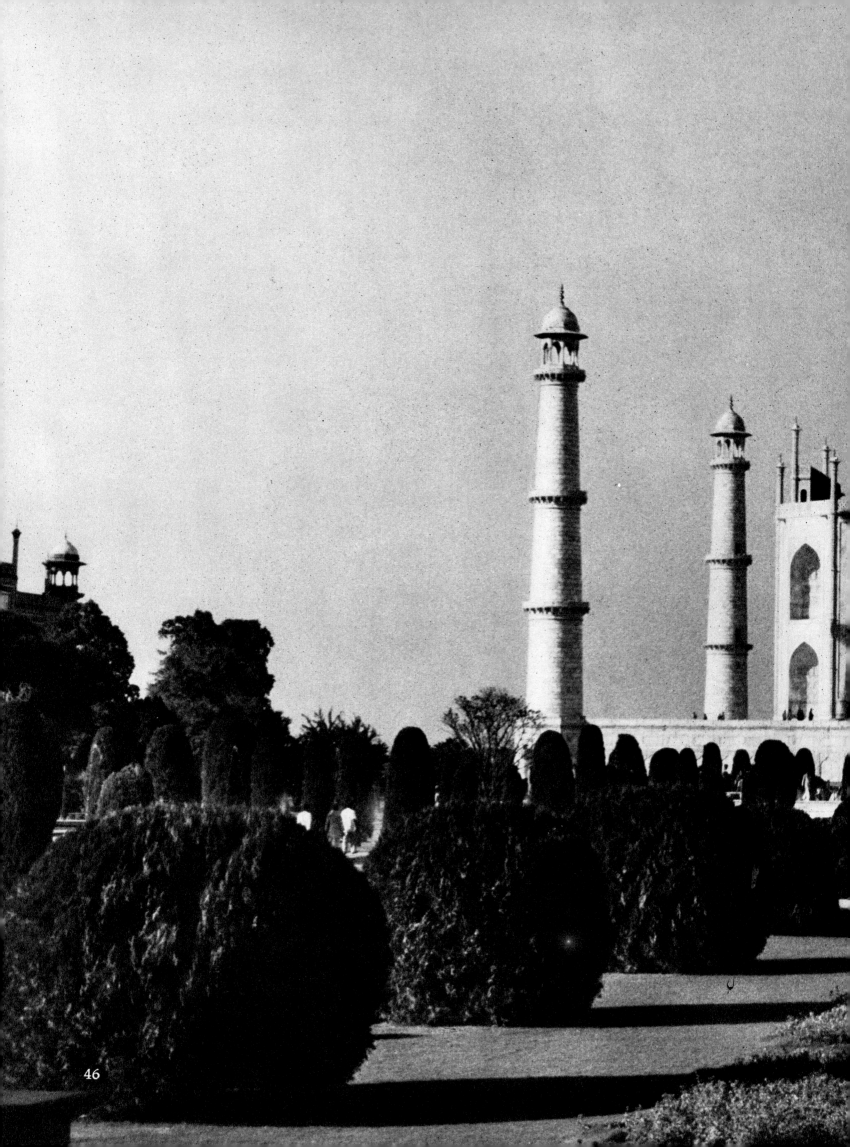

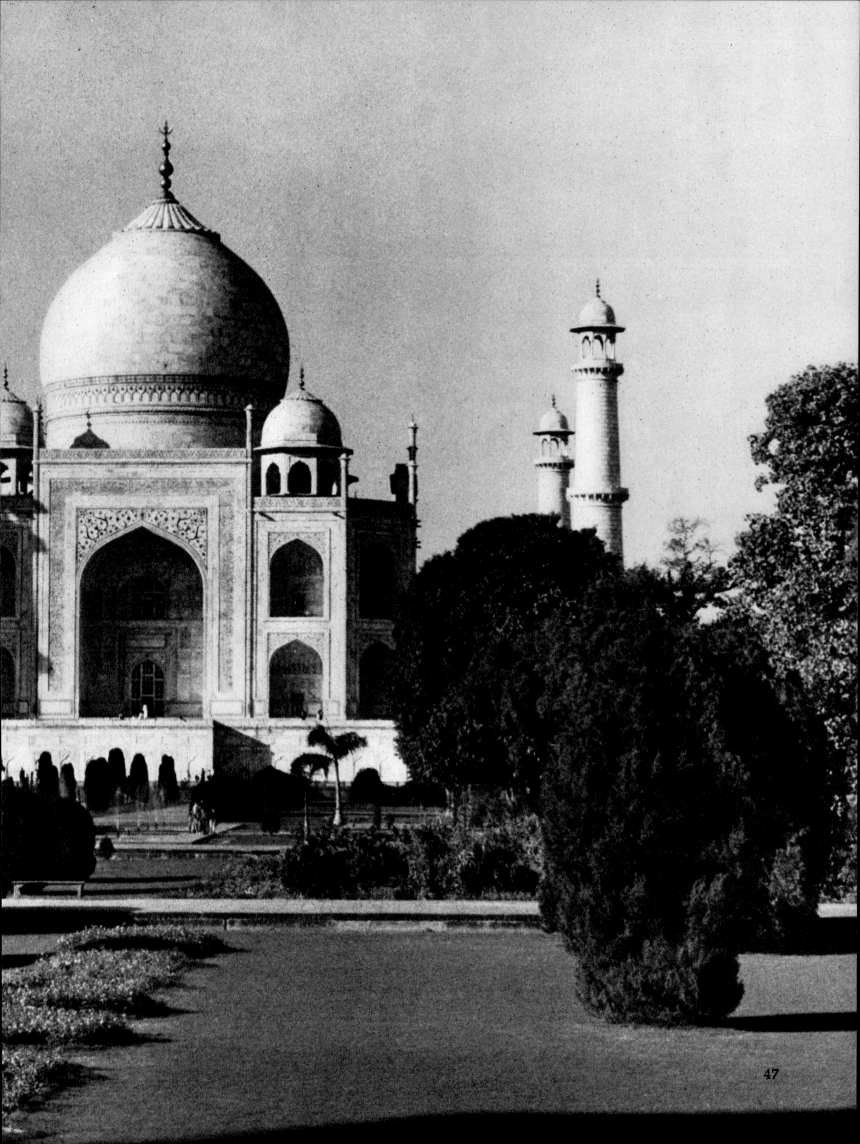

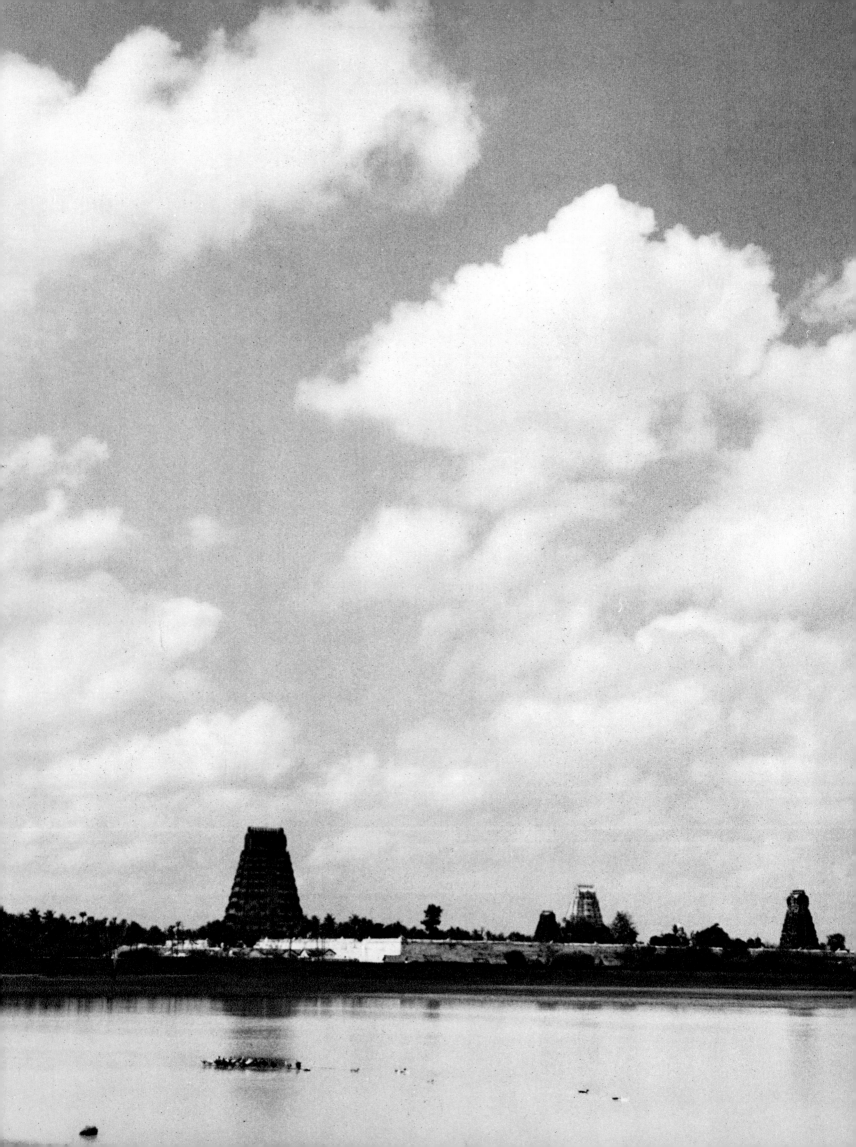

twice life-size, stands before him in the attitude of a god bestowing a grace, accompanied by the pot-bellied dwarfs who, like him, have their home in the Himalayas. And all round and above, and beyond the further bank of the Ganges, come the multitudes to salute Shiva and to give thanks for the creation of the world. Holy men, lions and tigers, deer and elephants, are all coming in joyous swarms. Gods and titans, celestial beings, genii, demons, serpent princes, and ordinary human beings are all hurrying as fast as their feet will go, or else they rest on their way with dazed and happy looks. A deer rests and scratches its muzzle with a hoof. A monkey peers down in delighted astonishment. A brahmin bathes in the river and then dries his hair in the sun of the newly awakened world. Arjuna—if it is Arjuna—makes the sign of obeisance to the god who has descended from the Himalayas to live among men. The world has been created at this very instant, and the rock glows with joy and adoration in the morning of the world.

Nothing like this relief was ever carved before, or ever again. The divine energy of life was never celebrated with so much fervor, so much grace and skill and delicacy. These creatures, who have suddenly come to inhabit a newborn world, are all life-size: so the elephants acquire a disproportionate space, but they, too, are trumpeting their joy. Out of that matrix of stone, that prodigious granite wall set in the broad sunlight, the sculptors carved scenes one would not have believed possible.

The Pallava princes, who reigned from 325 to 900 A.D., acquired wealth by their conquests in the East Indies. They traded with the West, for Roman coins have been found in the sandy shore. But neither their wealth nor their conquests provide any clue to the emergence of a style of such breathtaking humanity. "Arjuna's Penance" was not the only great carving at Mamallapuram. Altogether, along the beach, there are fifteen temples all carved in much the same way, and there are others which may have disappeared beneath the sea. Most of these temples seem to have been carved during the reign of the Pallava prince Mahendra I, an accomplished musician and poet, and his son Narasimha I. With the death of Narasimha I about 670 A.D., the great tradition ended. For a few more years the carving of shore temples went on, but the sense of urgency had vanished.

The music and poetry of Mahendra I have vanished, but of the man himself we know as much as we need to know. His portrait is in the sculptures which are as fresh today as when they were first carved, the palpable flesh made living in granite. There is even a portrait taken from life, showing him crowned, broad-shouldered, slim-waisted, with thick lips and prominent nose. Two of his wives stand beside him, slender and flowerlike; one of the king's hands clasps firmly the wrist of one of his wives. He stands there in the shadow of a cave, and in the thrust of his arm and the grip of his hand there is such a thirst for mortal beauty that the spectator is left gasping. It is as though he had entered unannounced into the mind and spirit of the king.

The Hoysala Ballala kings who flourished in the south some six hundred years later built as monumentally as the Pallava princes, but they had none of the Pallava love for the enduring sweetness of flesh. Their star-shaped temples are encrusted with

sculptures from top to bottom; there is no surface or cranny without some dancing figure or some elaborate decorative frieze, but the dancing girls are almost hidden in cascades of jewelry and the friezes in endless rows repeat the same motifs. The sculptors carved in soft stone, as if it were ivory or wood; and the ease with which they were able to execute their designs made them delirious. They went on and on, never stopping. Almost it gives the effect of filigree. Vast temples were erected, stage upon stage rising into the blue sky, like so many ziggurats. On every stage there were friezes, dancers, musicians, assemblies of the gods, so that there must have come a time when they were numbed by the prodigality of decoration.

To call them the Hoysala Ballala kings is to grant them the title they claimed by right of conquest, but they were kings only in name. They were tribal chieftains determined to imitate the appropriate royal gestures and to build monuments to their own glory; inevitably they outreached themselves. They adored the glitter of things, not the substance; so for over a hundred years they made baubles to their own magnificence.

But what baubles they are! The glittering ziggurats climb to the heavens. At Belur and Halebid the passion for ornament reaches its height. Never again, not even under Louis XIV at Versailles, was there to be such a frenzied addiction to ornament for its own sake. Look, for example, at Ganesa, the elephant-headed god who was the son of Shiva. His head lolls under the towering weight of his jewel-encrusted crown, his tusks bend and creak beneath the weight of more jewels, and his jeweled skirts hold him to the earth. So the Hoysala Ballala kings must have looked when they sat on their thrones.

This riot of decoration would have been disastrous if it were not accomplished with a consummate sense of purpose and if it did not answer to the needs of the Indian imagination. The fertile land demanded fertile ornament. The endless intricate carvings reflect the passion for fecundity. The small, gently curving breasts which appeared at the time of the Pallava princes have given place to breasts like great globes, obviously brimming with milk. We are far from the Pallava's insistence upon idealized forms; the forms are human, all too human. Ganesa himself, rolling among jewels, drunk with his own splendor, choking under the weight of his panoply, has a purely human vulgarity. But it should not be forgotten that the Pallava princes, who produced some of the greatest sculptures the world has ever known, were also addicted to ornament, for what else is "Arjuna's Penance" but a prodigious decoration? Around the central figure of the divine Shiva summoning the heavenly Ganges, they carved a myriad forms of worshipers. They, too, serve an ornamental purpose. Yet the figures carved at Mamallapuram possess a pure vitality and belong to the realm of art; the figures carved at Belur and Halebid belong to needlework.

In the end the Hoysala dynasty perished at the hands of Arab invaders. The Arab doctrine forbade all ornament, demanding the utmost simplicity. There was some irony in the fact that the tribal chieftains addicted to exquisite ornament should fall to the Arabs, who saw no purpose in decorating a world that was sufficiently decorated by the presence of Allah. The Arabs did not tear down the temples, which were

sturdily built, and to the Arab mind totally incomprehensible. They left them alone.

The enduring qualities of the Indian imagination survived the Mogul conquerors. Under Akbar, Islam acquired a chaste veneer of Hinduism. Ornament returned, more precious now because it was theoretically forbidden; and the Taj Mahal is as thickly ornamented with inlaid flowers as the temples of Belur and Halebid are ornamented with gods. Fecundity had not perished; it was merely channeled along the springing line which was the chief contribution of Moslem architects to the world. The forests of gods remained, as they will always remain, to haunt the Indian imagination.

For there is a richness in that imagination that could not be put out as a candle is put out. It flowers in adversity and has the power of continually replenishing itself. For the Hindus, we are all attendants at the wedding feasts of the gods, and man himself is more than half-divine. In the realm of the spirit he moves among the gods as a worshiper, but also as a brother, and when he dies he offers himself to Indra, the god of fire, as a morsel for the wedding feast. He believes that the gods rejoice in the offering.

In this faith the Hindus lived and built their vast temples, hoping they would endure for all time. The temples were the earthly mansions of the gods, and therefore it was proper that they should be majestic, intricately ornamented, and splendidly appointed. Sometimes, when you enter one of these temples, you have the feeling that even the gods must be a little bewildered by their immensity and determined splendor.

# *Plates*

page

53     The 238-foot tower of Kutb Minar, Delhi, completed in 1199 A.D. by Aibak Kutb-ud-din.

54     Gateway to Hoysalesvara temple, Halebid, Mysore.

55     Detail of temple of Kishava, Somnathpur, Madras.

56–57     Tank within the temple precinct, Kanchipuram, Madras.

58–59     Roadside market.

60     Peasant woman.

61     Rural sheep market between Delhi and Agra.

62–63     Temple musicians; one plays a *shahnai*, another a drum, another a small set of cymbals.

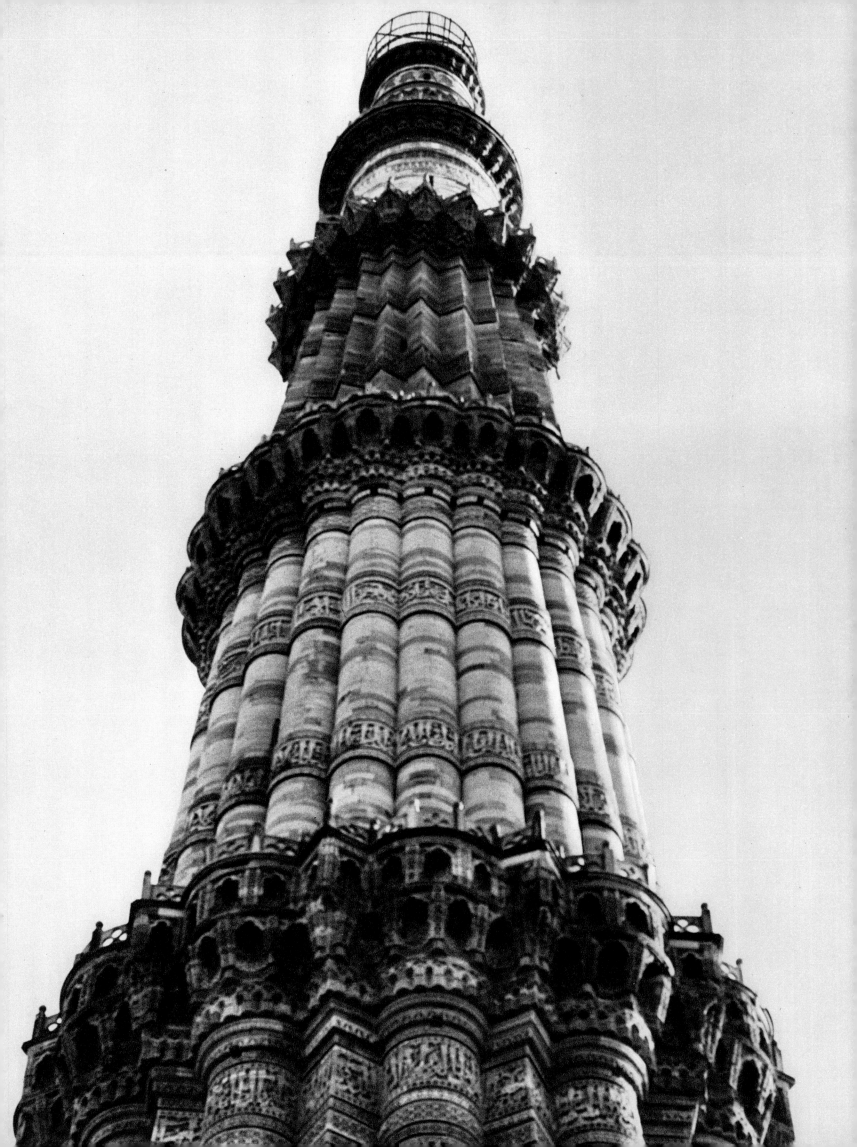

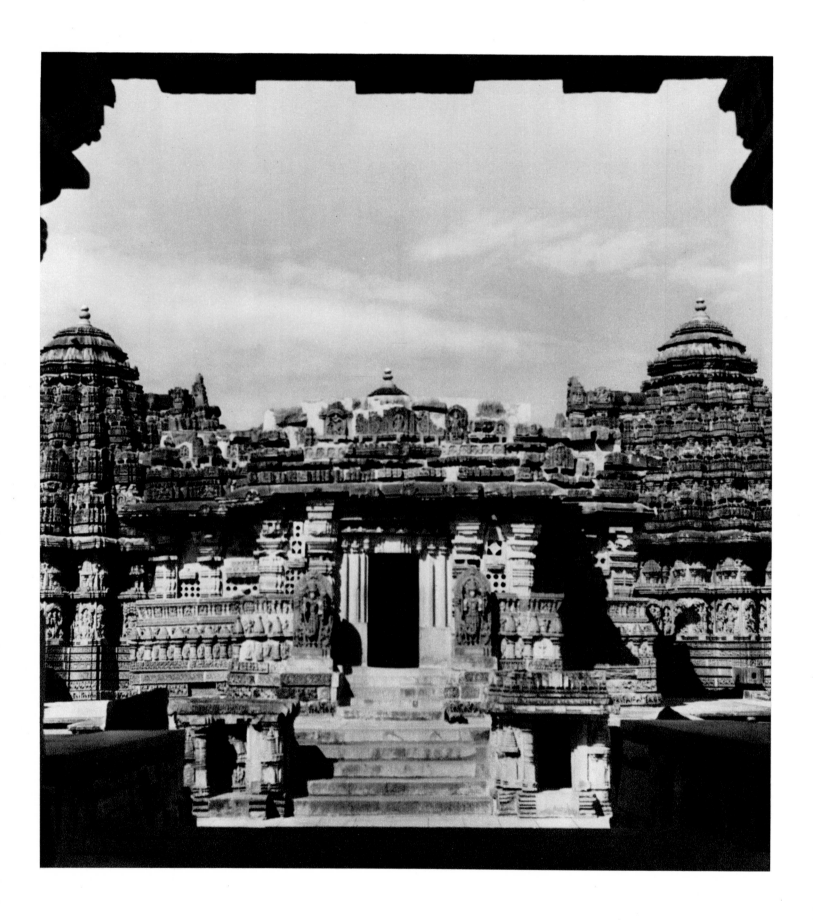

54

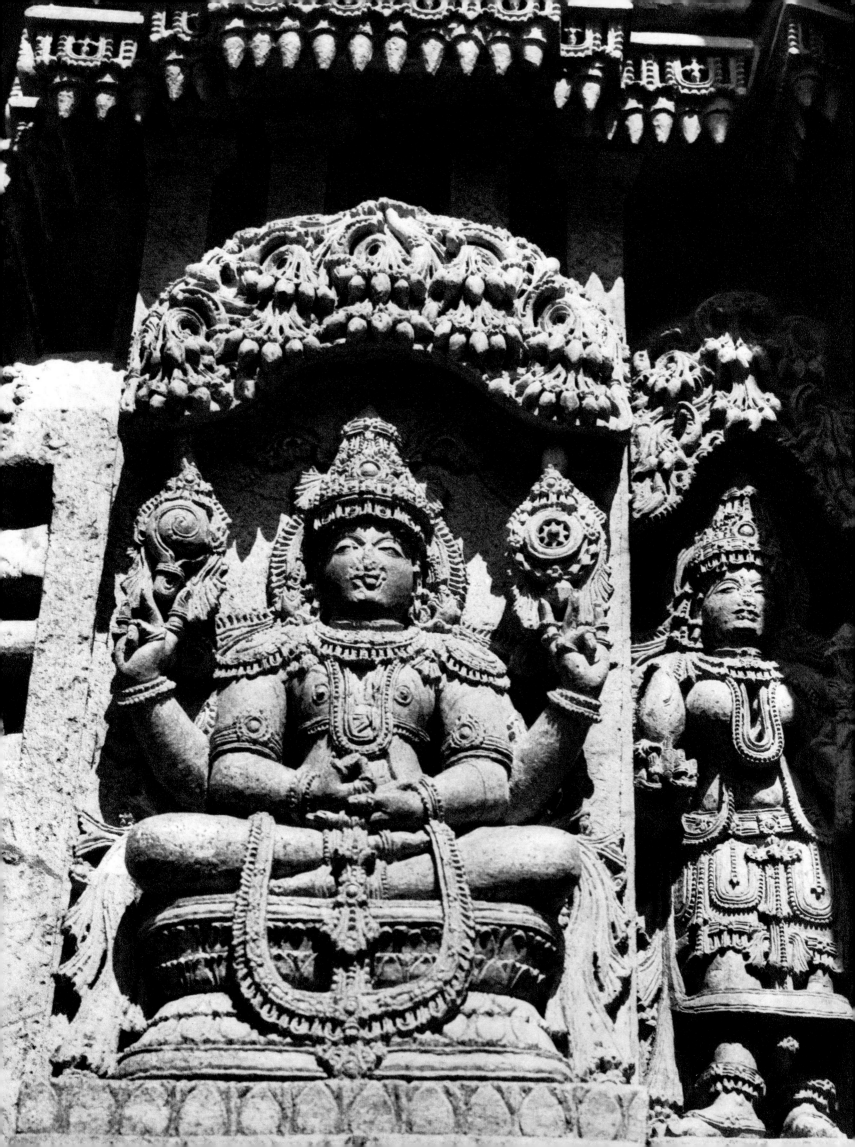

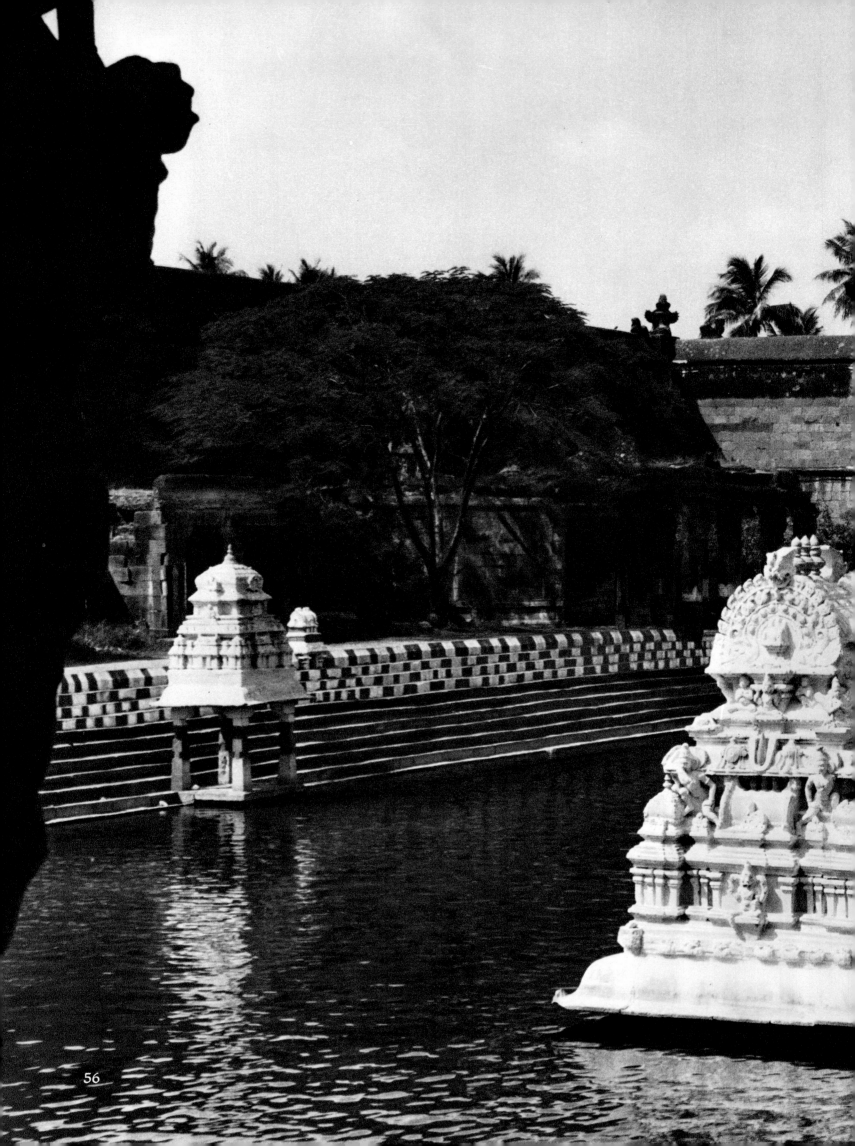

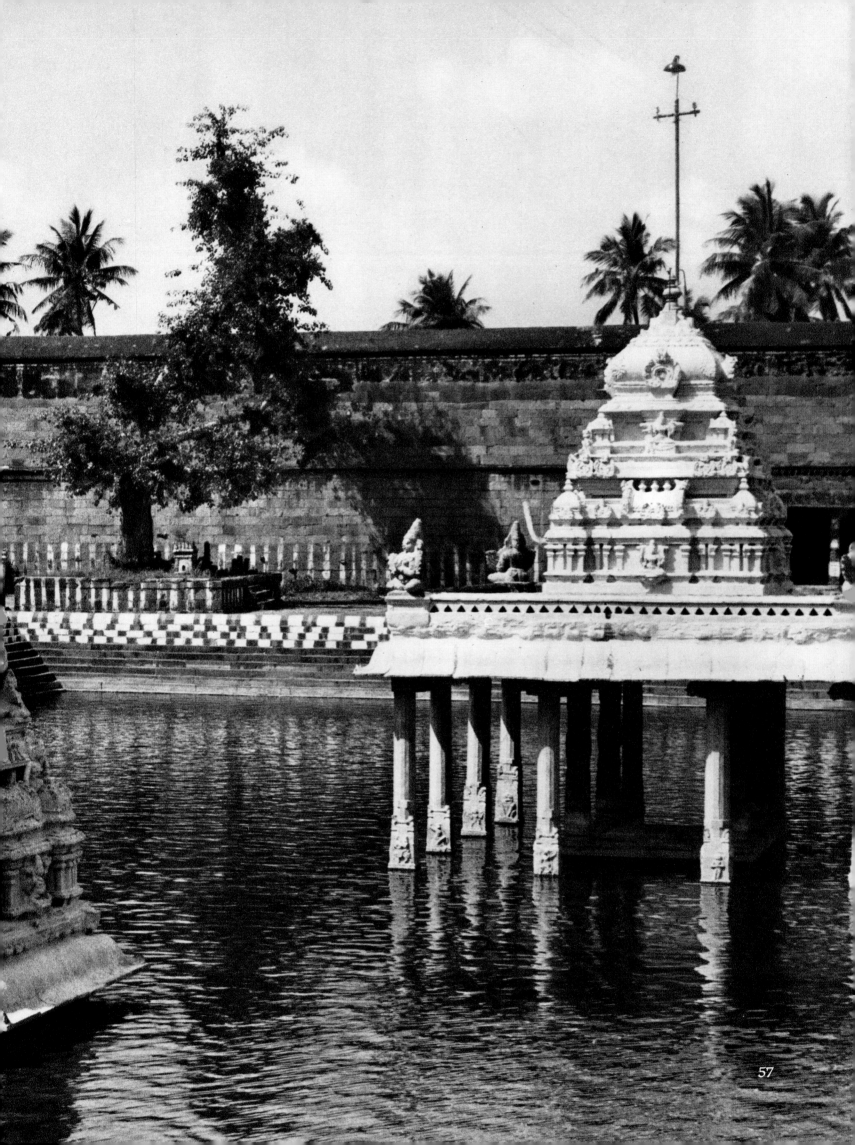

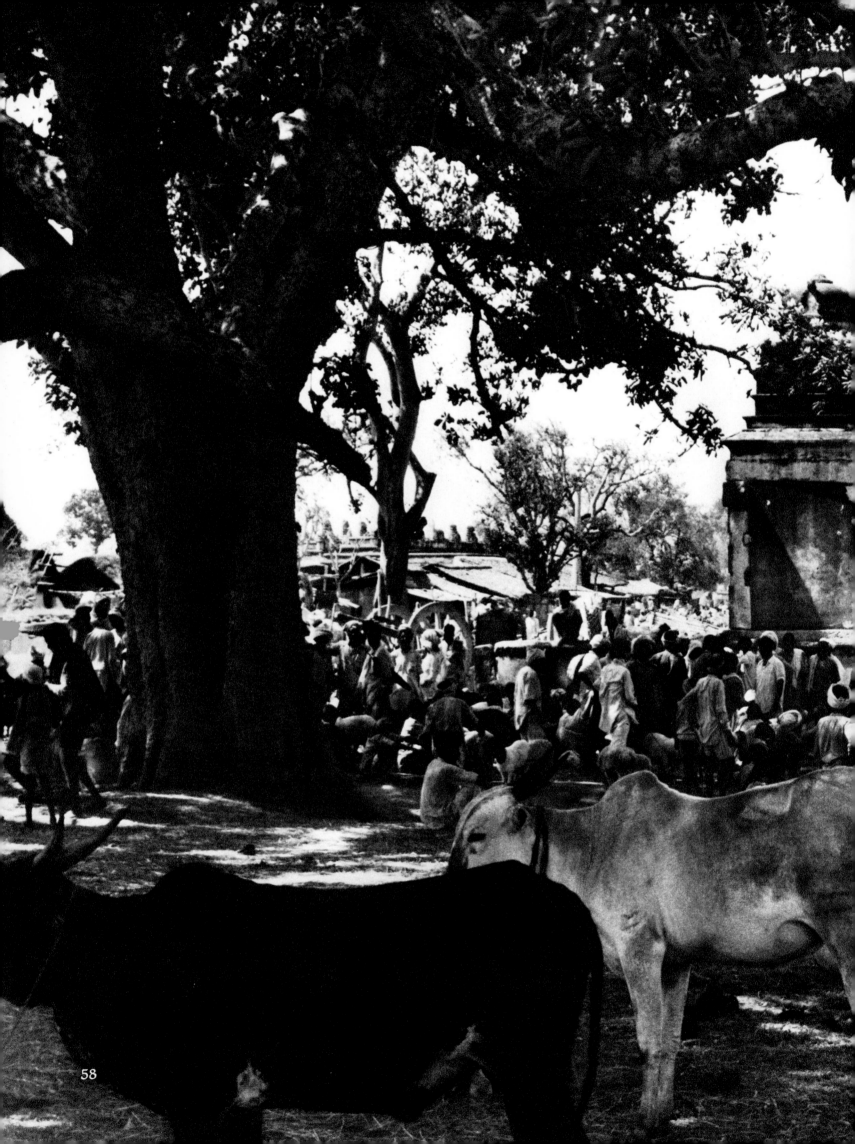

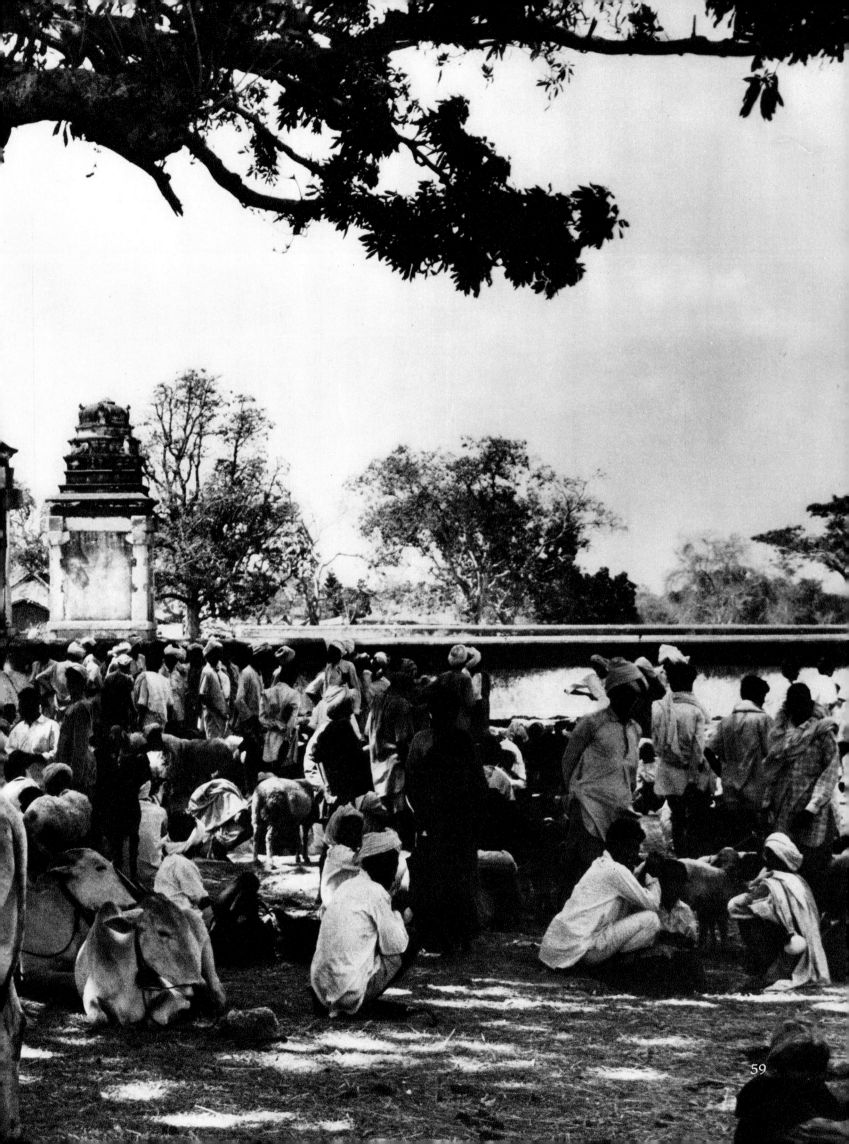

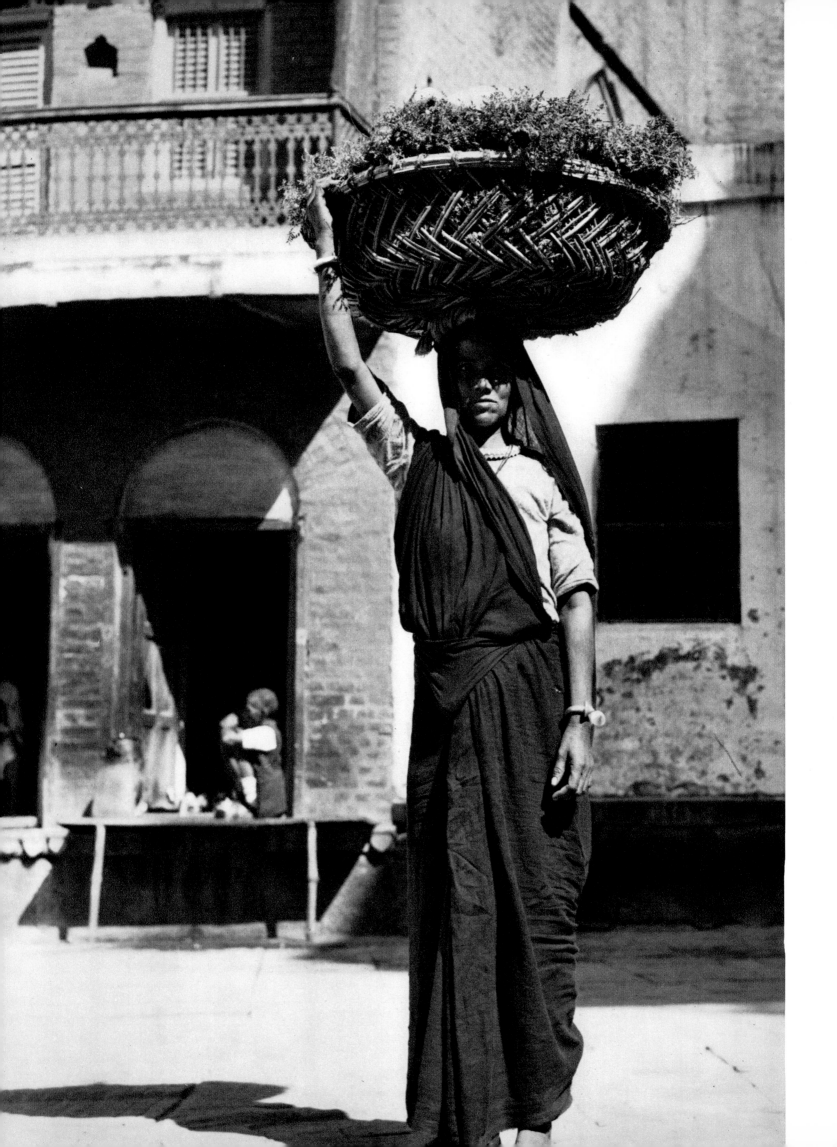

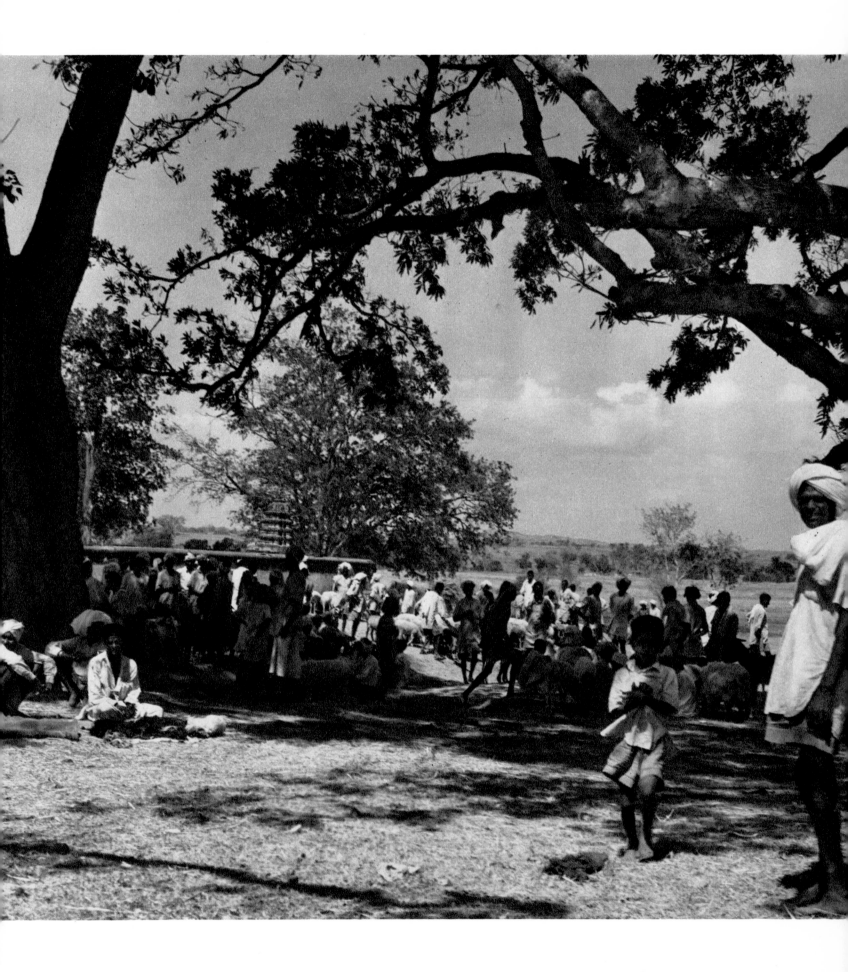

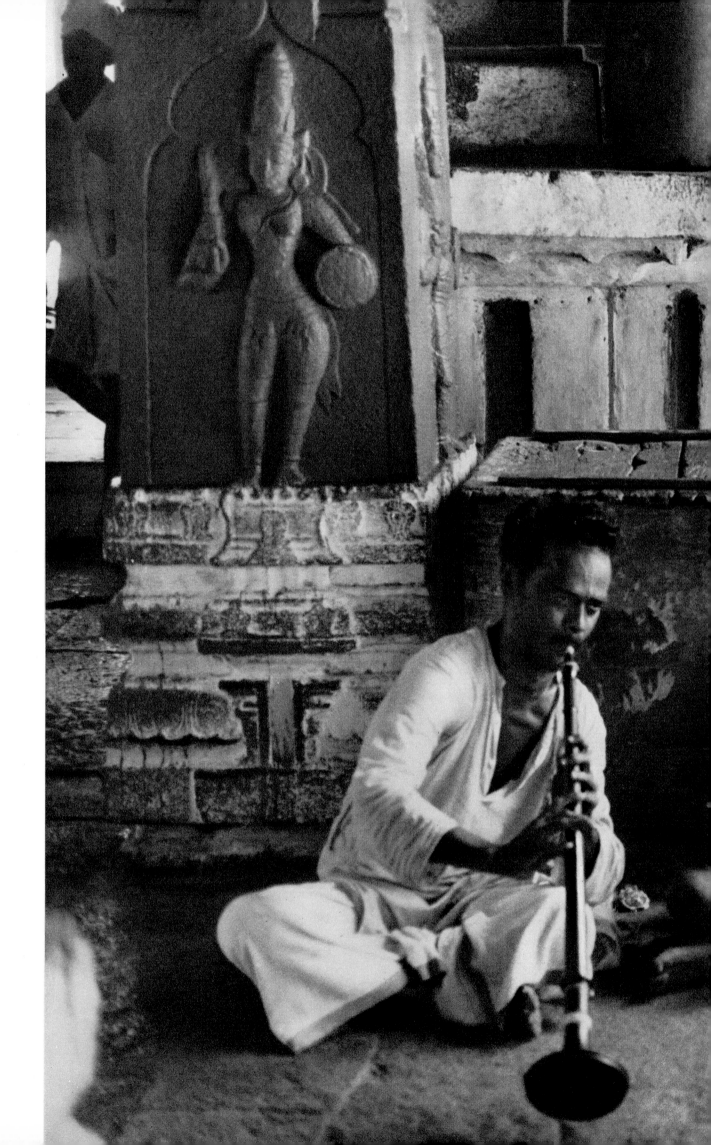

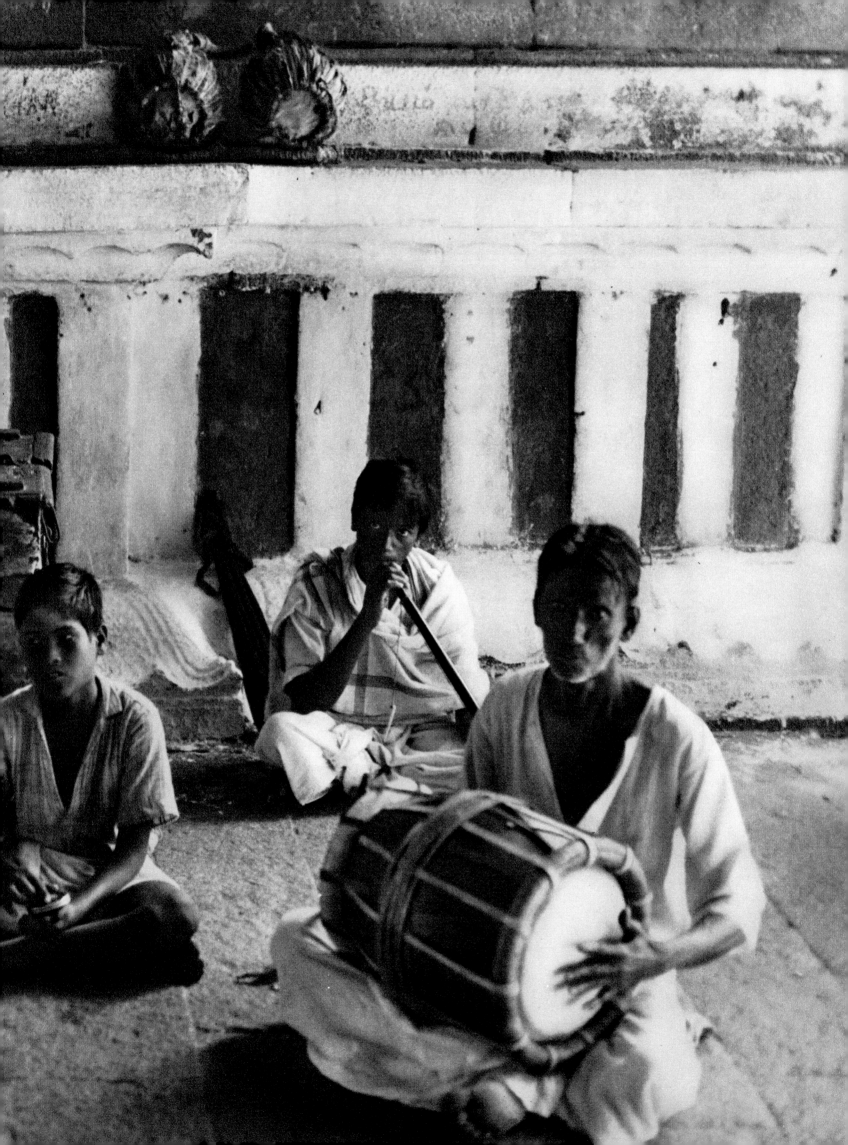

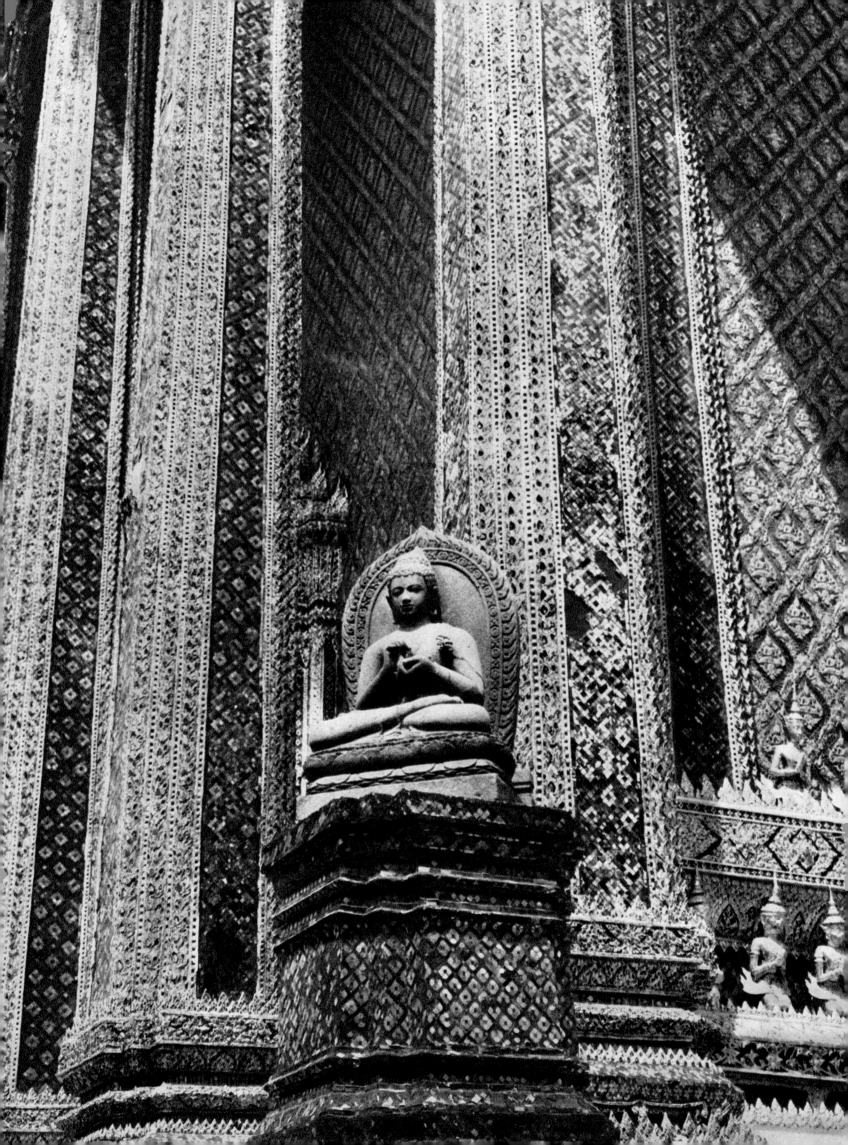

# Thailand

<span style="font-variant: small-caps">The traveler in the Far East finds himself coming upon India wherever he goes. In the</span> islands of the East Indies, in Java and Sumatra and especially in Bali, in Thailand, Burma, Malaya, Indo-China, China, and Japan he is continually meeting India face to face. India is everywhere—in the temples, in the faces of the gods, in habits of mind, in dances, in gestures, in songs, in the way men live their lives. The great waves of Hinduism and Buddhism were flung across the whole expanse of Asia. Ideas which began to mature twenty-five centuries ago in the valley of the Ganges are still bearing fruit. The Balinese worship the ancient Hindu gods, and Japanese civilization is permeated through and through with reverence for Gautama Buddha, the prince who was born on the foothills of the Himalayas.

So now, outside the royal chapel in Bangkok, we meet India again in the shape of a curly-headed boy who seems to be writing something on a tablet while calmly observing the scene around him. He sits cross-legged on his throne, the jewel-encrusted walls of a palace rising behind him. We recognize him well, for the sculpture belongs to the traditional form of Gupta art of the sixth century A.D., and he resembles the more famous Teaching Buddha at Sarnath—this not only in his posture and virile grace, but also in the elaborate folds of his gown, the small wave-caps which break the still surface. There is about Gupta art wherever it is encountered a certain quiet firmness, at once strenuous and delicate, an enchanting liveliness, a splendid nobility. These artists were in love with the human form, but also with divinity. Not blood, but starlight, flows through the veins of their gods.

Against this vast glittering wall the boy is perfectly at ease. The wall does not threaten him in any way; on the contrary, it acts as a kind of backcloth, an extension of his throne. His throne is detached from the wall, as he himself is detached from the world. There is the faintest of smiles playing at the corners of his lips, as he watches the world passing below. We tell ourselves that this is the young Buddha

<span style="font-variant: small-caps">opposite</span>: The Dhanya Buddha, or Lord of the Worlds, enthroned beside the wall of Wat Phra Keo (Temple of the Emerald Buddha), Bangkok.

observing the world from outside the Temple of the Emerald Buddha, calm and detached, represented by a curly-headed boy.

As it happens, he is not Gautama Buddha, nor is he curly-haired, nor is he taking notes, nor is there any temple in Bangkok called the Temple of the Emerald Buddha— this name is a misnomer for the royal chapel attached to the palace of the King of Thailand, which contains among its most precious possessions a figure of the Buddha twenty-two inches high cut from solid jasper. For some inexplicable reason jasper was thought to be emerald.

The boy is not the Buddha, but greater than the Buddha. He is not an earthly being who became enlightened, but a giver of light, a savior who eternally blesses the world, sublimely calm in the midst of the world's storms. Flaming worlds, world after world, decorate his throne. His curls are crowns. His hands are raised in the mudra of "one who teaches," but what he teaches is not to be put down in words: he teaches only the example of his own blessedness. He is not of this world, nor of any world. From his solemn meditations worlds are born, while we who live below are merely his dreams.

Such presences, appearing to men's inner eyes, are revelations of a holiness so vast and so enduring that they are almost beyond mortal thought. Enthroned above the worlds, beyond all time and space, above all the Buddhas who have ever appeared or will ever appear, they proclaim an eternal blessedness. Their eyes are closed, but they see all. Their lips are closed, and their unspoken words become the ages. The breath that pours through them is the life flowing through all things from the beginning, which is no beginning, to the end, which is no ending. All this is represented by the dreaming boy.

Although this sculpture betrays its Indian influence, nevertheless it was carved by Thai sculptors working in a tradition at least a thousand years old. Traditions rarely survive intact for so long; the edges crumble, the heart withers, and within two hundred years there is usually only a decaying remnant. But it was the peculiar strength of the Gupta sculptors that they perfected a method of sculpture and a way of looking at the human form which survived almost to our own day. Almost a Gupta master could have signed it. Almost, but not quite: for here and there, in subtle modulations of detail, in the folds of the gown, in the enchanting wave-caps near the left shoulder, and in the plumpness of the cheeks and rounded arms, the Thai master has left his imprint.

The Thai artists were in love with youthfulness. On occasion they could portray the Lord of the Worlds with features of august power, and this happened especially when they came under Khmer influence. But mostly they preferred to represent him as a dreaming boy with some litheness about him, not brooding or bemused by his own majesty, but as one who will wake soon and go whistling on his way.

This springing youthfulness is something that seems to belong essentially to Thailand, for nowhere else in the world except in ancient Greece have the artists celebrated youth, the divinity of youth, with such quiet passion. It is not only that they represent

the gods as youths or young men walking in a perpetual springtime, but even when the god is old and wrinkled, there is something youthful about him. And their temples, too, have the exuberance of youth.

It comes perhaps from the air, which is not the heavy languorous air of India flowing like juices, but lighter, softer, and far more transparent. Hence the ease of movement in these sculptures, a sense of a world in which there are no impediments. It is no accident that the Thai sculptors are the supreme masters of the human hand. Nowhere else have hands been rendered so expressively, so exquisitely, divinity flowing from them. The slender fingers curl like petals, weightless even when they are cast in bronze, anatomically impossible, possessing a grace which a flower might envy. These hands bestow peace and fearlessness upon the devotee; power streams through them; they are the instruments of divine justice, for they turn the Wheel of the Law. They are the spiritualized expression of the power wielded by the Lord of the Worlds or by the manifestations of the Buddha, and if you look at them closely you will see that they are modeled on the hands of a twelve-year-old.

So, too, with the Thai temples, which were not erected to impress the onlooker with magnitude suggesting the vast presence of the god within. They are ornate, playful, radiant. Planes and outlines, not the mass, have been stressed. The planes shimmer, encrusted with mosaics, and the outlines are never straight, but provided with thousands of decorative hooks, claws, teeth, serpents' fangs, porcelain chips, glass splinters, lightning conductors—a controlled and delicate jaggedness designed to prevent the eye from resting along the edges of things. This wonderfully contrived jaggedness has the effect of joining the temple to the sky. The sky and the temple are hooked together, indissolubly linked, and so the light flows more easily from one to the other. Something of the same effect is produced by the lacework on Gothic cathedrals, but the Thai temples have the greater exuberance. The jagged outline gives the effect of movement, so that the temples always seem to be hovering two or three inches above the surface of the earth. Emerging from the elaborate heaviness of Khmer tradition— those heavy, gnarled Buddhas which resemble the boles of long-dead trees—the artists of Thailand were determined to give lightness to everything they touched.

Lightness, airiness, winged elegance, speed, and soaring grace: such is the contribution of Thai architects to the civilization of southeast Asia, and it is no small one. The dreaming spires, the whorls of flame, the incessant crenellations and serrations, the glitter and the shining do not produce a feeling of restlessness. On the contrary, they give an impression of intricate clarity, and eagerness, and a desire to please.

Though the Thais have learned much from India, and the shapes of their gods and all their rituals derive from Indian sources, nevertheless the Thai imagination lacks the Indian passion for immensity. There comes a time when Indian art appalls by its sheer enormousness, the vastness of the forms, the hugeness of the conceptions, the endless reaching out to infinity. The giant caves of Elephanta, the enormous courtyards carved out of the living rock at Ellora, the great sculptured boulders at Mamallapuram speak of a people in love with vast shapes of power, forever matching themselves with the

# Plates

*page*

69    Two demons outside the pantheon containing the statues of past kings, Wat Phra Keo, Bangkok.

70    Wall of Wat Arun (Monastery of the Dawn) at Dhonburi, twin city of Bangkok. The terraces are supported by statues of demons and angels.

71    Demons guarding an entrance to Wat Phra Keo.

72    One of the four smaller towers of Wat Arun; in the niche is the Moon God on his white horse. The trident of Shiva tops each tower.

73    Towers and demons at Wat Arun.

74    Stone demon, carved in China, at Wat Po (Monastery of the Reclining Buddha), Bangkok.

75    Guardian demons at Wat Po.

76    Four great *chedi*, or pagodas, at Wat Po, representing the first four kings of the Chakri dynasty.

77    Stone figure guarding the entrance to Wat Arun.

78–79    Towers at Wat Phra Keo.

80    Head of the Reclining Buddha, Wat Po.

81    The Reclining Buddha, of stucco-covered brick covered with gold leaf; the figure is 160 feet long and 40 feet high.

82    Sitting Buddhas at Wat Po; there are 394 such statues in the galleries surrounding the courtyard of the main chapel.

83    Ornamental statues, Wat Phra Keo.

84    Demons guarding the gateway at Wat Arun.

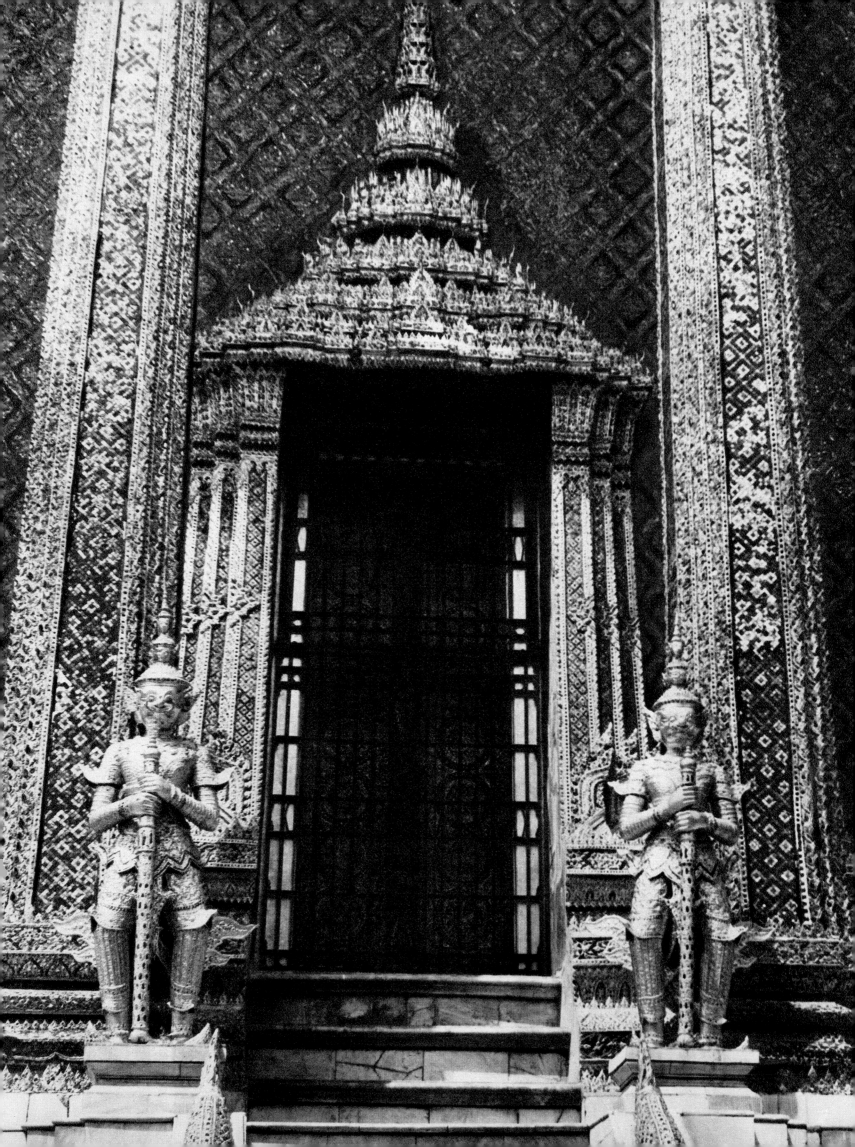

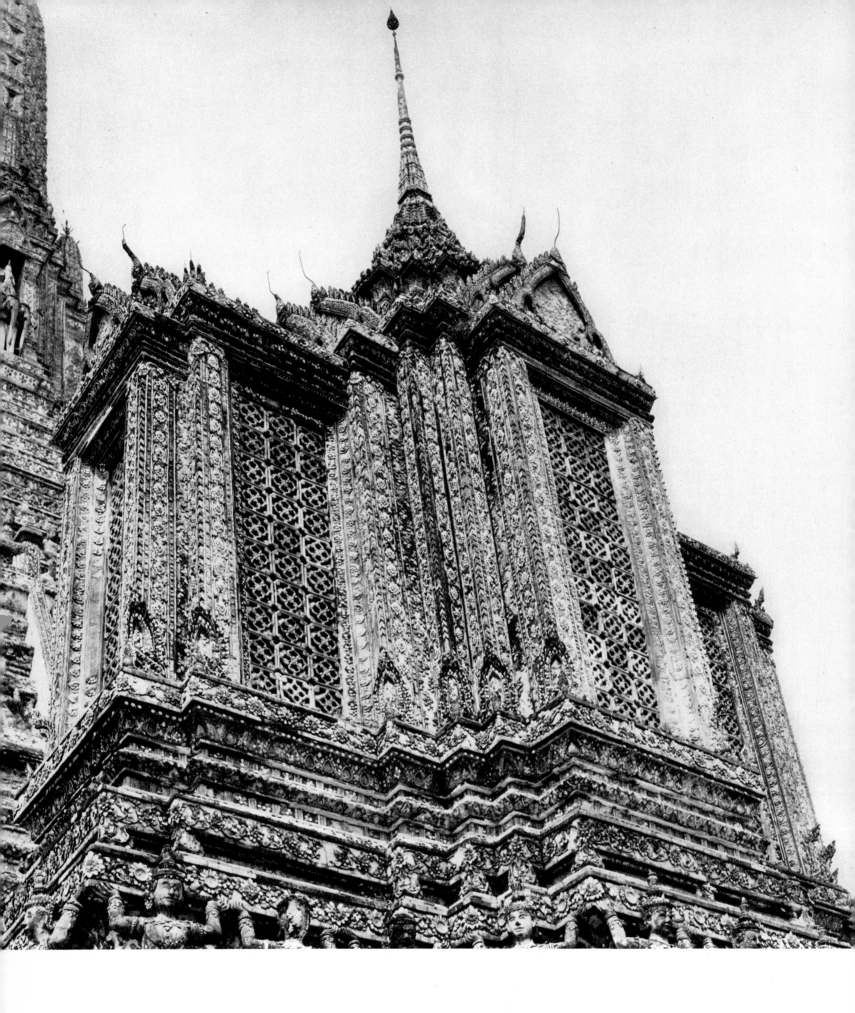

70

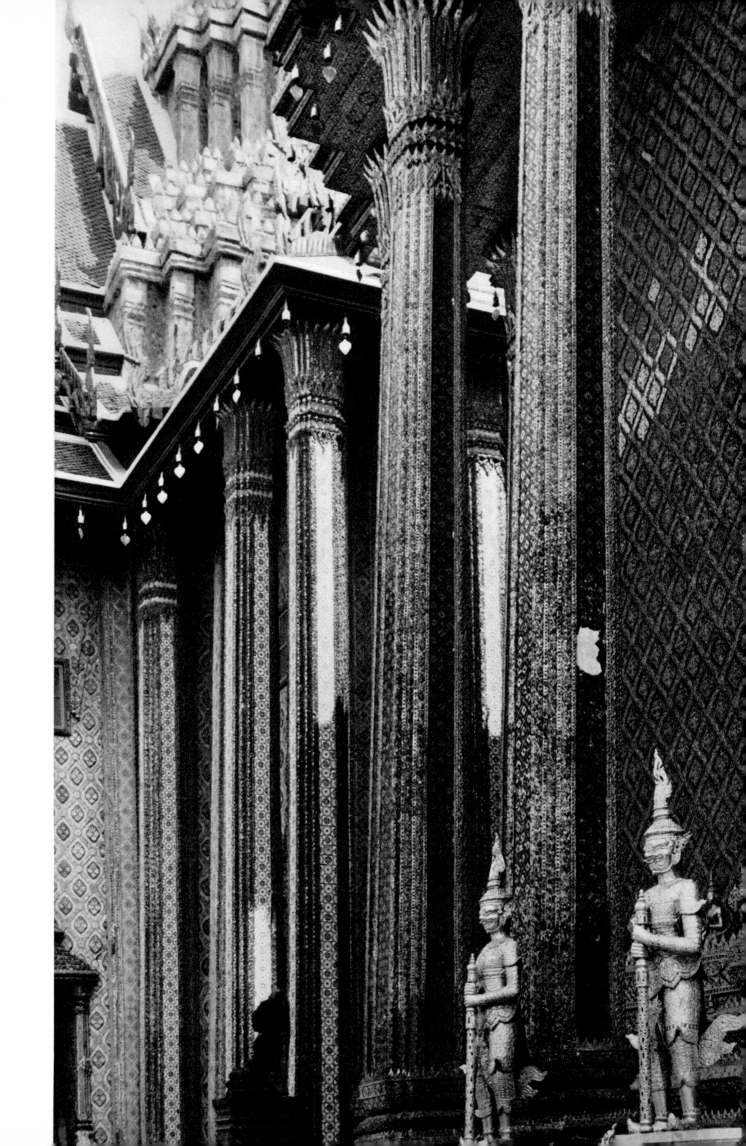

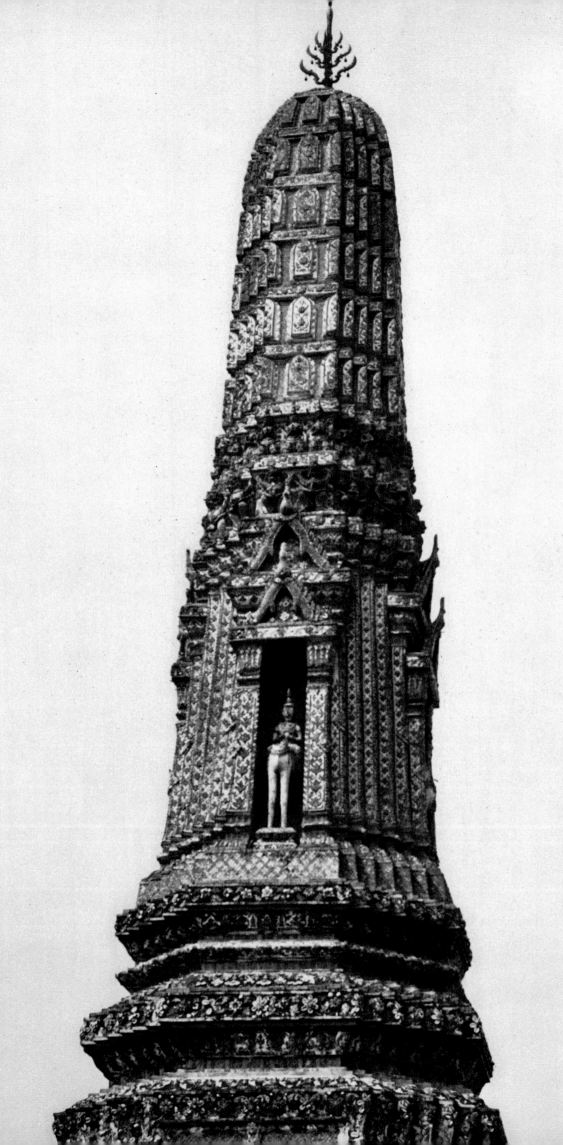

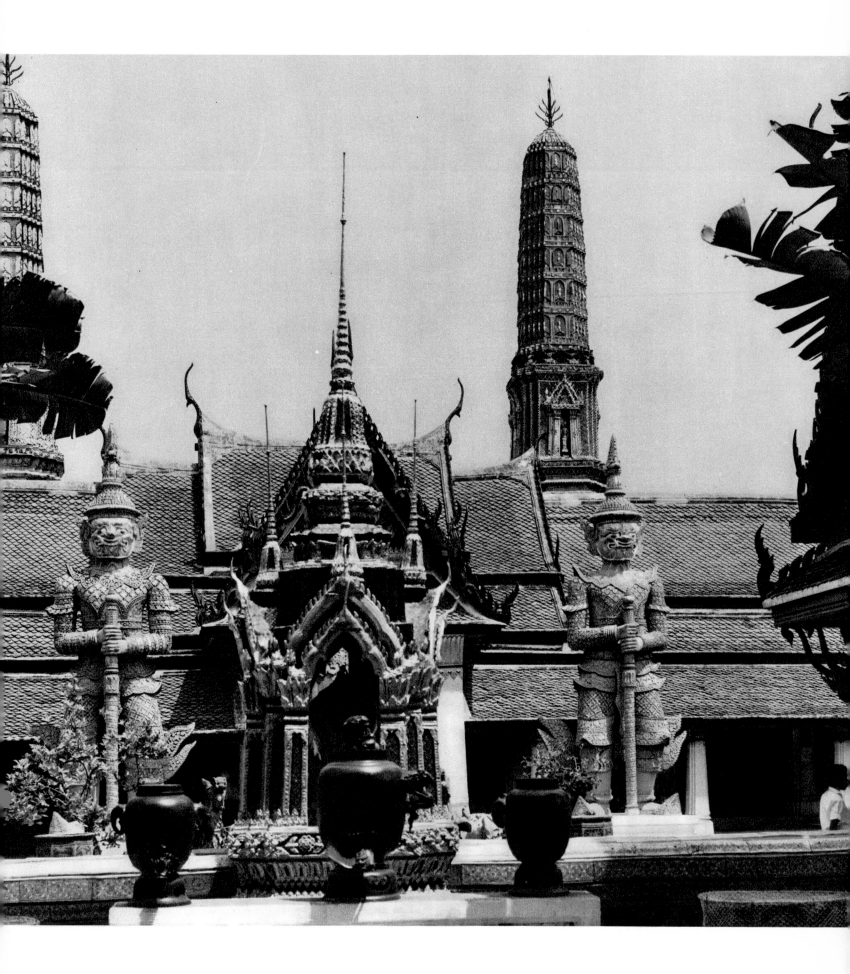

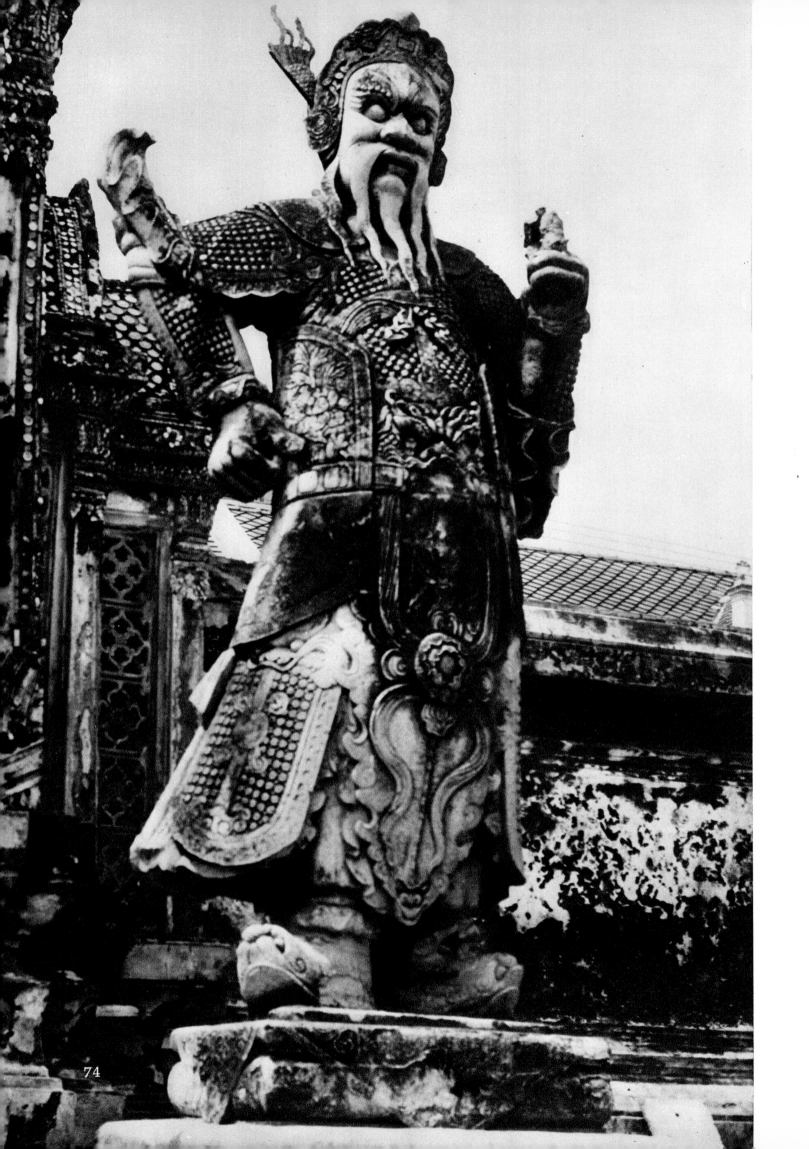

74

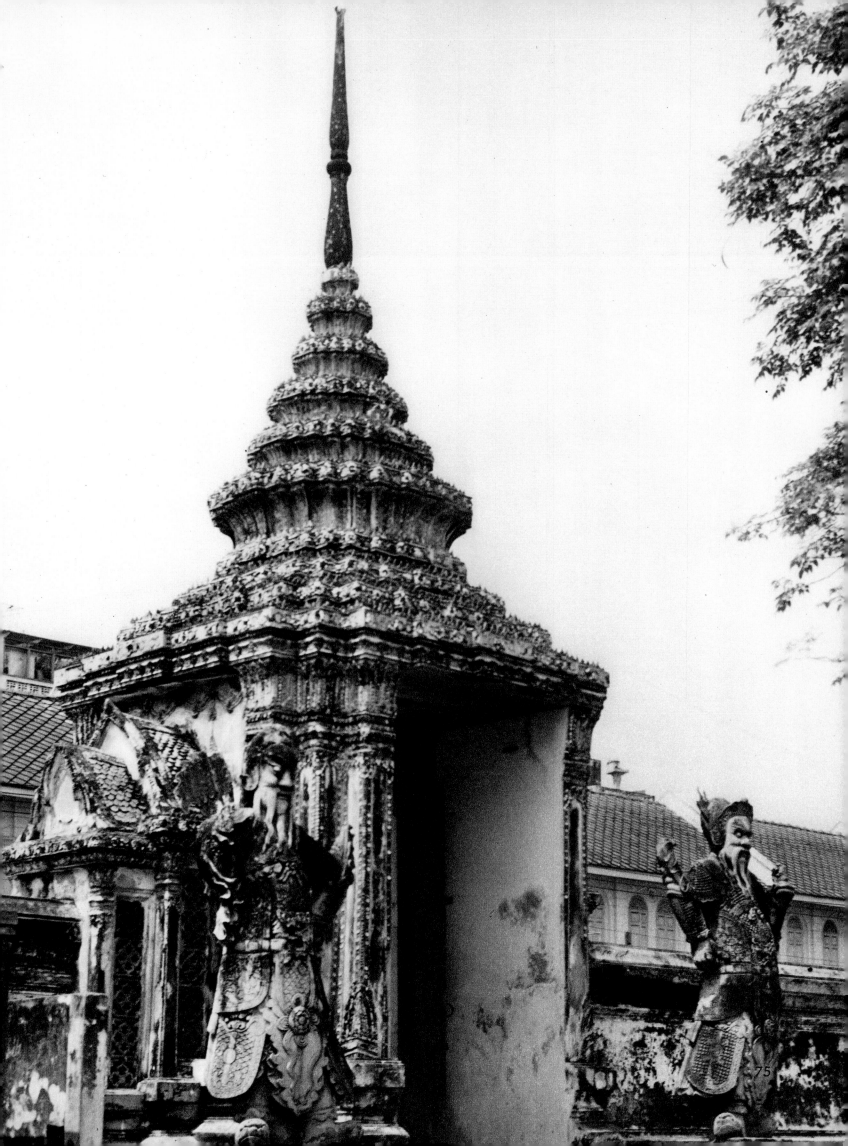

75

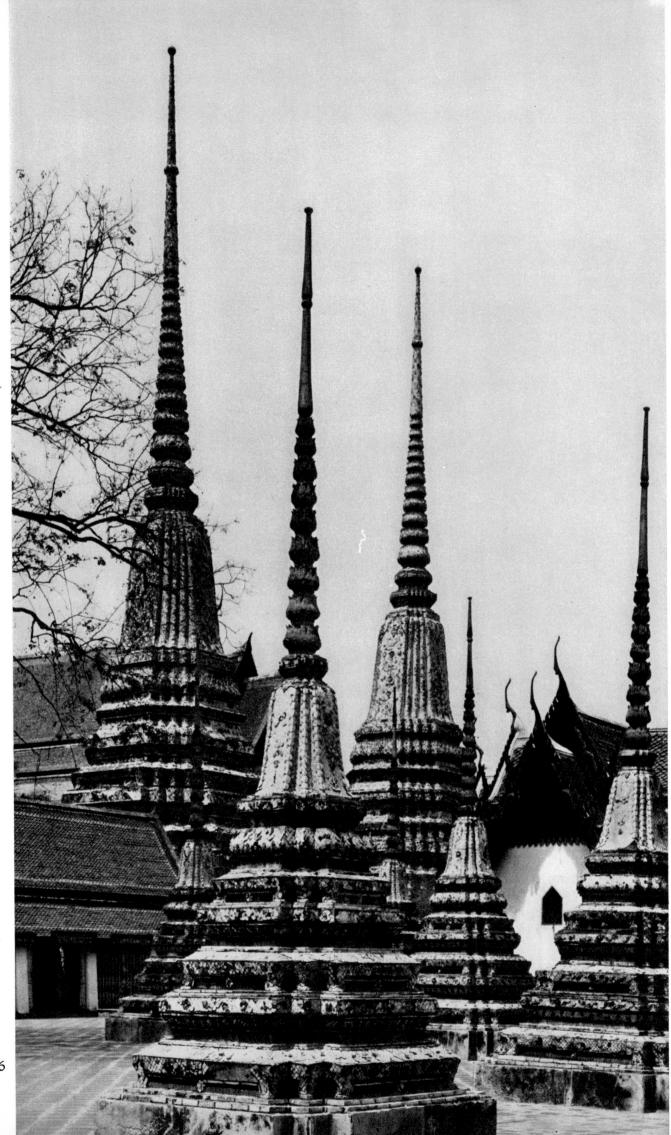

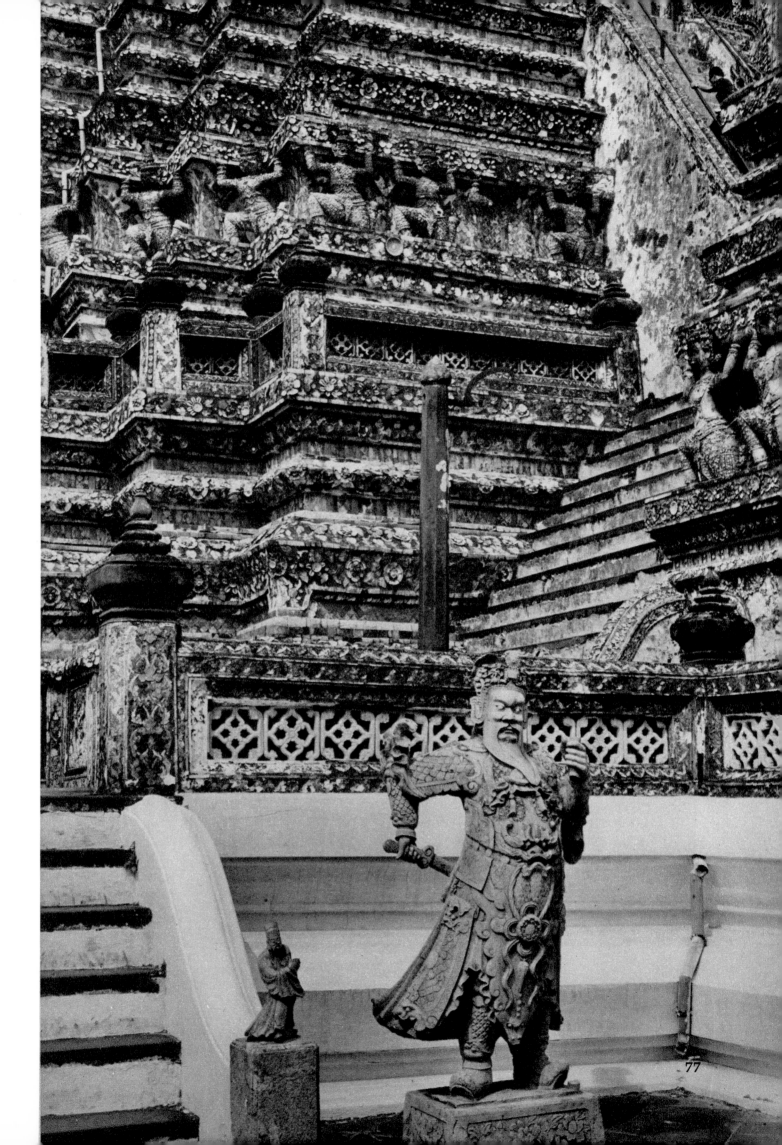

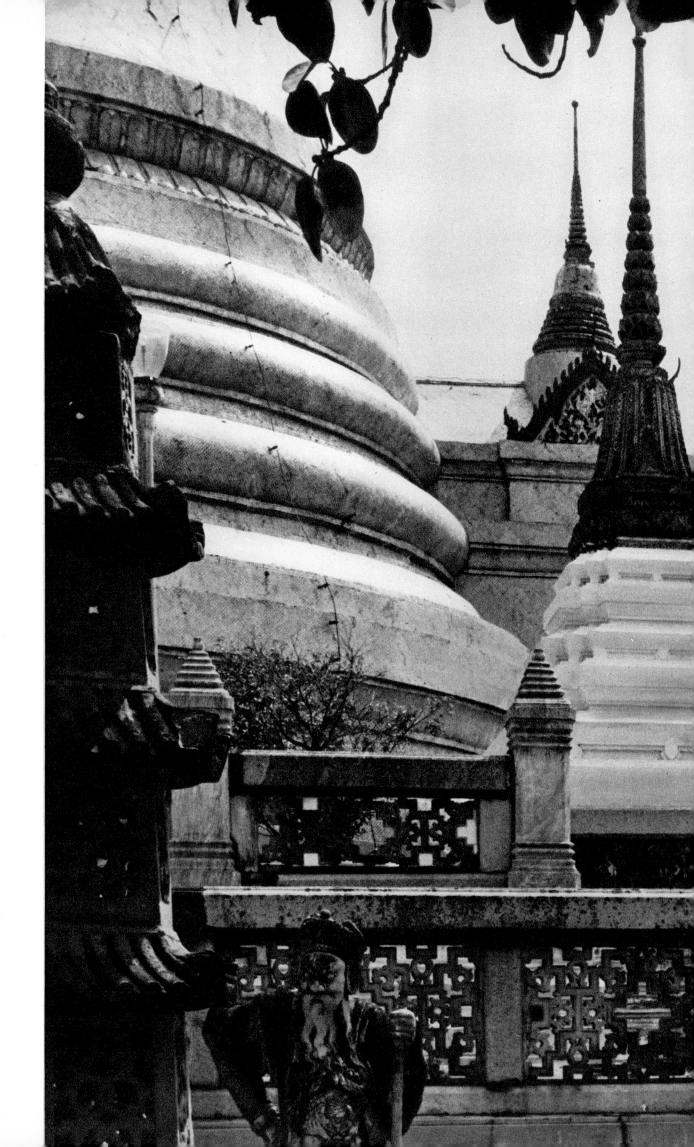

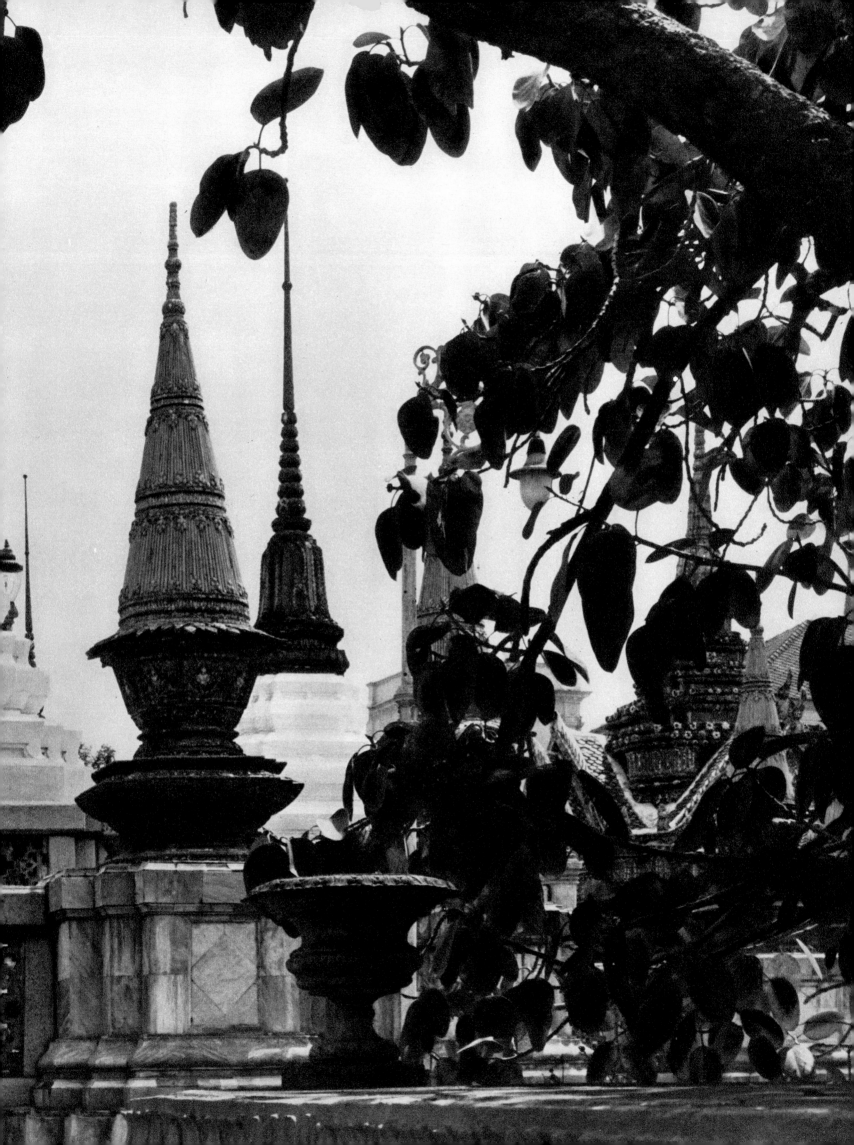

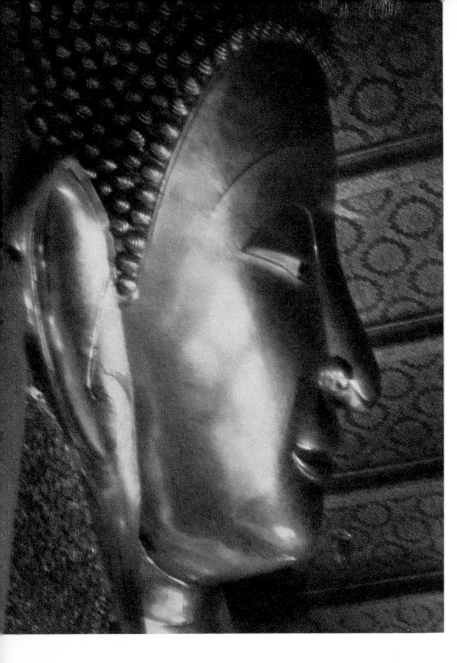

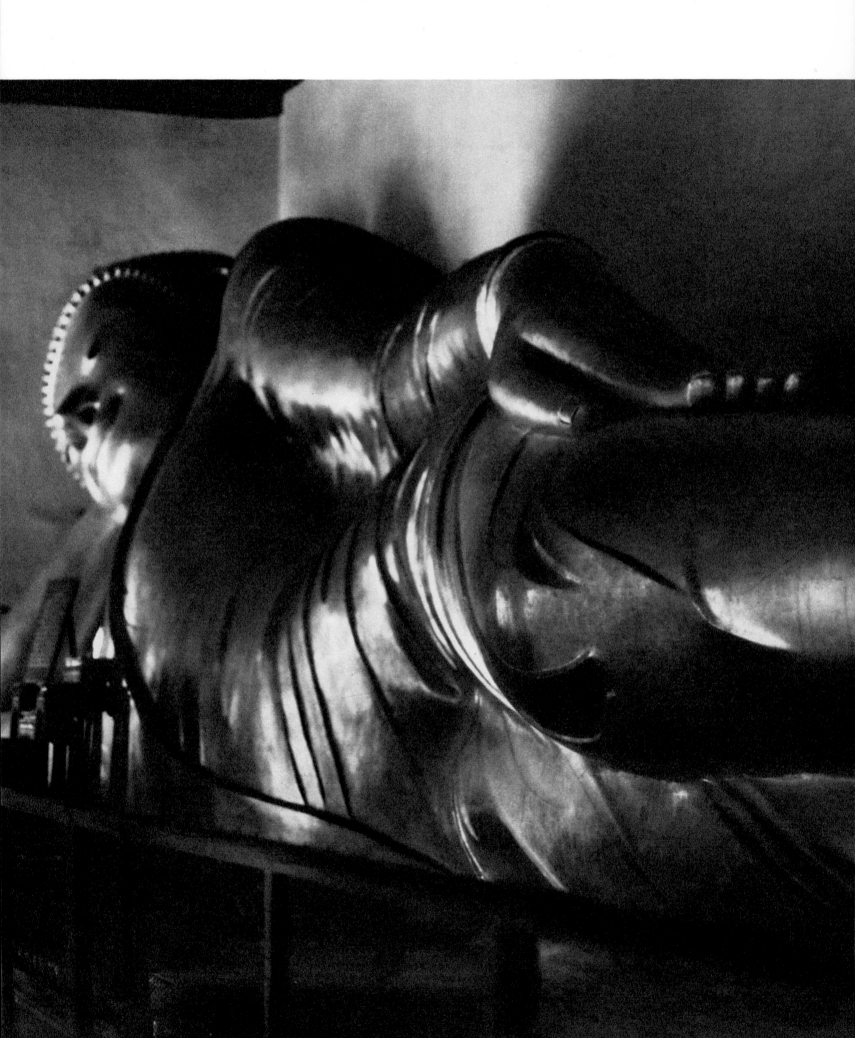

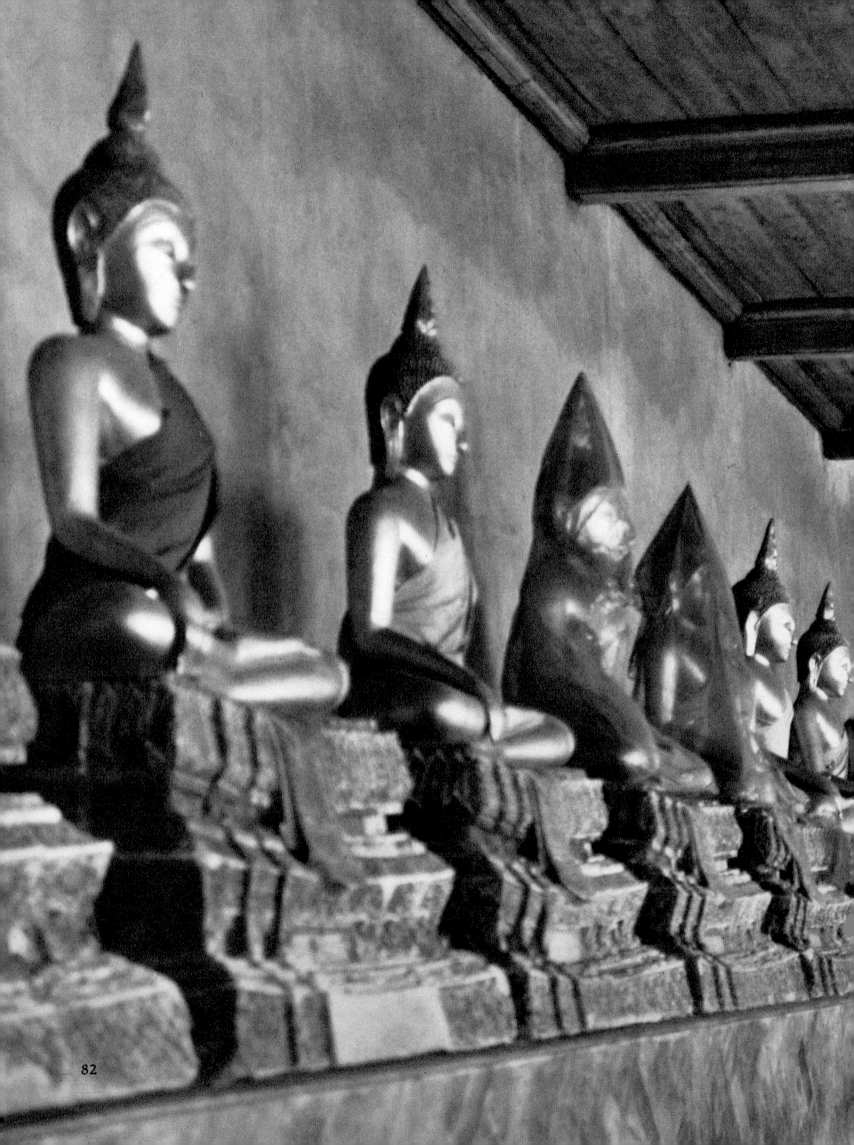

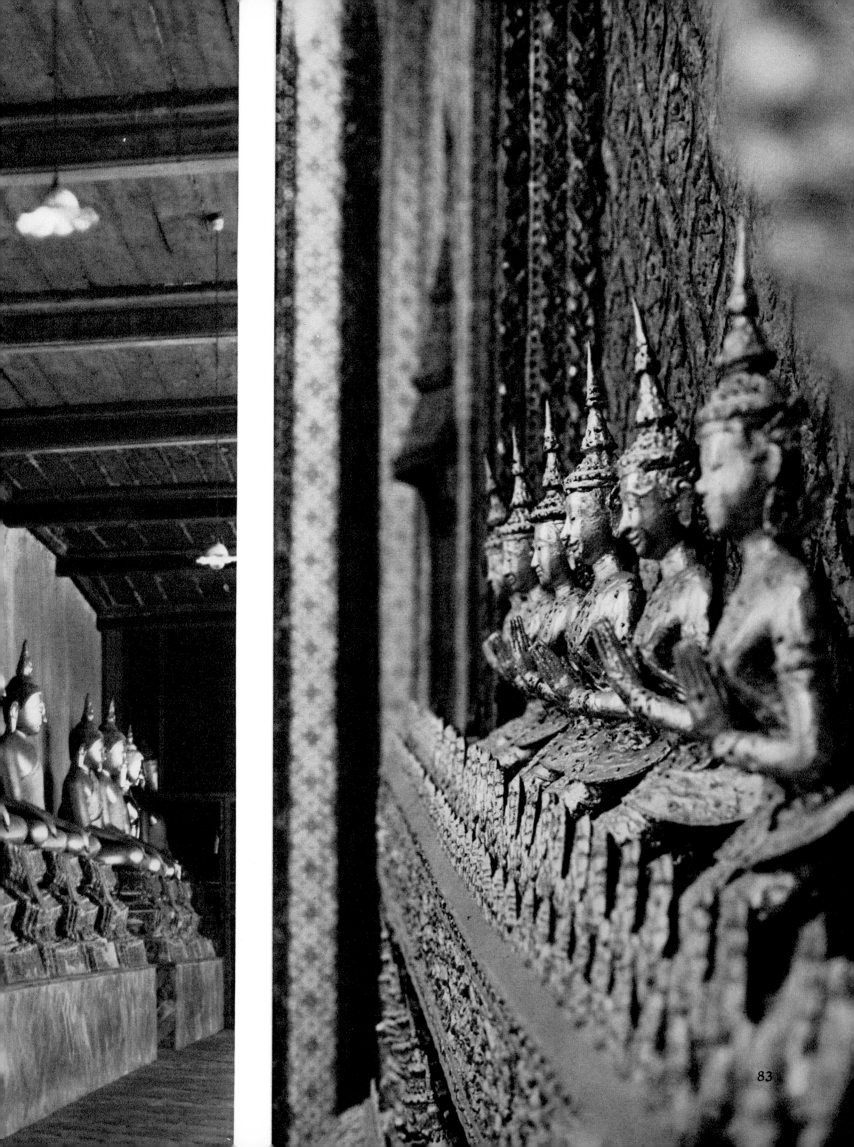

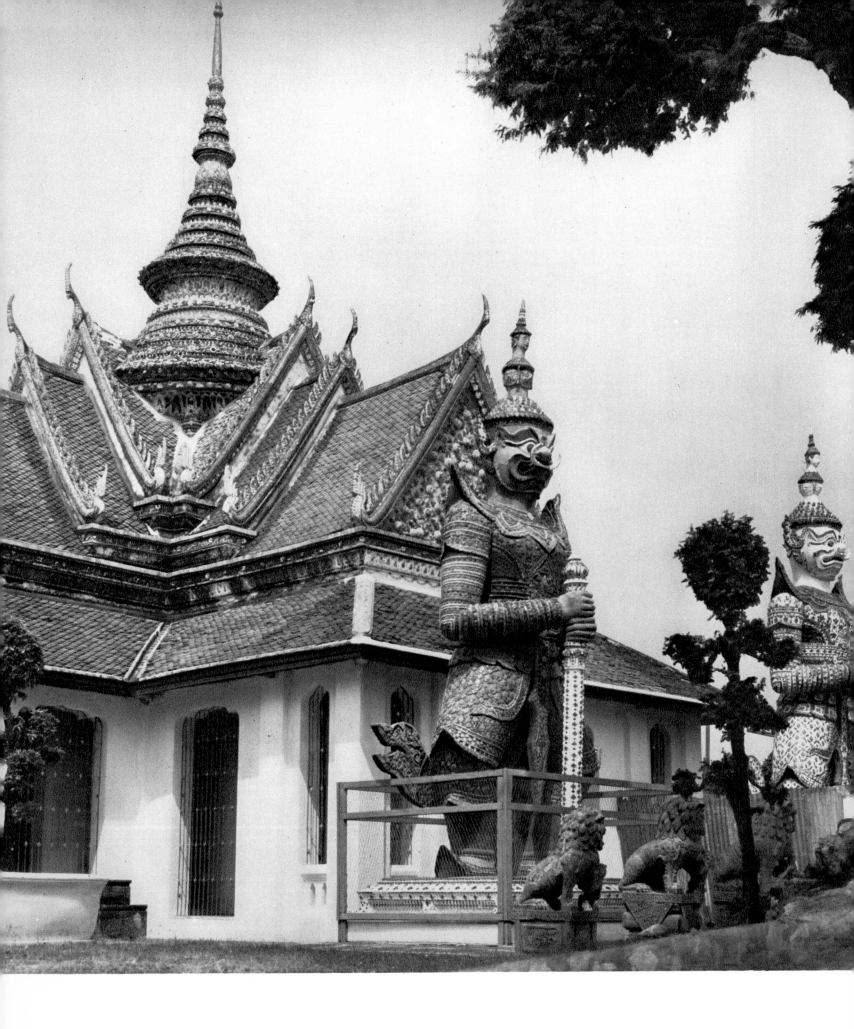

84

Himalayas. The Thais are more modest, for they accept the world as it is. The gods are their brothers and sisters, to be worshiped without too much solemnity. Go to the Thai temple, and you will see the worshipers visiting and gossiping in happy informality, chattering and cracking jokes, chewing betel-nut and smoking during the services. "Why not?" they will tell you. "The gods are our friends."

This happy informality extends to all the gods within reach. There is nothing exclusive about Thai religion, and though Buddhism remains supreme at the core, the ancient animistic gods have their place on the periphery; so, too, do the Hindu and the Chinese gods. Even today Brahman priests can sometimes be found serving in Buddhist temples; Vishnu and Indra are still worshiped; the Rice Goddess is represented by a banner floating across the rice fields; and there are the guardian spirits of the house, which must be offered candles, flowers, and incense. Never was there such a medley of gods! But there is no war between them, for each has his allotted place within the harmony of the Thai imagination. Those enviable people have the best of all worlds.

The Thais have accomplished what very few peoples have: they have learned to live at peace with their gods. Long ago they discovered that the Hindu and Chinese gods served a useful purpose. What, for example, could be more useful than Chinese guardian gods, to place outside their temples? Flames rise from their heads, their eyes bulge, horrendous scowls are permanently written into their features, and they wield their massive clubs with a purpose. They are not very frightening, but how pleasant to set them up before the temple gates! And since Buddhism is notoriously sparing in its account of the deities who form the winds and the storms, how pleasant to make offerings to Indra, the most ancient of all the Indian gods, the giant swashbuckler whose chariot is the sun and who holds the lightning at his fingertips! And the Rice Goddess, too, must be worshiped, though no one any longer knows what she looks like, and so she is represented by a simple banner. There is nothing eclectic in the Thai religion, for eclecticism implies deliberate choice, and they have not chosen the gods. They chose Buddhism, and all the other gods are no more than decoration, like the mirrors and scraps of porcelain and colored glass that decorate their temples.

These charming, small-boned people seem to have been granted the special gifts of tolerance, equanimity, and gaiety. The weight of the world does not hang heavy on their shoulders. They consider a life well lived if a man has been friendly with the gods and followed the precepts of Gautama Buddha. Their lives center on the temples and the market place, and they regard the Buddhist priests with a kind of affectionate respect, a deep but gentle attachment. Perhaps in all the world they are the only genuinely happy people.

Some part of their happiness derives from their traditional affection for art. Since they spent so much of their lives in the temples, they were concerned that their temples should be decorated worthily. The sculptors and painters were dedicated men who devoted their entire lives to their art; like the monks they went through an ordination ceremony, wore the proper robes, and offered sacrifices. Unlike the monks they took no

part in the ordinary ceremonial life, but were granted a position of special independence within the community. The monks were regarded with affection, for they were part of the human family. The artists were regarded with awe, for they seemed in the eyes of the Thais to be touched with the divinity they represented in their paintings and sculptures. They were a people apart, privileged, and almost inaccessible. They were so valuable that we hear of sixteenth-century kings going to war for no other purpose than to capture a painter, a sculptor, or a skilled craftsman. As far as I know, wars for this purpose were never fought anywhere else.

Only a people with a delighted awareness of art could have built these temples or granted so many privileges to the artist. From the very beginning there seems to have been ingrained in them a sense that life was savorless without worship and without art. When Heinrich Zimmer came to the end of his long study of Indian art, he added a brief chapter on the derivative arts of southeast Asia. Of the Thai sculptors he spoke with reverence, continually repeating the words "purity" and "grace." It was no more than their due. Yet the words tell us little enough. Something far more than "purity" and "grace" is at work, and it is not altogether satisfactory to derive the art of Thailand from India. Their gods possess Indian names and functions first acquired on Indian soil, but the Thais transformed them. They brought the gods out of the heavens and set them walking among men. They made the gods new.

For what is most apparent in the Thai imagination is a certain sweetness and gentleness, a profound composure, which exists nowhere else in the world. They see the world with innocent eyes, with a directness that confounds our tragic vision. They see the world as the ancient Greeks saw it, in brilliant fragmentation, in bright jagged colors, scarcely hoping to see more than fragments. India was one fragment, China another, and they accepted both without discrimination. They saw no reason to set the fragments quarreling with one another. There was no deadly conflict between them. Why should not the gods live happily together, since men were intended to live happily together? So Indra, Vishnu, the Rice Goddess, the guardian gods of China, and countless other gods sit happily at the table where Gautama Buddha presides. It seems the most civilized way.

No one should mistake the sweetness and innocence of the Thais for weakness. They call themselves "the free," and so they are, and so they have been through recorded history. No other nation in Asia has preserved its freedom for so long. There is iron beneath those innocent smiles.

Again and again while looking through these photographs, I have been reminded of a small gilded Buddha I once saw. He came from Thailand and was scarcely more than ten inches high. He wore a thin gown patterned with stars and carried a water jug over his shoulder. He looked scarcely more than ten years old, and in case anyone should mistake him for a wandering mendicant, he wore the hook at the lower corner of his robe which in Thailand is the indisputable sign of the Buddha. He had plump cheeks and smiled like a child, and there was about him a certain memorable negligence and innocence. He did not have to do anything. It was not necessary for him to

become the Lord of the Worlds. He was simply a child wandering on his way, and he was the Buddha, and this was enough.

That wise innocence can be seen in nearly all these photographs of Thailand. It is in that amazing photograph depicting the Lord of the Worlds, but it is also in the young Buddhist monk leaning negligently against the temple rail, in the shapes of the buildings, in the leaping spires, in the decorations at the temple gates. Almost it is fairyland. Here there is no death, no falling away. Here it is eternal springtime, tragedies never occur, and the purest joy may be obtained as easily as one plucks an apple from a tree; or so it seems in this most enviable country.

# *Plates*

*page*

89     Buddhist monk in the courtyard at Wat Phra Keo, Bangkok.

90–91     Gilt Buddhas showing thumb marks left on the gold leaf by worshipers.

92–93     Devotees burning incense and offering flowers in front of the royal chapel, Wat Phra Keo.

94–95     View from the courtyard of one of the galleries in which Buddhas are sheltered at Wat Po, Bangkok.

96     Pantheon at Wat Phra Keo.

97     One of the entrances, Wat Po.

98–99     Segment of Thai sculpture showing Cambodian influence.

100     One of the 394 sitting Buddhas at Wat Po.

101     Buddha image at Wat Po.

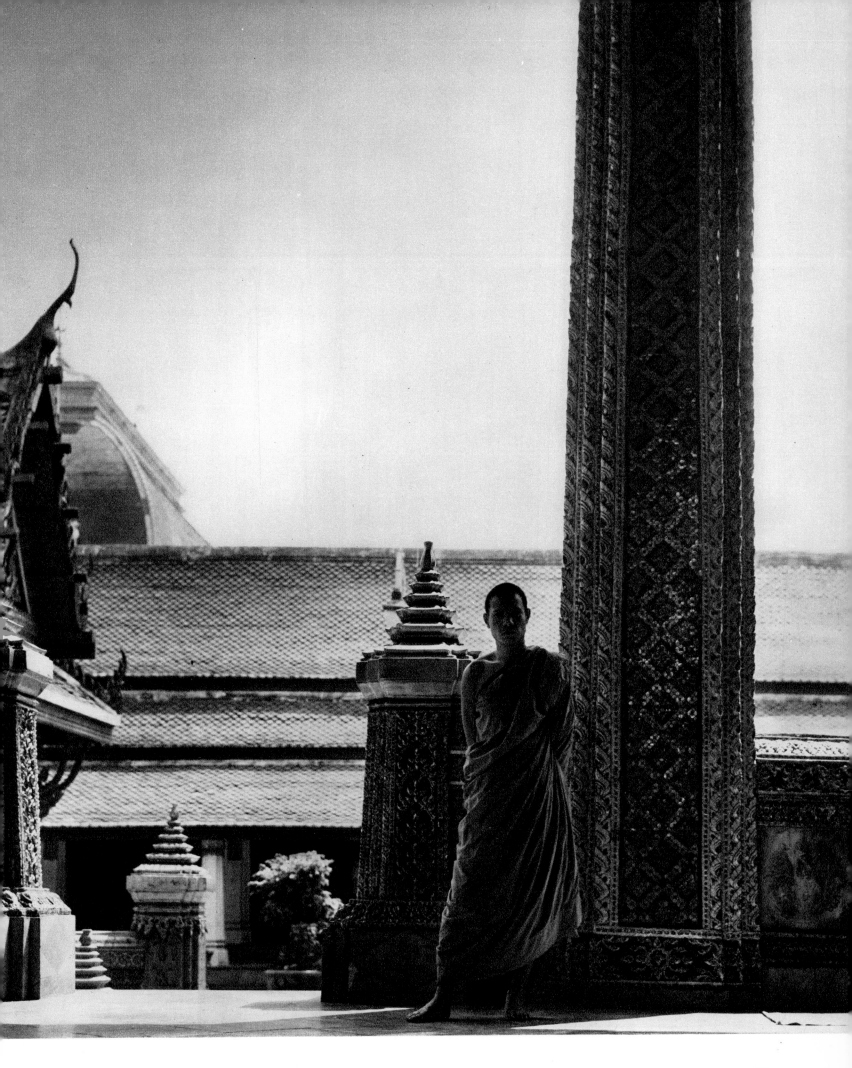

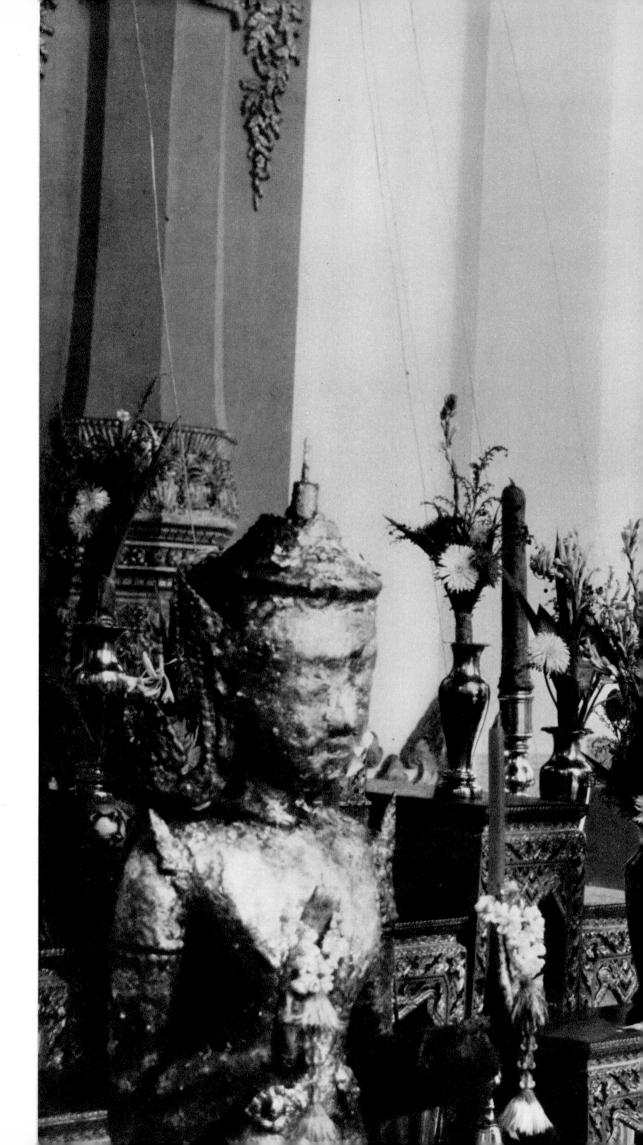

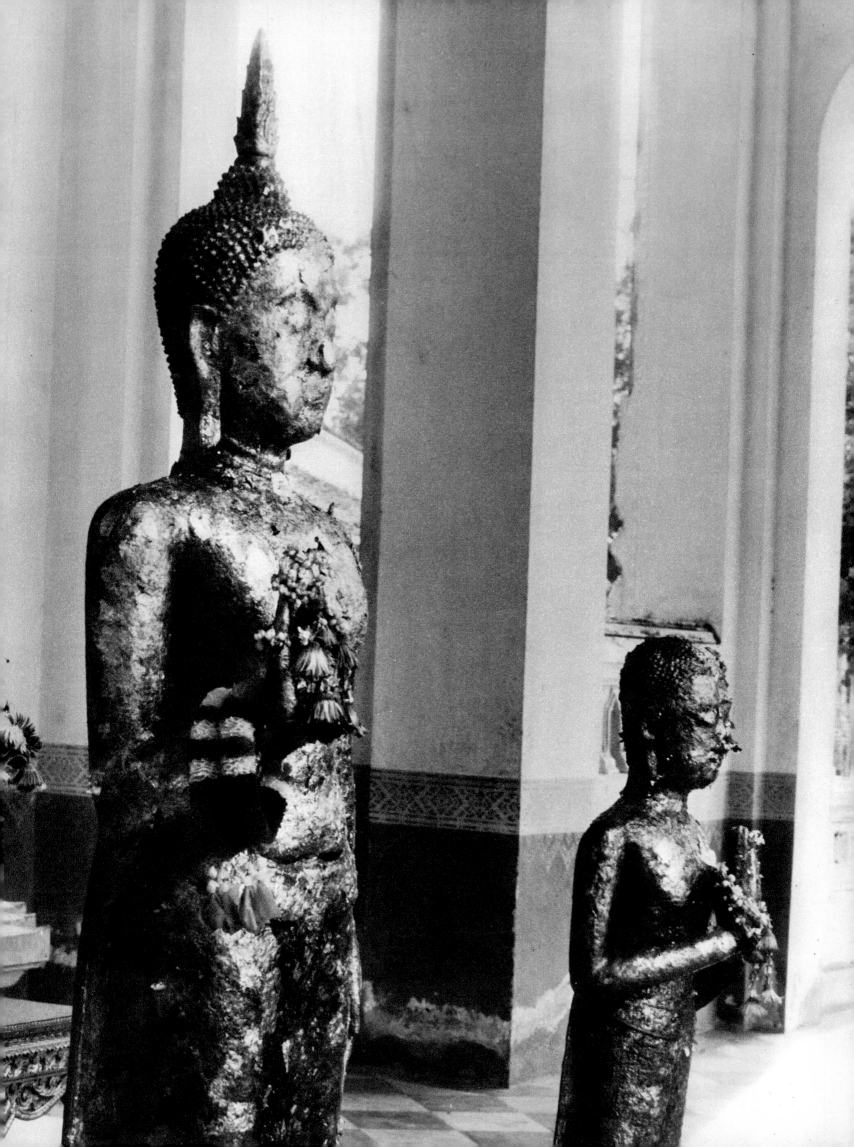

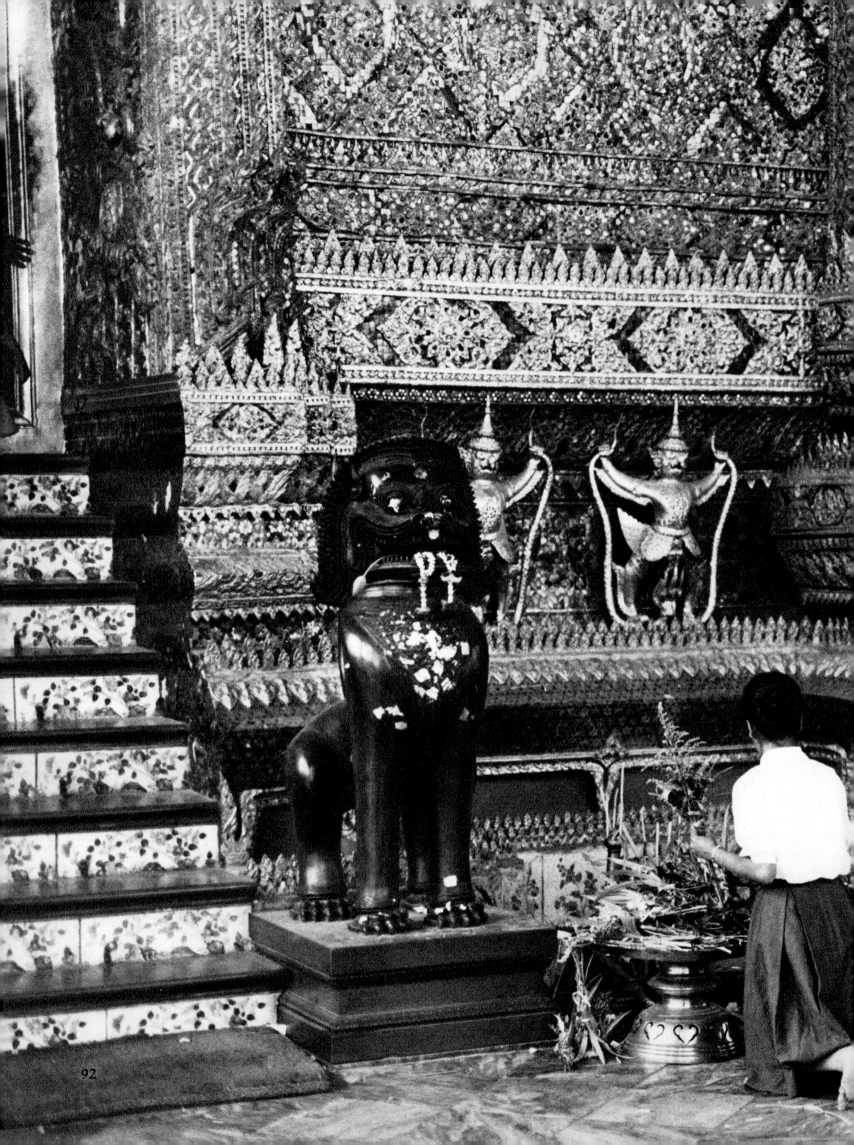

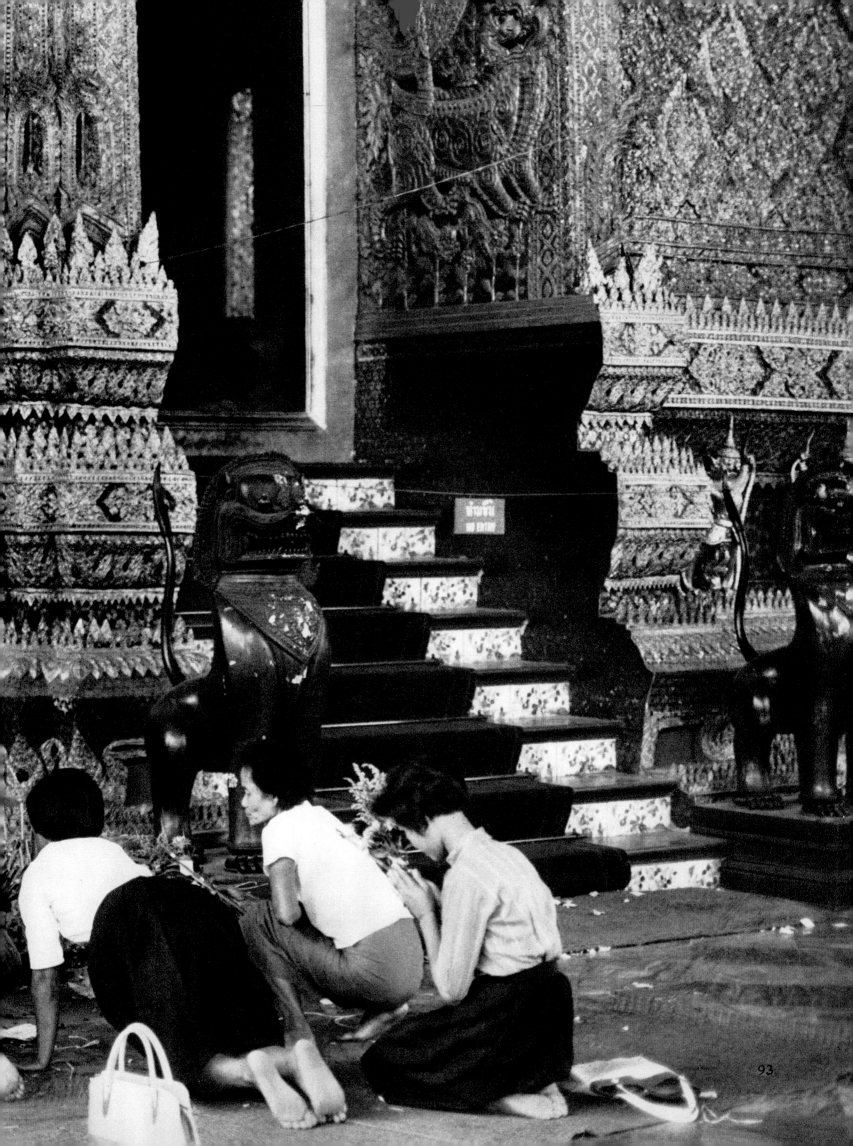

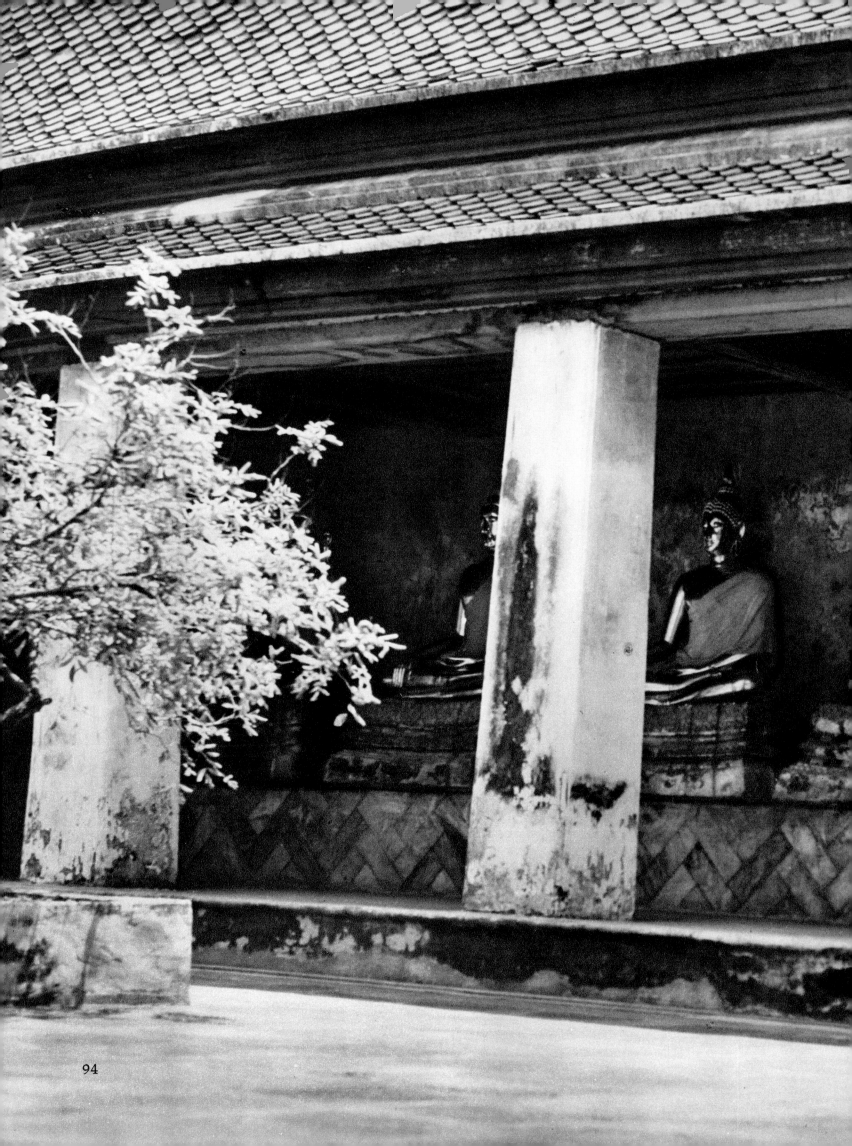

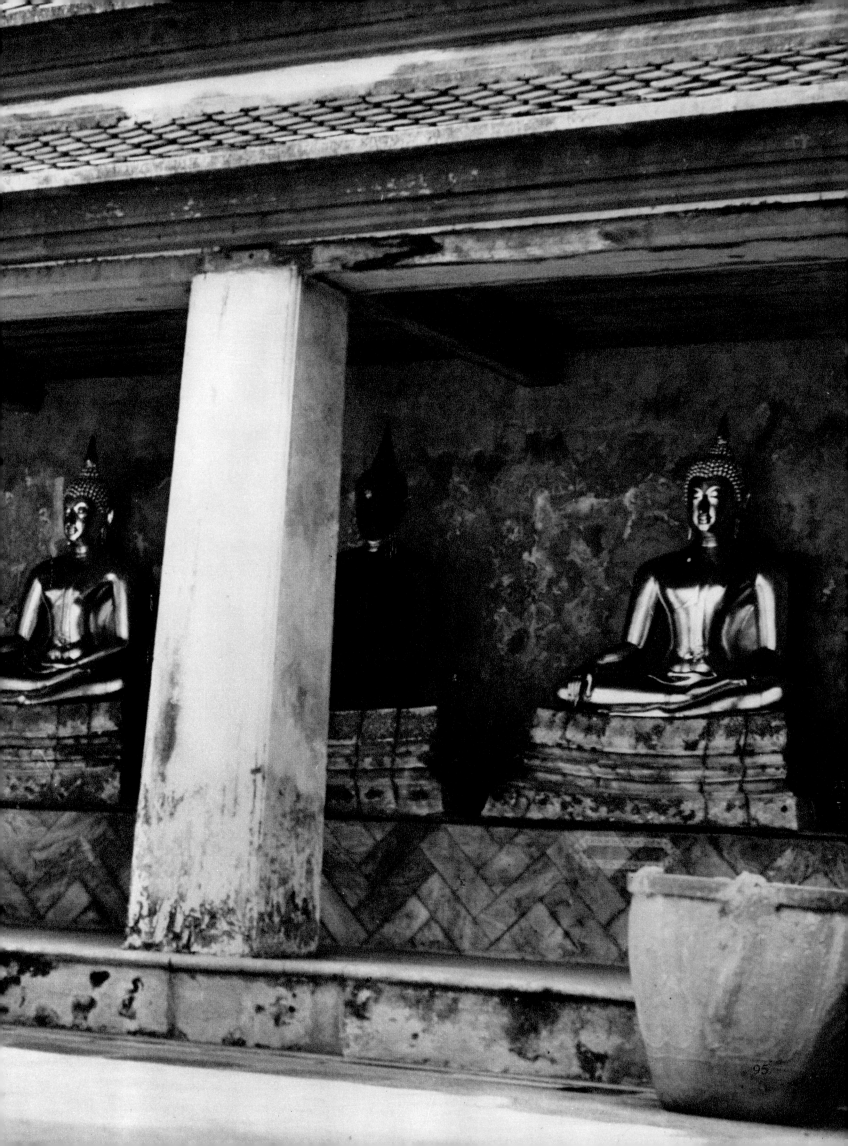

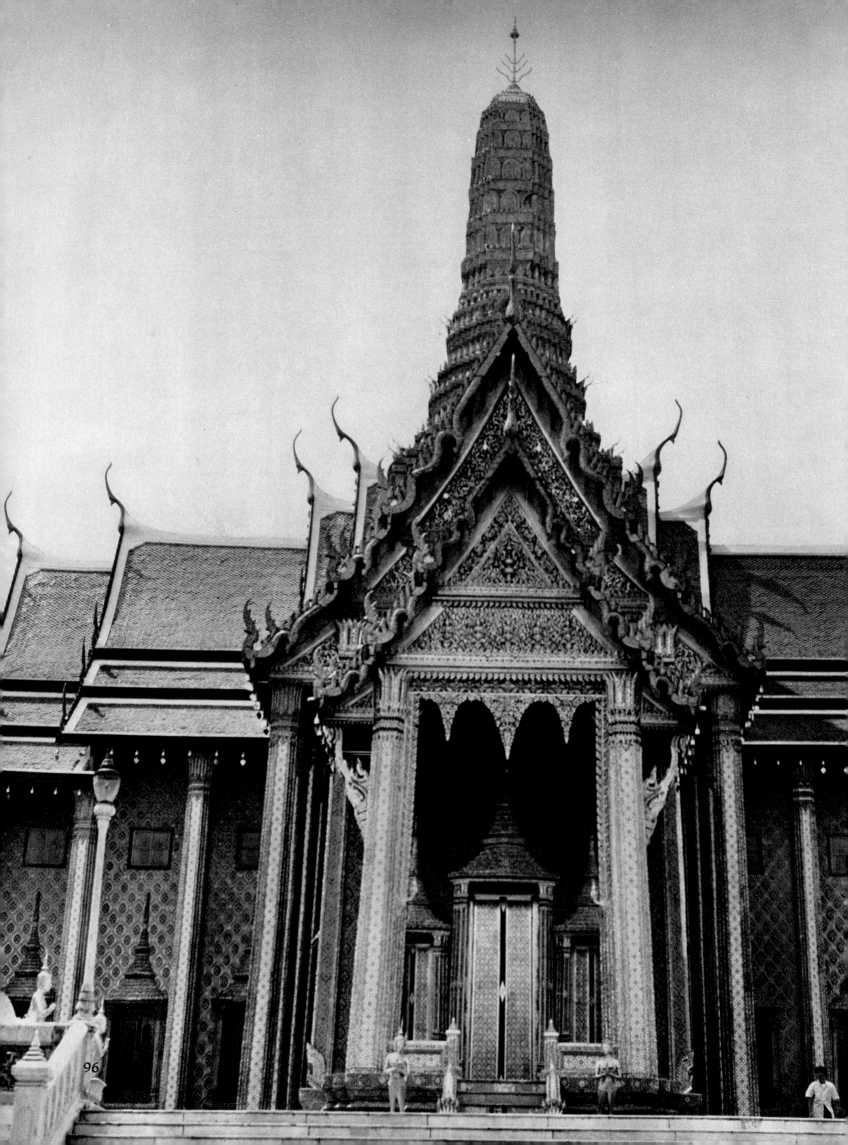

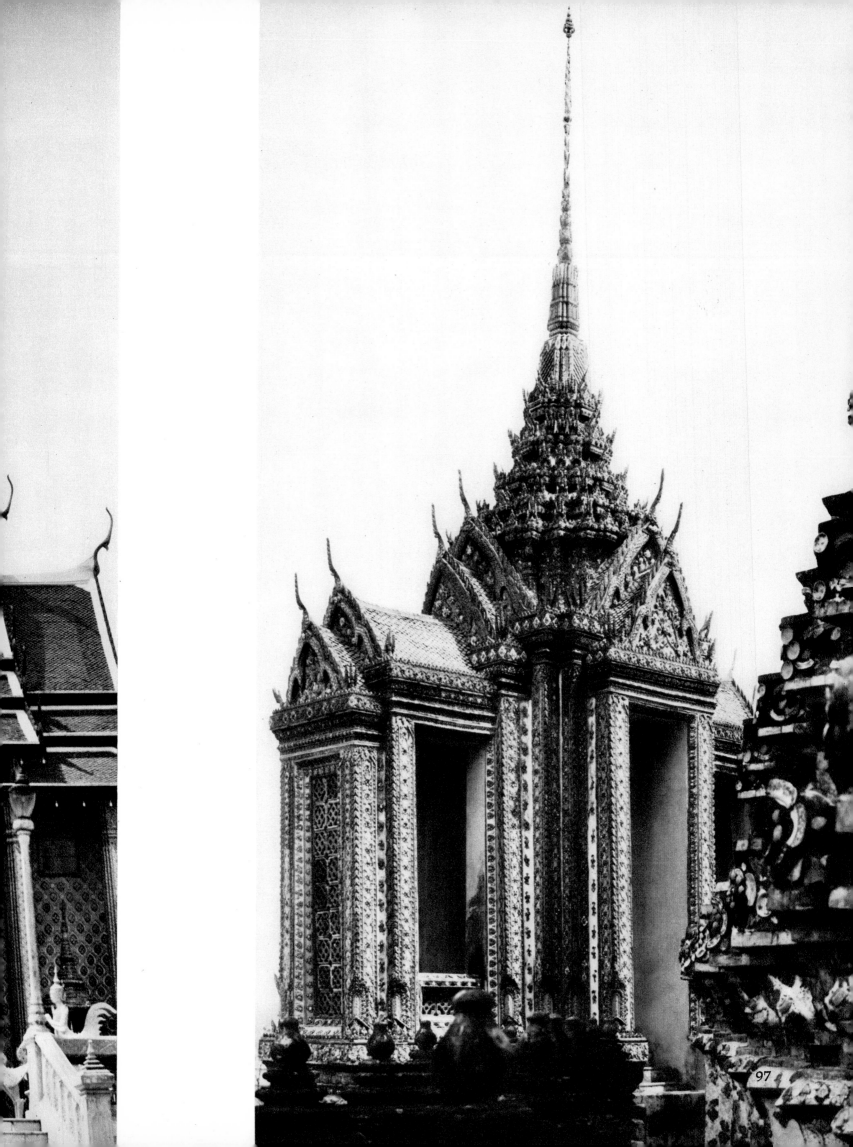

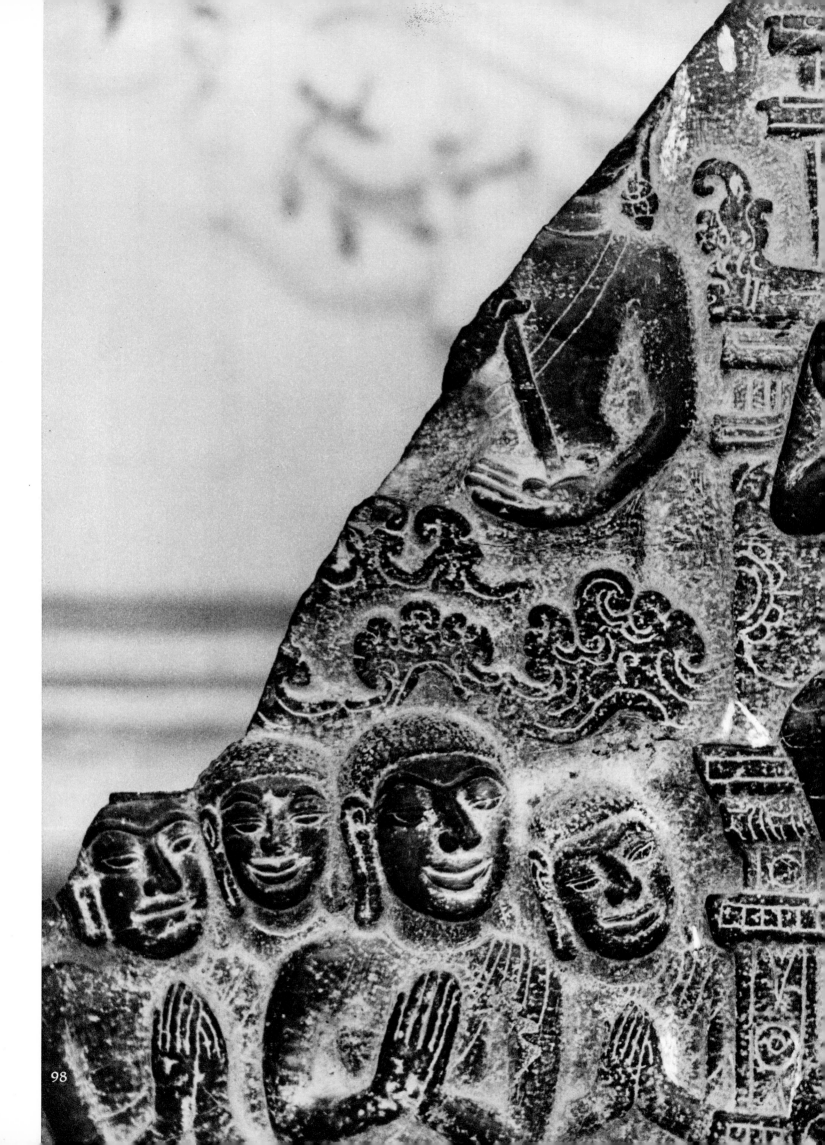

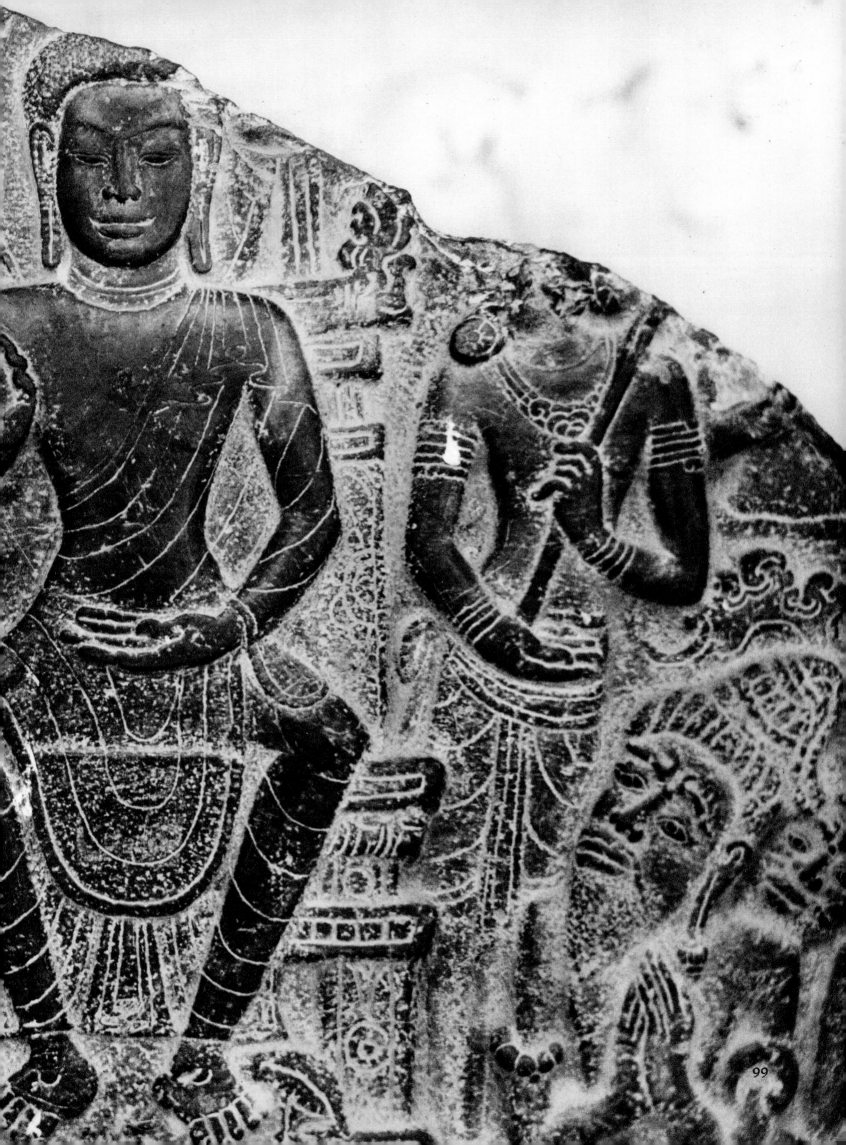

99

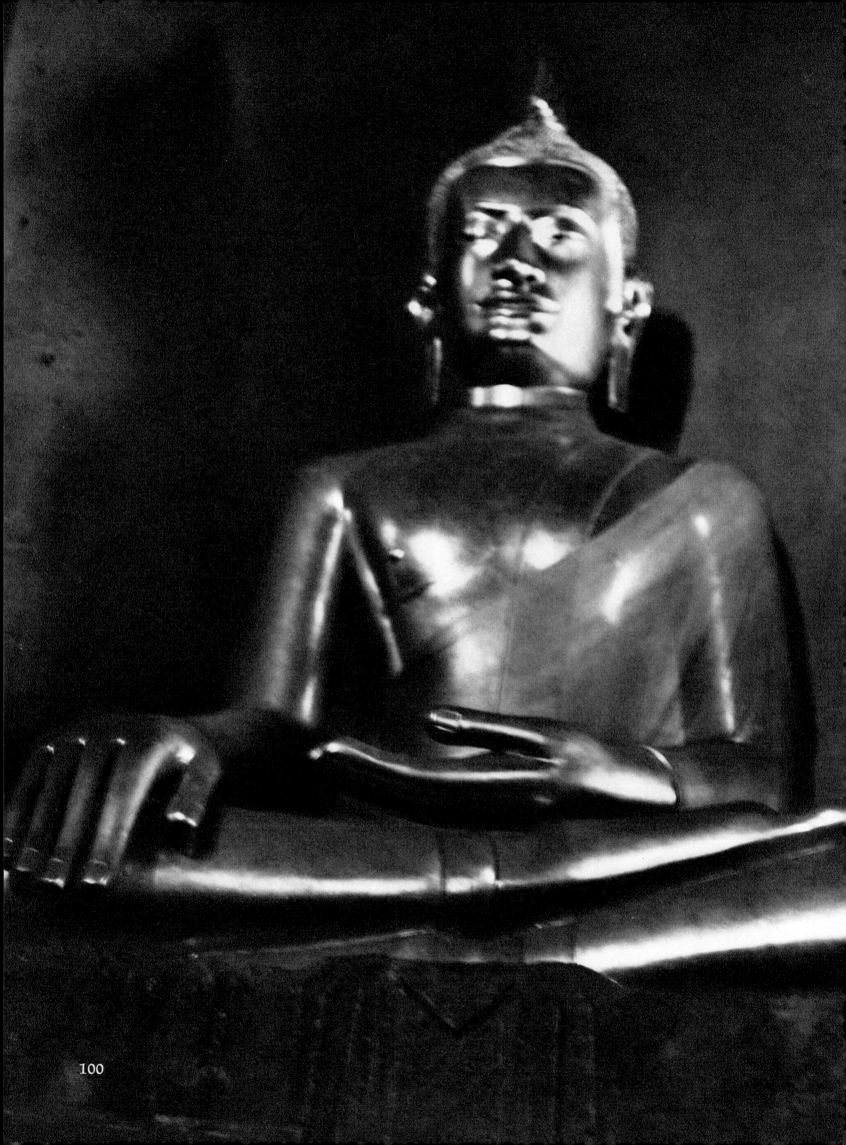

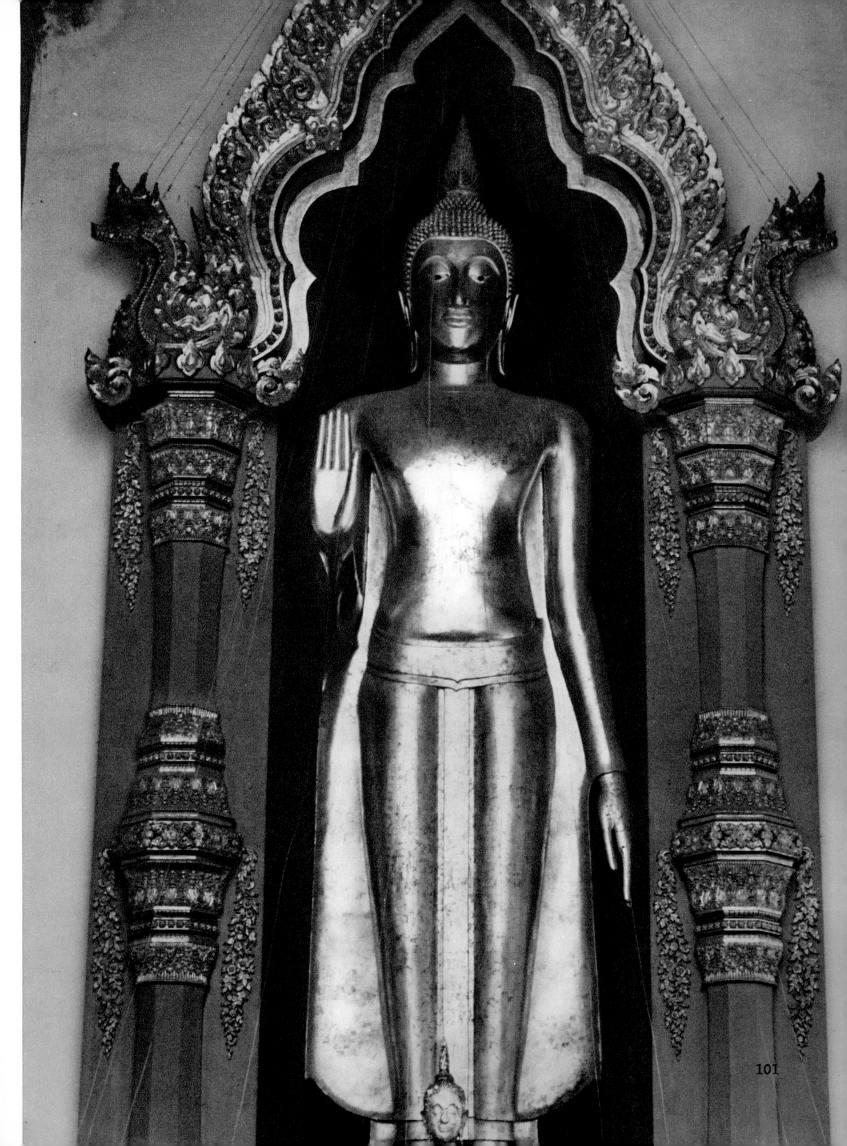

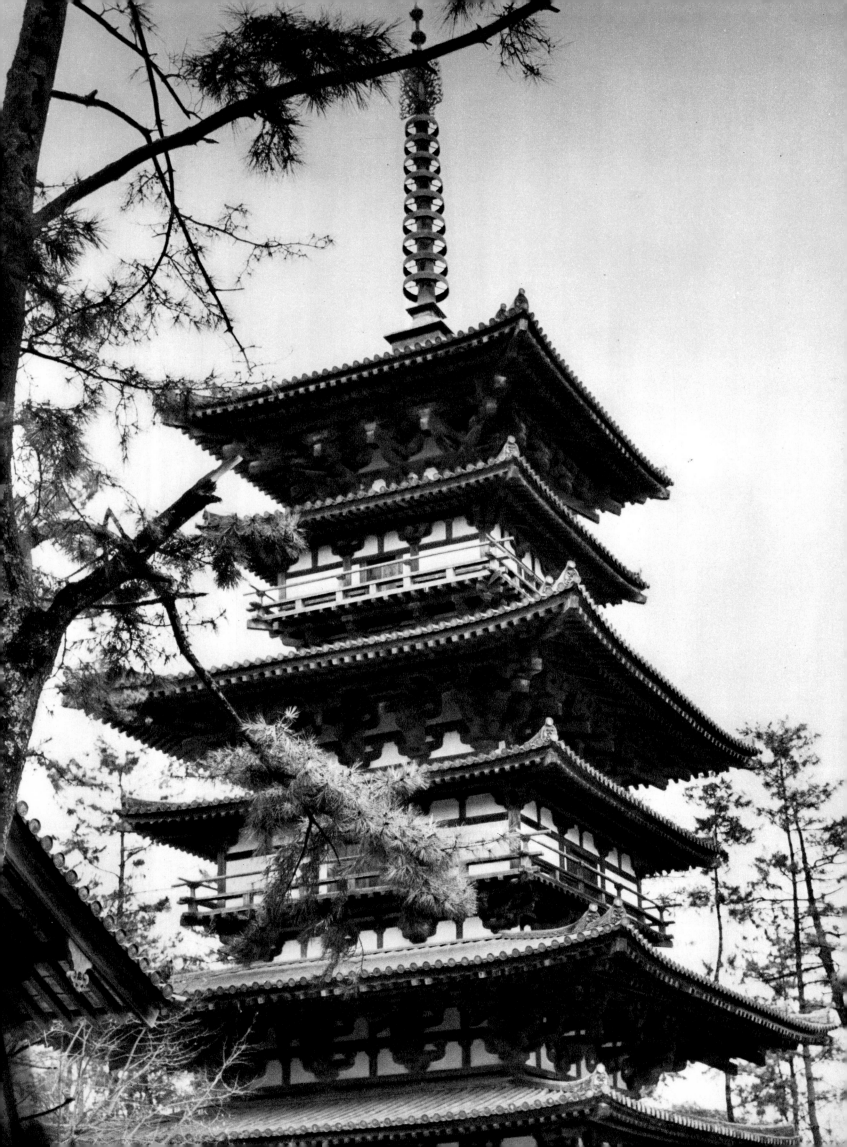

# Japan

JUST AS THE PARTHENON, RISING ABOVE THE SHOULDERS OF THE ACROPOLIS, PRESENTS US WITH an abstract portrait of the goddess Athena, so it seems to me that a Japanese temple with its gilded and flaring roofs is an abstract portrait of some ancient god who still rules over Japan, though his name is unknown. Half-close your eyes, and the shape of the face appears. It is a noble face nobly adorned, clean-cut and delicately featured, with power in it. The eyes—the many eyes—are concealed beneath the shadowy bars of the roofs, which become progressively more attenuated. We recognize a forehead and a crown, and a mouth appears in the ornamental gateway, while the thrusting neck is represented by the stone stairs, guarded by lions, which reach up toward the temple in their blazing whiteness. There is no nose and only a suggestion of ears, but these are often dispensed with in abstract portraits. Moreover, this is not an abstract representation of a human face. The temple is the portrait of a divinity who looks out upon the world from under hooded lids, sees, knows, and is aware. Aware most of all of his own dignity and power, but also of his elegance, his supernatural beauty.

So it has been throughout the history of temple-making. Laws may be passed forbidding the representation of the human person, icons may be hurled down from the walls, and every effort may be made to banish the human image from the walls of churches, but the human image insistently reappears. The vast Gothic cathedrals, encrusted with ornament, are abstract portraits of the dead God on the Cross, the body outlined by nave, apse, and transepts. Mohammedan mosques, painted in jeweled colors, their luxuriant domes promising the milk of Paradise, are as deliberately feminine as the Gothic cathedrals are deliberately masculine. Men cannot represent their gods without endowing them with some characteristics of themselves, nor can they build temples without being reminded of the face of the god they worship.

It is permissible, though dangerous, to peer into the face of that unknown, ancient god of Japan, who appears in the façade of so many temples. We may remark certain aspects of the face, while other aspects will be forever incomprehensible to us. We

OPPOSITE: The three-tiered, 115-foot-high Yakushiji temple at Nara, built in 680 A.D. by the Emperor Temmu.

may remark, for example, the slender youthfulness and springing thrust, a certain self-consciousness, and a sense of eager involvement in the world around him. He is not a god who ever sleeps. He rises clean into the air, more in love with the sky than with the earth, so that he gives the impression of being almost detached from the affairs of earth. His youthful shoulders, if we could see them, would not be massive; they, too, would be slender, elegant, with no hard muscles, quivering and alive.

True, the Japanese temples are not wholly Japanese: their ancestors are to be found in China, where the tiered roofs were first invented, perhaps on the analogy of the tiered roofs of their tents when the Chinese were still wanderers on the edge of the Gobi Desert. The Japanese cut clean away from the heaviness of their Chinese mentors. They redesigned their temples and sent the roofs spinning up to heaven, with a lightness and delicacy foreign to the Chinese prototypes. The Chinese are a massive people who think in massive images; their gods are heavy and thick-jowled, represented usually in the form of old men of ageless wisdom. The Japanese gods are eternally young.

Youth, of course, has its penalties, and the Japanese temples reflect the twin penalties of fragility and of daring too much. Almost they are not heavy enough for the burdens they bear. They taper away into nothingness, and sometimes one has the feeling that a puff of wind could blow them over. They burn easily; every year witnesses its own bonfire of temples, but since the architectural plans are carefully preserved, they rise again like the spring leaves. Like youth they die only to be born again.

One suspects that death, indeed, has very little to do with this young god: it is so easy for him to die, so easy for him to be born again. He is not there to console us for our coming deaths; he promises us no paradise. He delights in ceremonial occasions, parades and processions by lantern-light, but he delights most of all in the dawn, the sunlight streaming on his face. He does not peer down on cemeteries, and it is inconceivable that he should offer rewards and punishments. His rising from the earth is an affirmation of the thrust of living things—their tenderness, their fragility, even their trustfulness. His prototype is less the ponderous Chinese temple than the young shoot with the petals wrapped over one another, though now the petals, the flaring roofs, are gaudily displayed.

If he belongs to anything, he belongs to the seasons; he is closer to the changing weather of nature than to people, though he abundantly presides over their affairs while pretending to be detached from them. Though we call him a god, he has no gender, being both masculine and feminine, strong and delicate, courageous and timid. When we see a crocus, we do not ask whether it is male or female. So it is with this ancient youthful face which peers down at us, blessing us among the cherry trees and the cryptomerias.

Not that all the temples in Japan are of this kind. The Chinese influence was so extensive and enduring that whole forests of Japanese temples were built in a recognizably Chinese manner, squat, heavy, radiating imperial power. Chinese influence came in wave after wave, with an impact so strong that each wave left the Japanese breathless, and many years passed before they had absorbed its full meaning, exhausted

all its possibilities by refining and testing it against their own sensitivities; then a new wave would come, and they would have to begin all over again.

Nevertheless, from the very beginning there were certain elements which remained unchanging. The Japanese sense of space differed remarkably from the Chinese. They saw the world in smaller and more brilliant segments, not firmly anchored, but floating tremulously in the sea-haze. They loved the curves of things. While the Chinese imagination tends to concentrate its energies within the round-cornered square, a shape endlessly repeated in seals, in written characters, in the shapes of buildings, bronzes, furniture, even fans, the Japanese imagination finds its most perfect expression in the curved line flowing free. The curve of a flame, of a woman's arm, of flowing silk, seen in an instant, in a lightning flash: such is the preoccupation of the Japanese imagination. For the Japanese the most exquisite of all things is a petal. It is not the petal as we see it, but one lit with interior flames, and superbly aware of its own evanescence. "The world is fleeting," says the Japanese artist. The Chinese artist replies: "No, the world endures."

So it was out of that evanescence, the bright curved gleaming petal or new moon or dewdrop falling, that the Japanese fashioned their artistic world, so that a painting would consist of myriads of elegant and curving designs all held in suspension, like ripples of water seen through a shining mist. It was a visionary world, brighter and more transparent than the world they saw about them, though sometimes it happened that the two worlds would momentarily coalesce. The philosopher on the mountainside would see a bird rising from its nest hidden in the grass and clap his hands in astonishment, for had he not seen a world being born out of nothingness? The artist would attempt to catch the bird on the wing at that very instant, at the moment of surprise. His task was to explore the suddenness of things, and he was not so much concerned with the world as with the gaps of brightness through which another world, more quick, more living, could be seen.

Look, for example, at the Kinkakuji, the Gold Pavilion in Kyoto, which nestles in the forests below the mountains. It was built in 1397 by the Shogun Yoshimitsu Ashikaga as a summer villa for his years of retirement. He was a despotic ruler, merciless, mercilessly efficient, and utterly corrupt. To the horror of the Japanese he swore fealty to the Chinese emperor and offered to pay every year a thousand ounces of gold in tribute, excusing himself by saying there was no harm in accepting a crown from someone so far away and there was some truth in the Chinese contention that Japanese pirates had sunk too many Chinese ships. He relinquished his office in 1393 and retired into the country to give himself up to a life of contemplation, tea-drinking, incense-judging, and the collection of beautiful works of art. He had brought peace to Kyoto by his merciless skill. Now in retirement he brought the same merciless skill to the development of a refined taste. He had become hereditary shogun when he was barely nine years old, and he was only forty when he retired. The Gold Pavilion was already in existence. It was the summer villa of one of the court nobles. But Yoshimitsu recreated it, laid out new gardens, planted a grove of maples, and so altered and

# *Plates*

*page*

107    Stone Buddha in a temple garden.

108    Main hall of the Buddhist Todaiji temple at Nara, founded in 745 A.D.

109    Belfry of the same temple.

110    Rattan chair at Ryoanji temple, Kyoto.

111    Decorative calligraphy on a Zen temple, Kyoto.

112    Bronze lanterns in the Shinto shrine of Kasuga, at Nara, founded in 768 A.D. There are some 3000 of these lanterns, each inscribed with the name of its donor.

113    Gateway to a Shinto shrine, Nara.

114    Gardens laid out about 1485, at Ginkakuji temple (Silver Pavilion), in Kyoto.

115    Ginkakuji temple.

116–17 Kinkakuji temple (Gold Pavilion), Kyoto.

118    Lanterns at Kasuga shrine, Nara.

119    Stone lanterns at Nara.

120    Devotee at the gateway of a Shinto shrine.

121    Sacred well attached to a temple.

122–23 Shinto shrine, its gateway flanked by stone lanterns given by devotees.

124    Nijo Castle, Kyoto, built in 1603 by the first Tokugawa shogun, Iyeyasu.

125    Doorway and façade, Nijo Castle.

126    Paper lanterns in a Buddhist temple, Kyoto.

127    Farm girl at Miyoshinji temple, Kyoto.

128    Geisha trainees in Kyoto.

129    Kiyomizu temple, Kyoto. Dating from the eighth century and rebuilt in the seventeenth century, it is dedicated to the eleven-headed "goddess of mercy," Kwannon.

130–31 Chion-in temple, Kyoto, one of the largest in Japan; it was constructed between 1619 and 1641.

132    Deer at Kasuga shrine, Nara.

133    Buddhist temple, Kyoto.

134    Portico of a Buddhist temple, with paper lanterns, Kyoto.

135    Strips of paper bearing predictions of fortunetellers, strung between trees for good luck, Kyoto.

136    Stone lantern in a private garden, Kyoto.

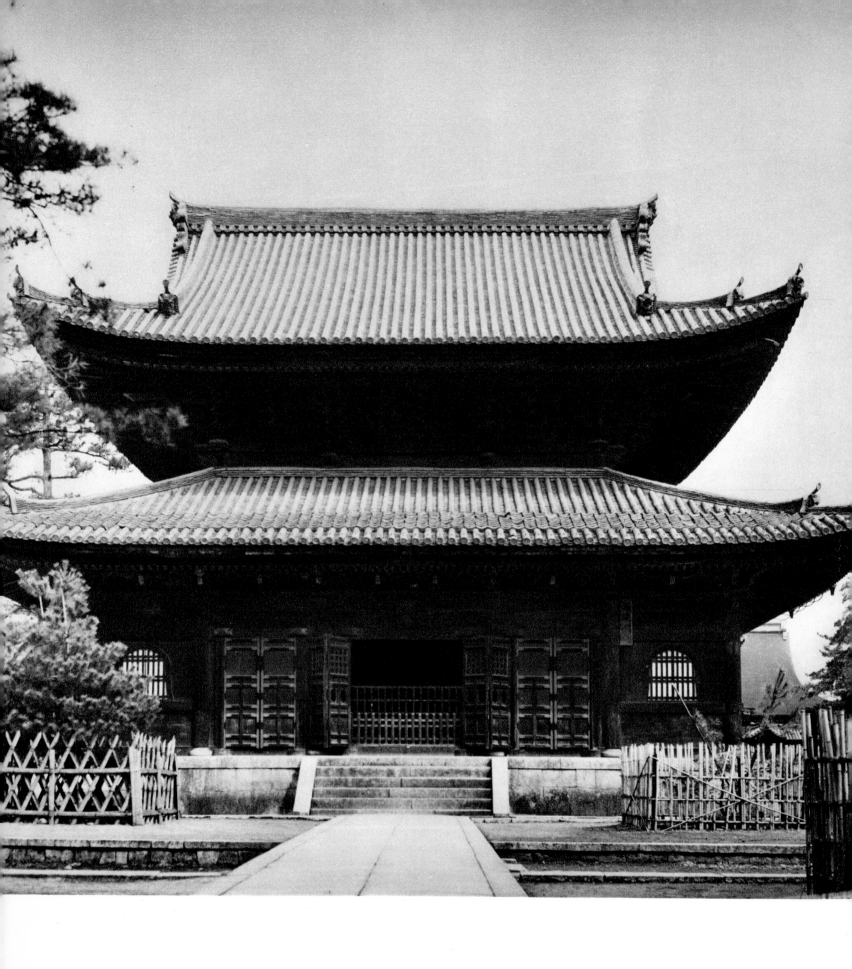

108

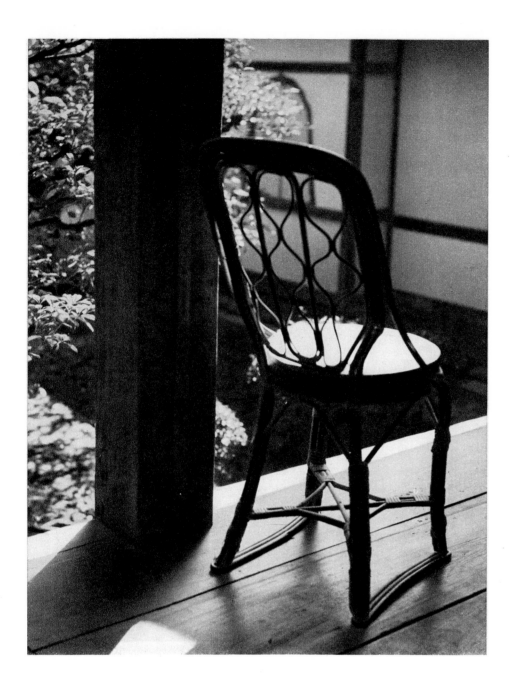

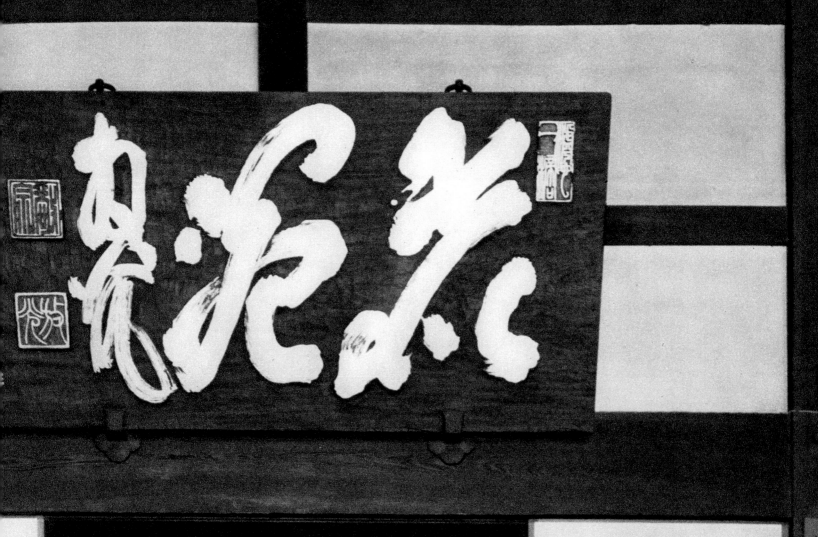

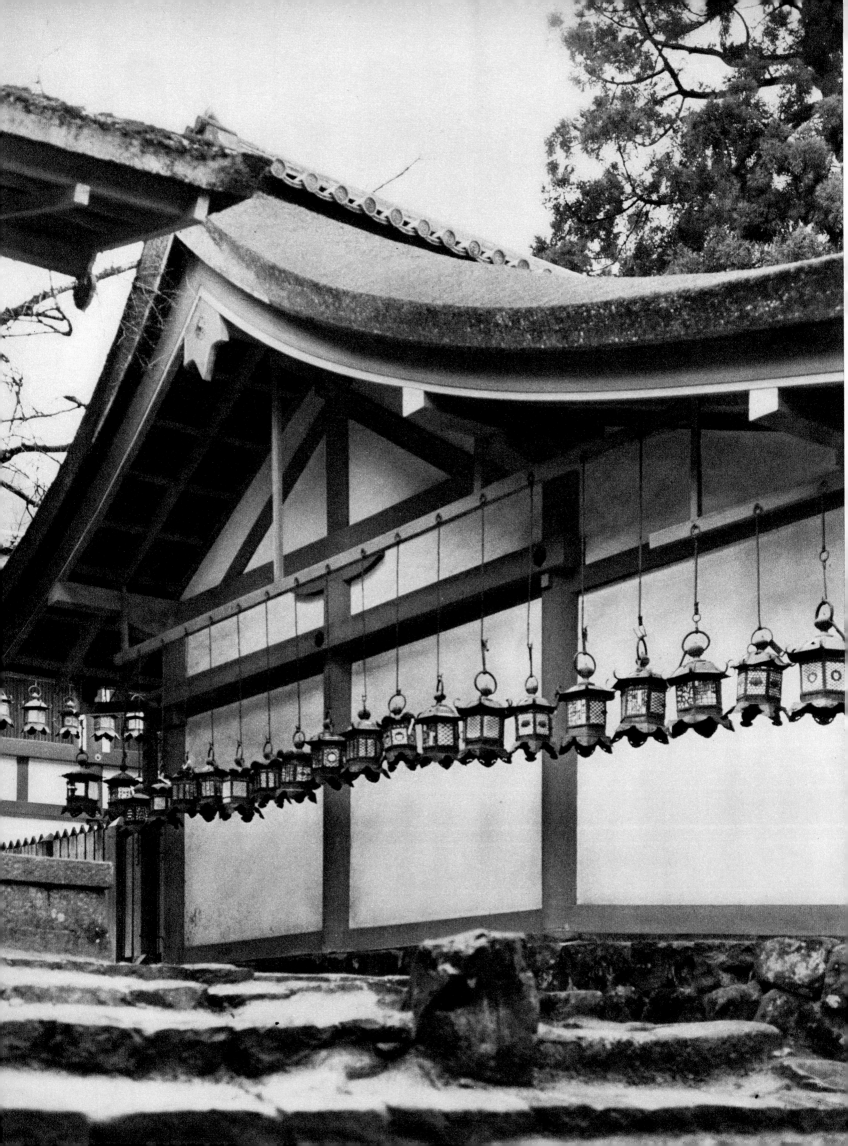

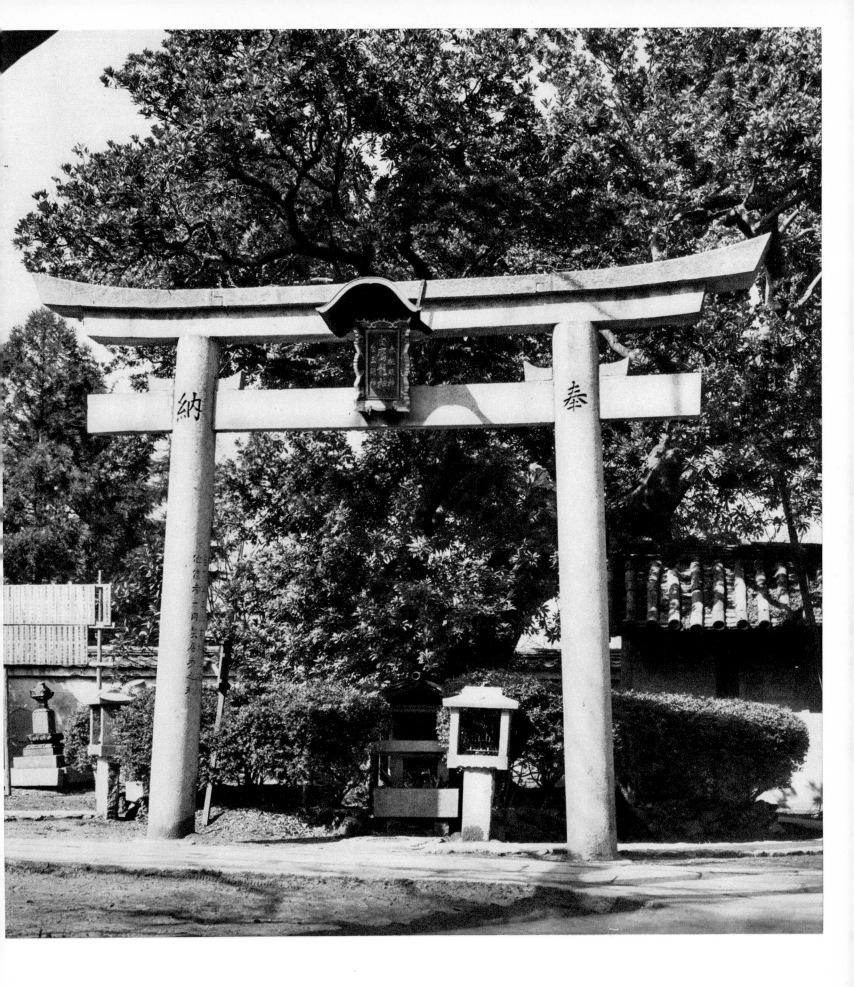

113

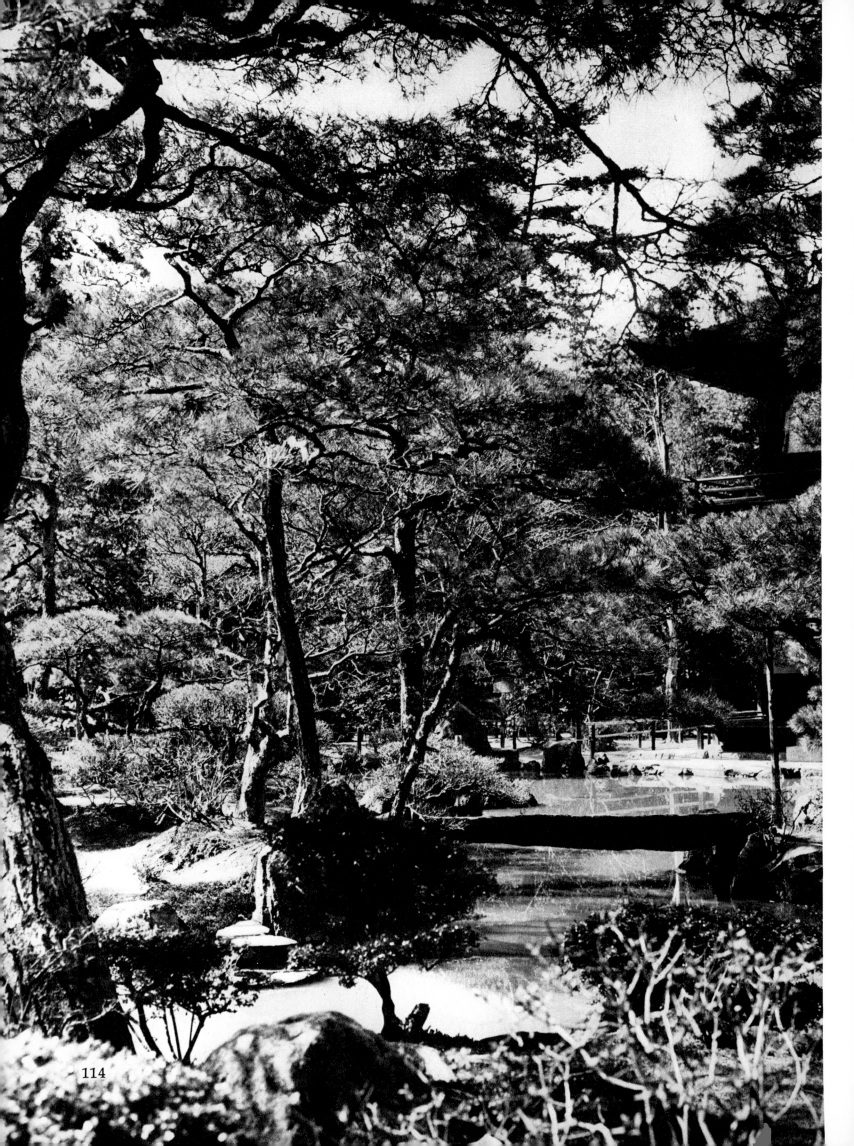

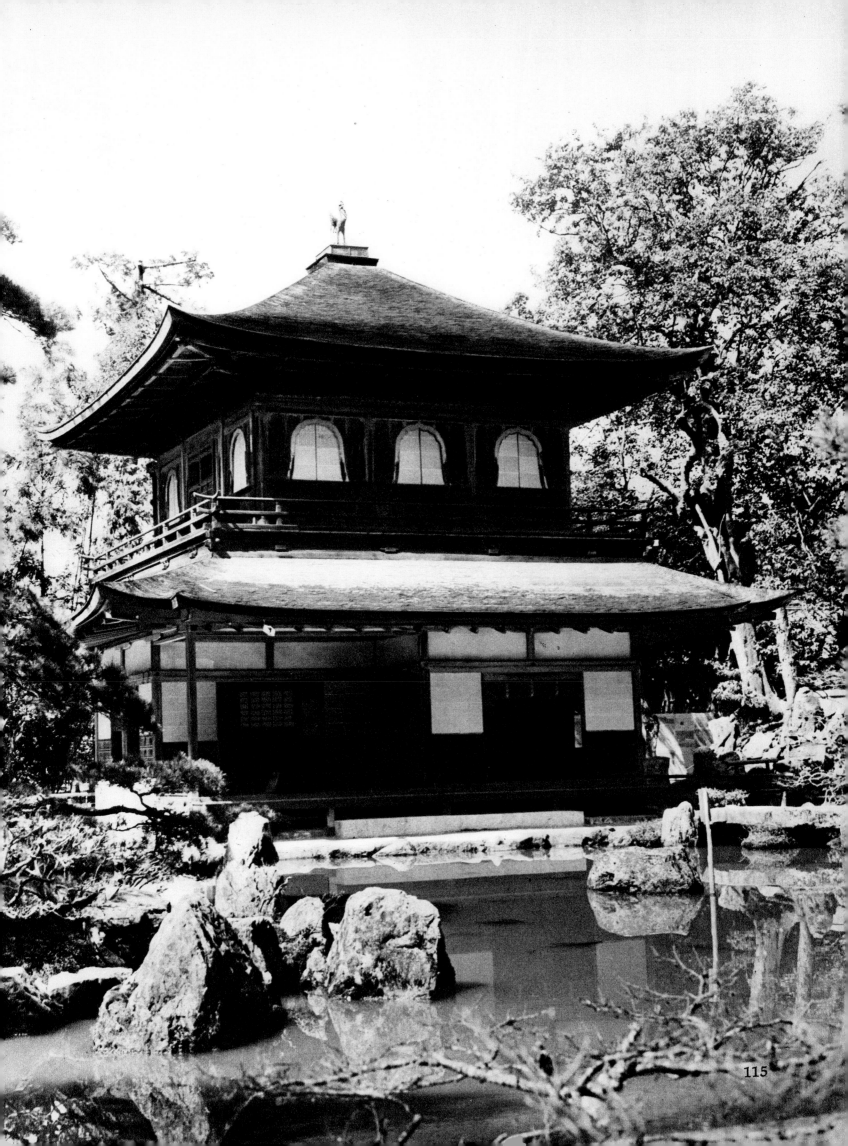

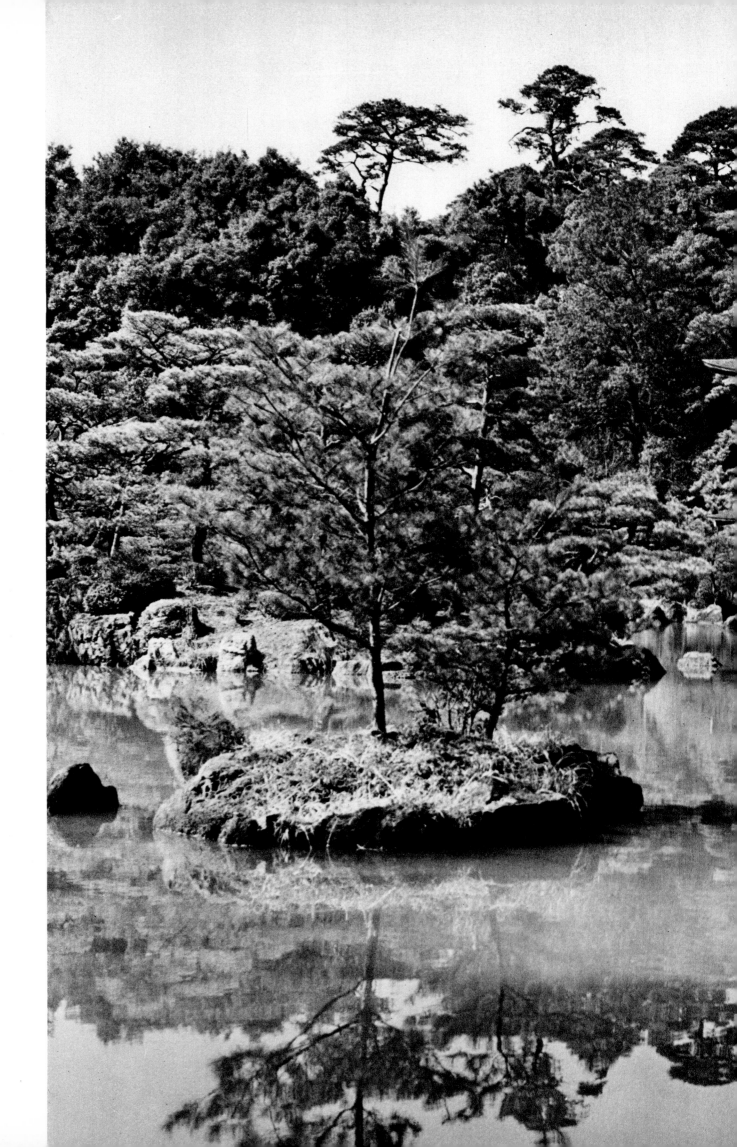

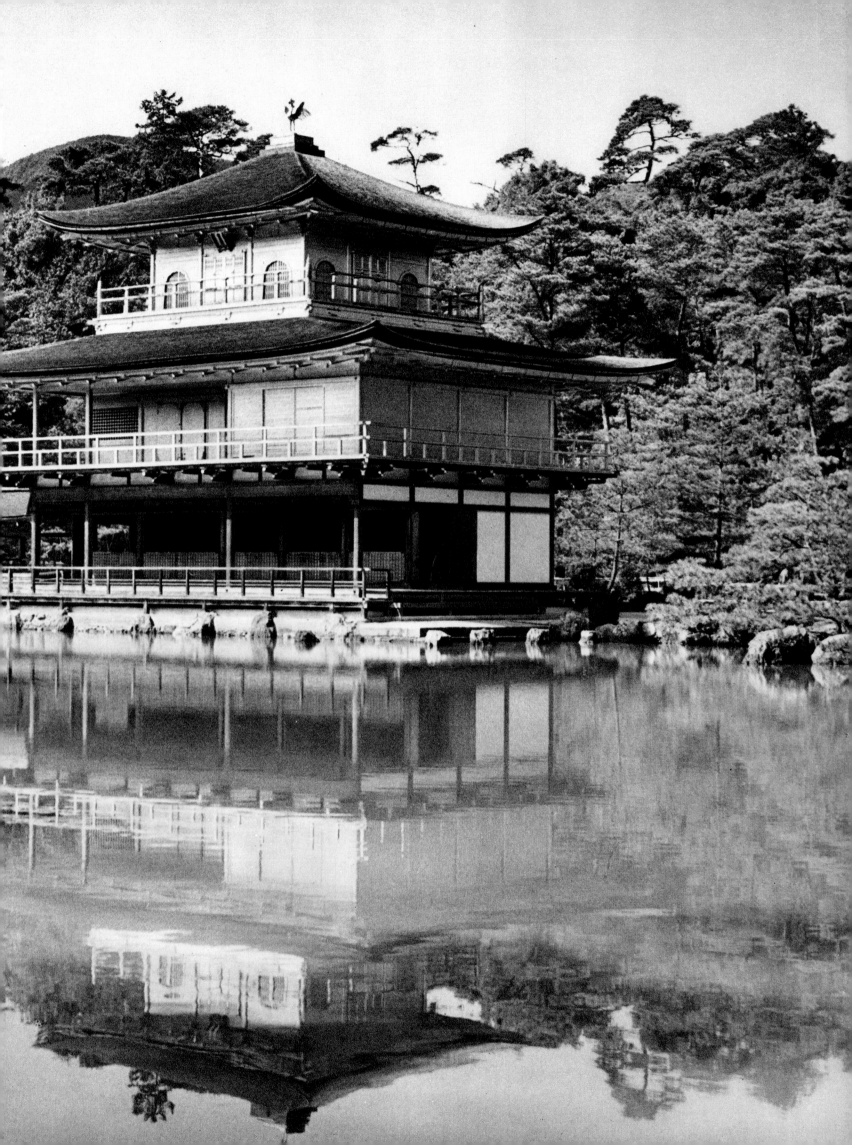

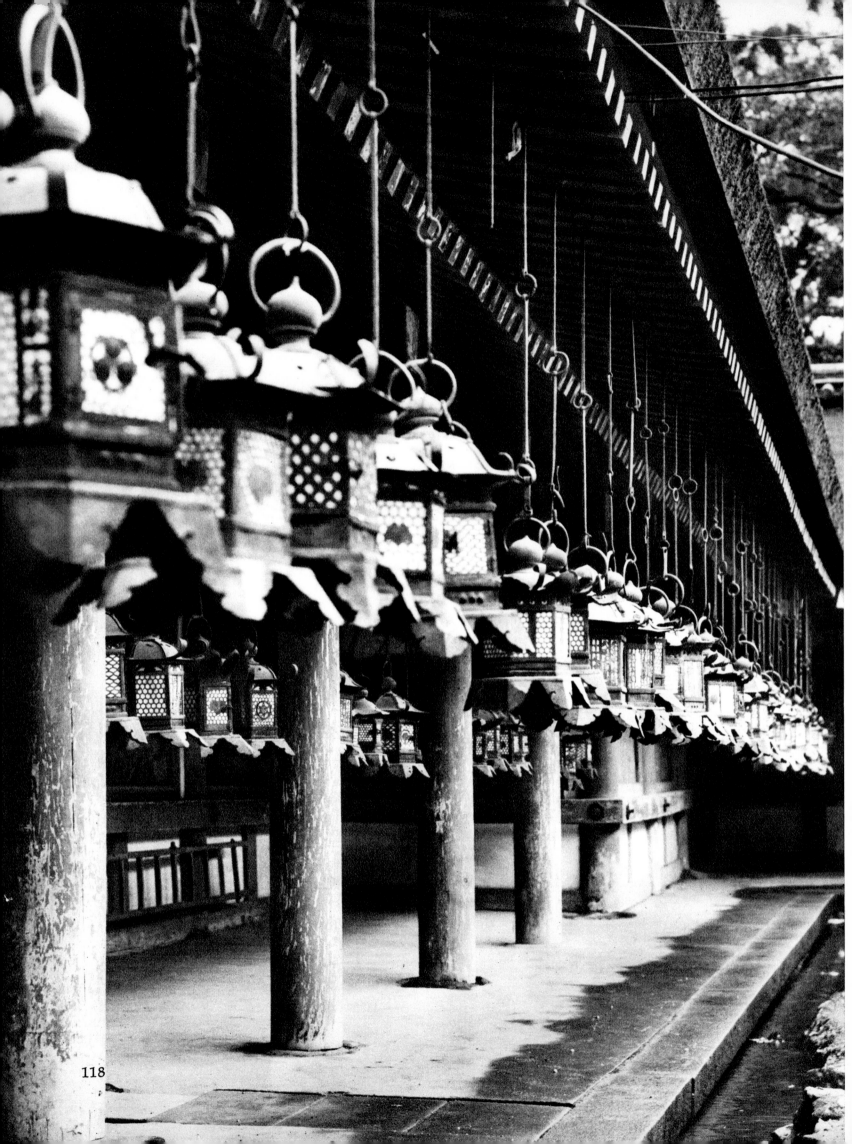

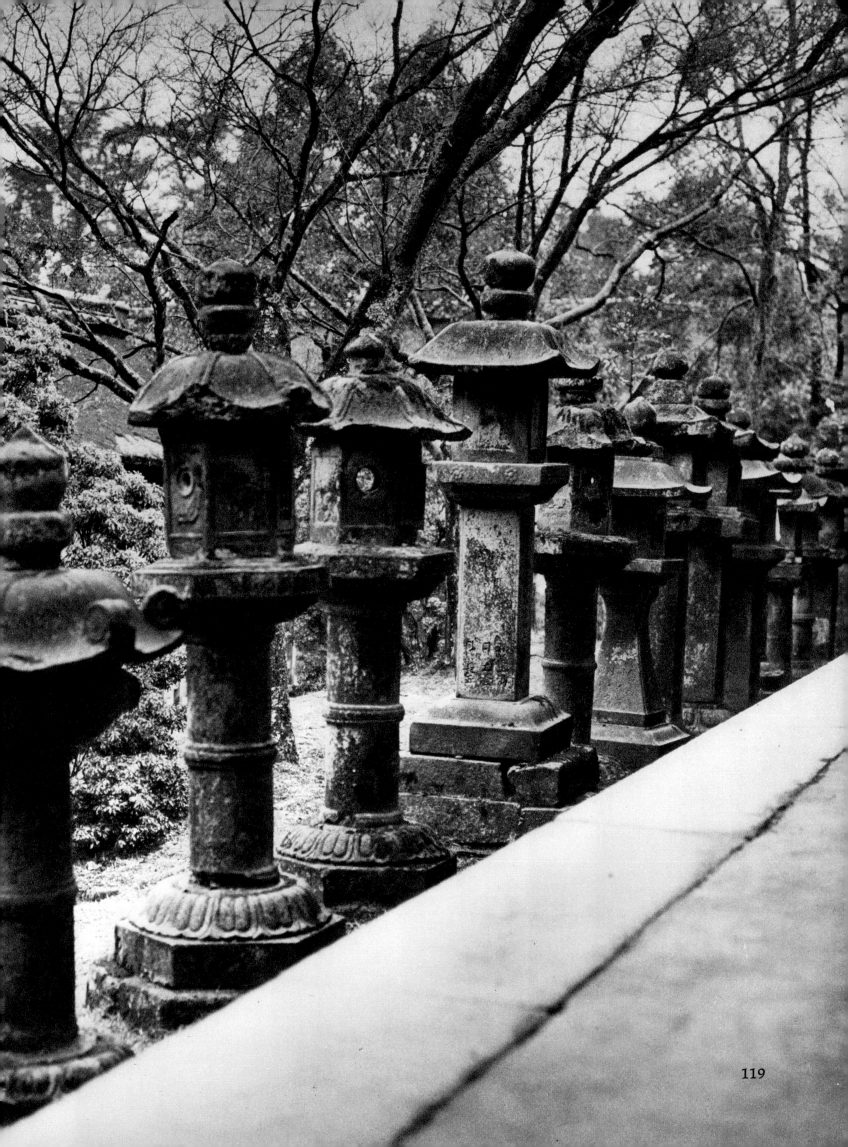

119

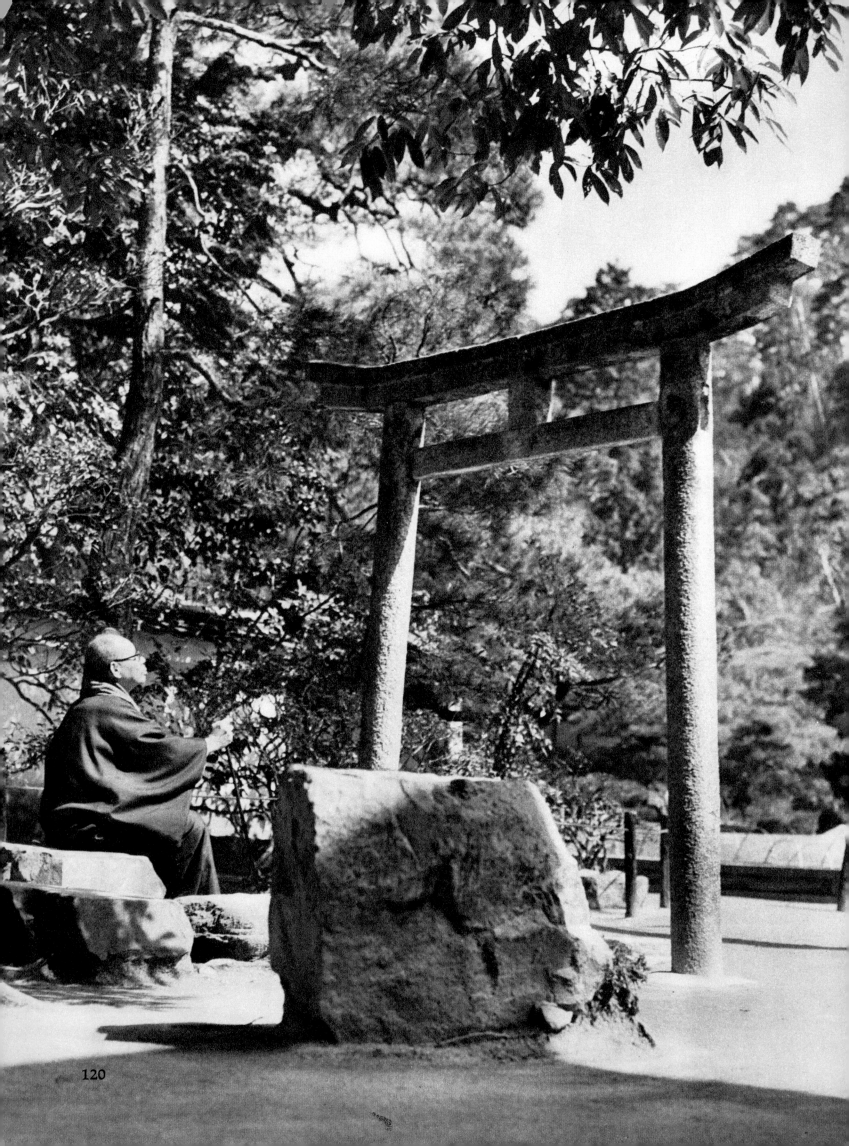

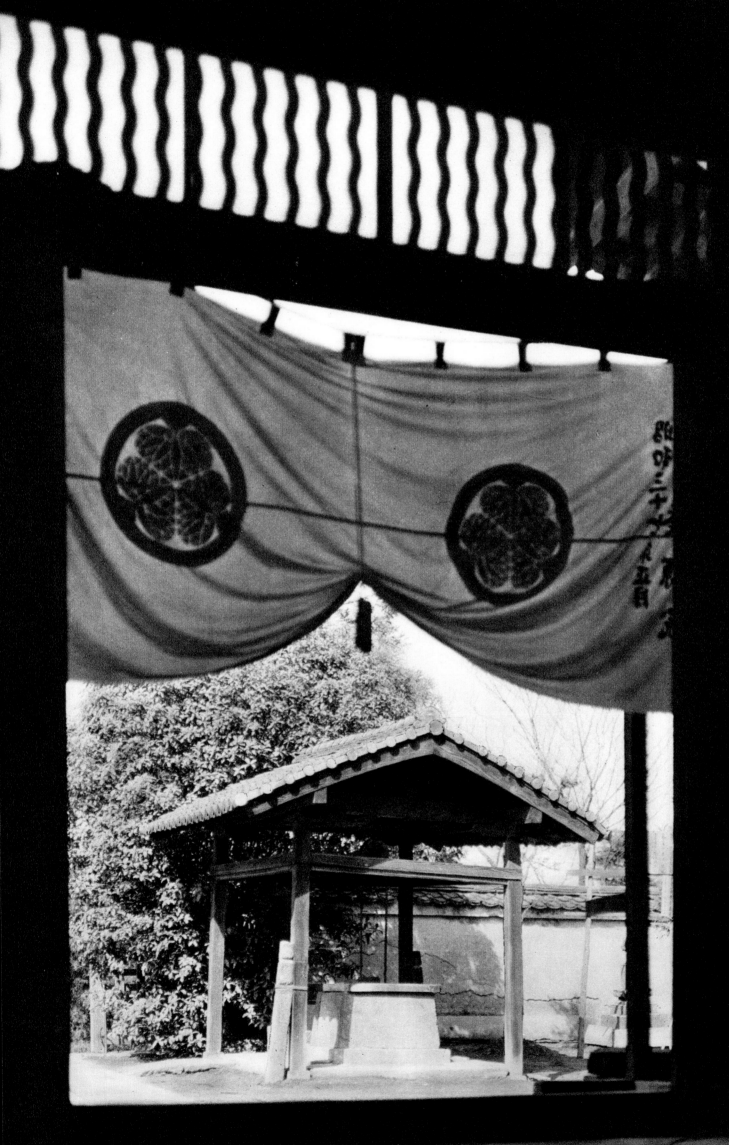

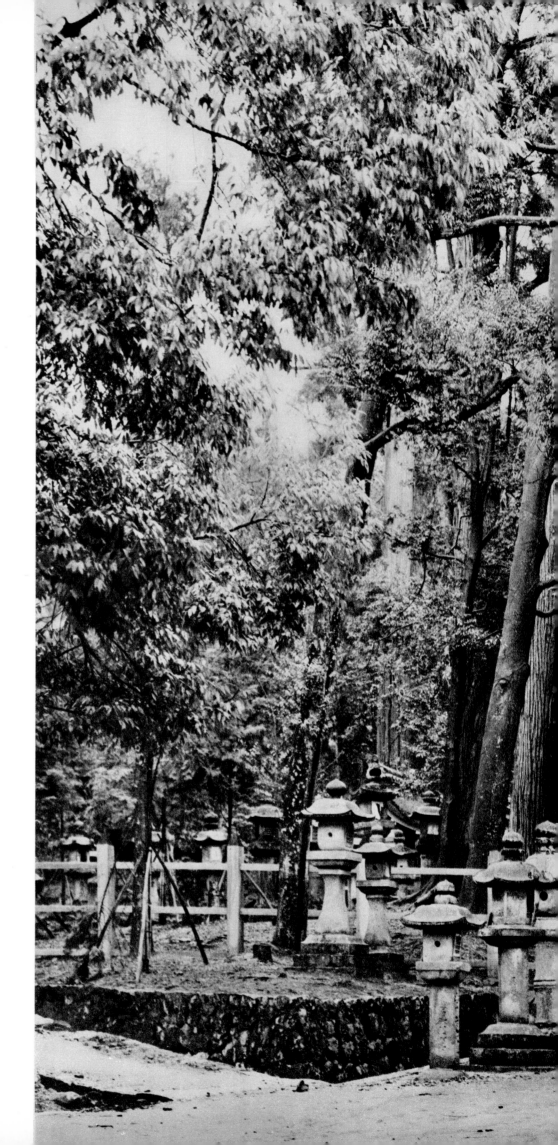

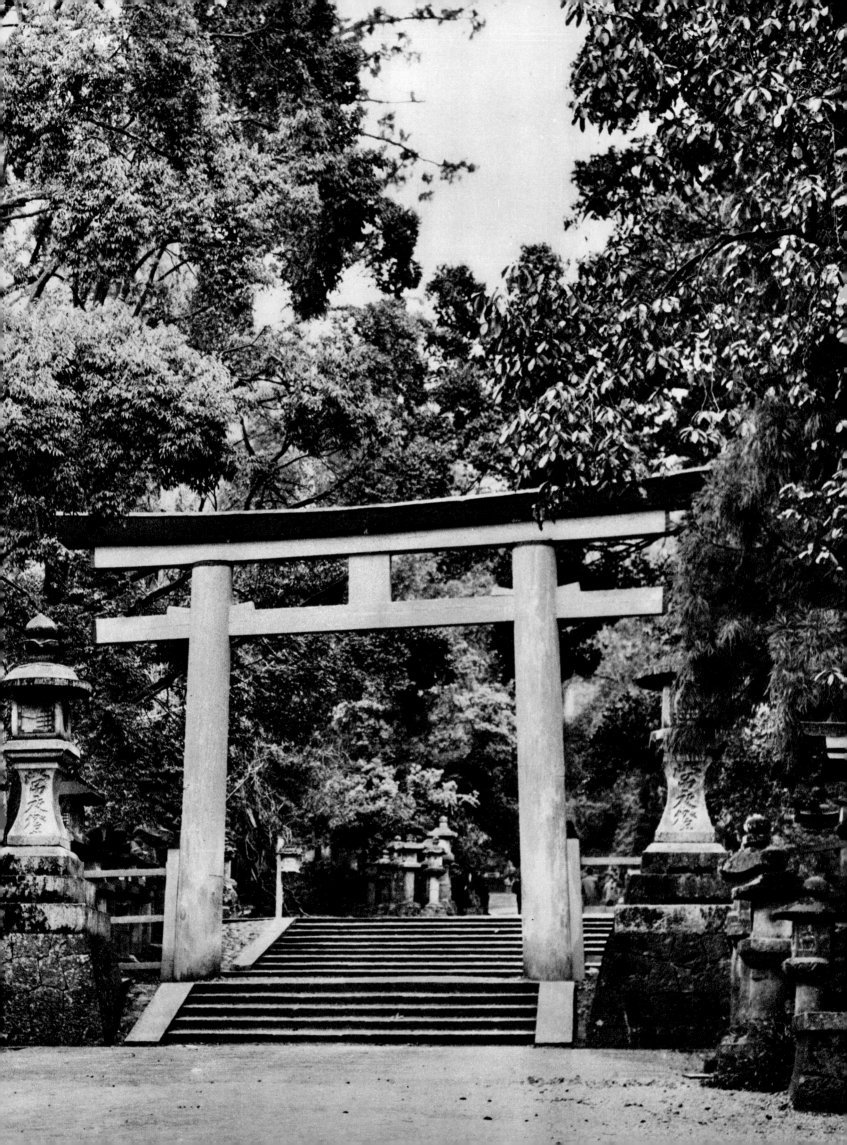

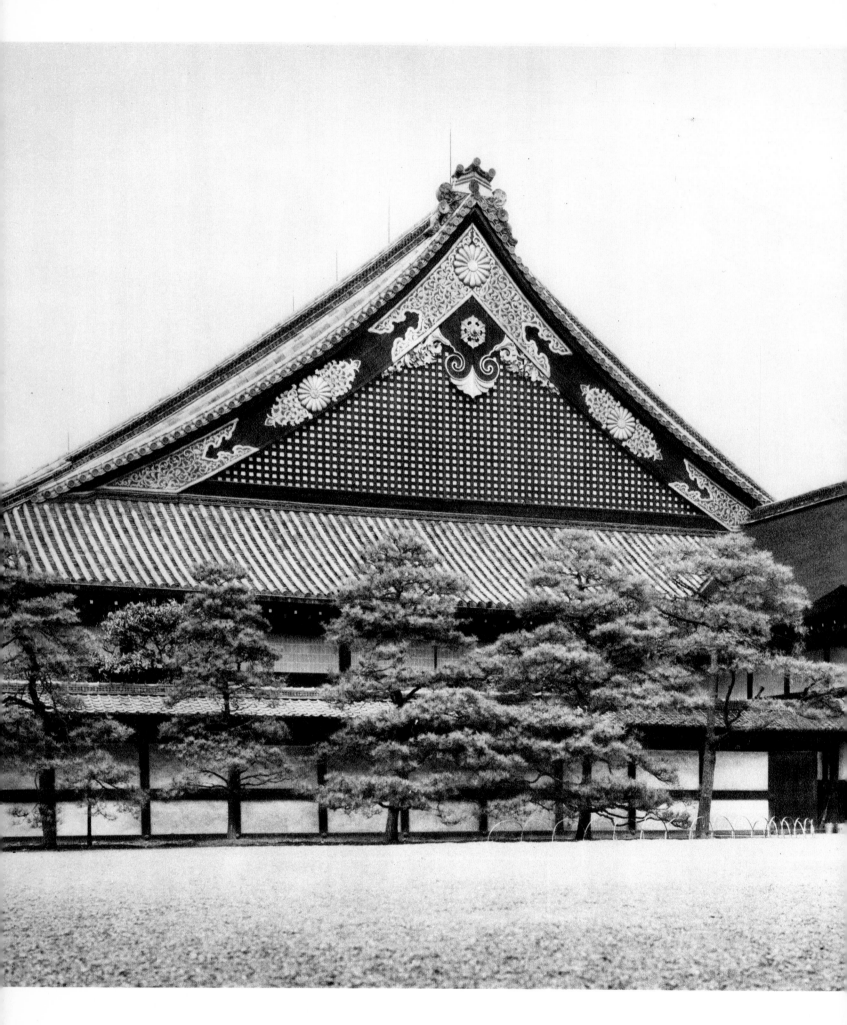

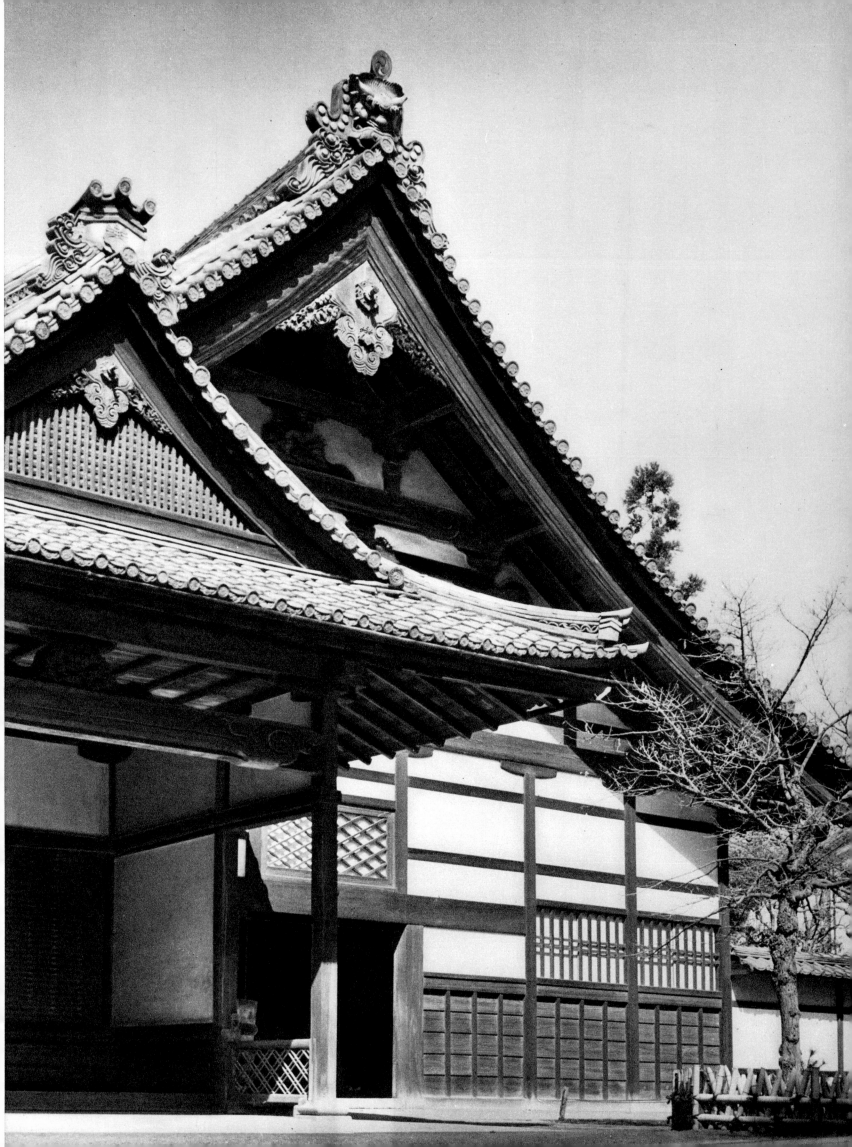

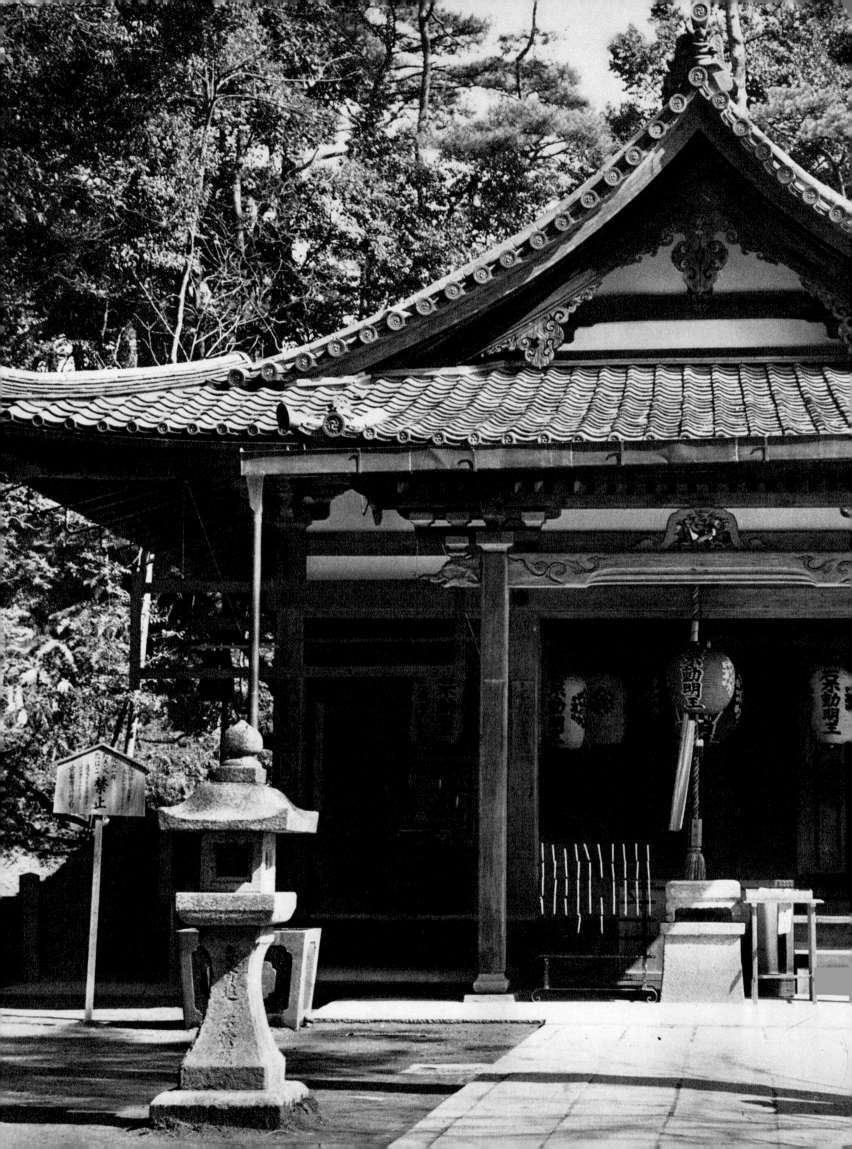

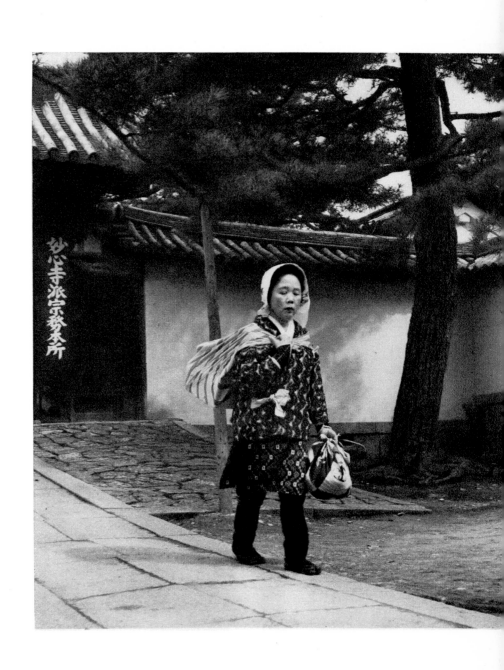

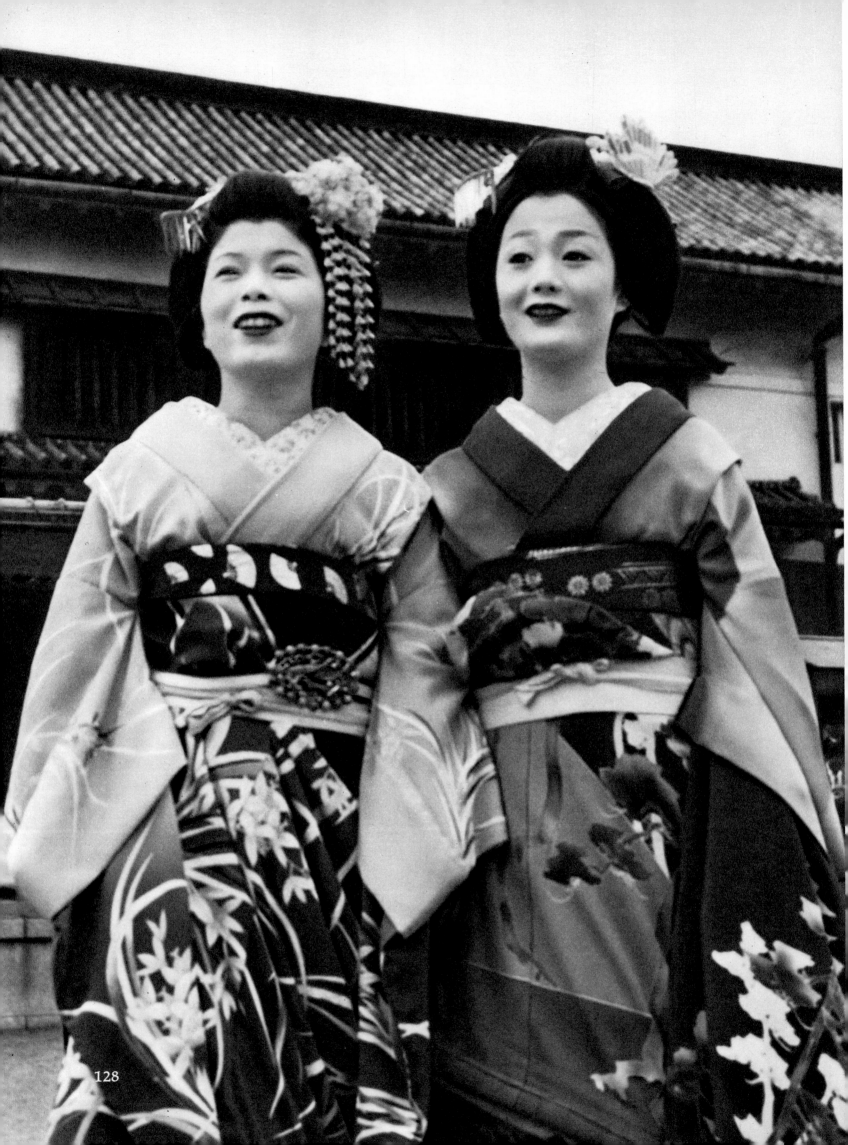

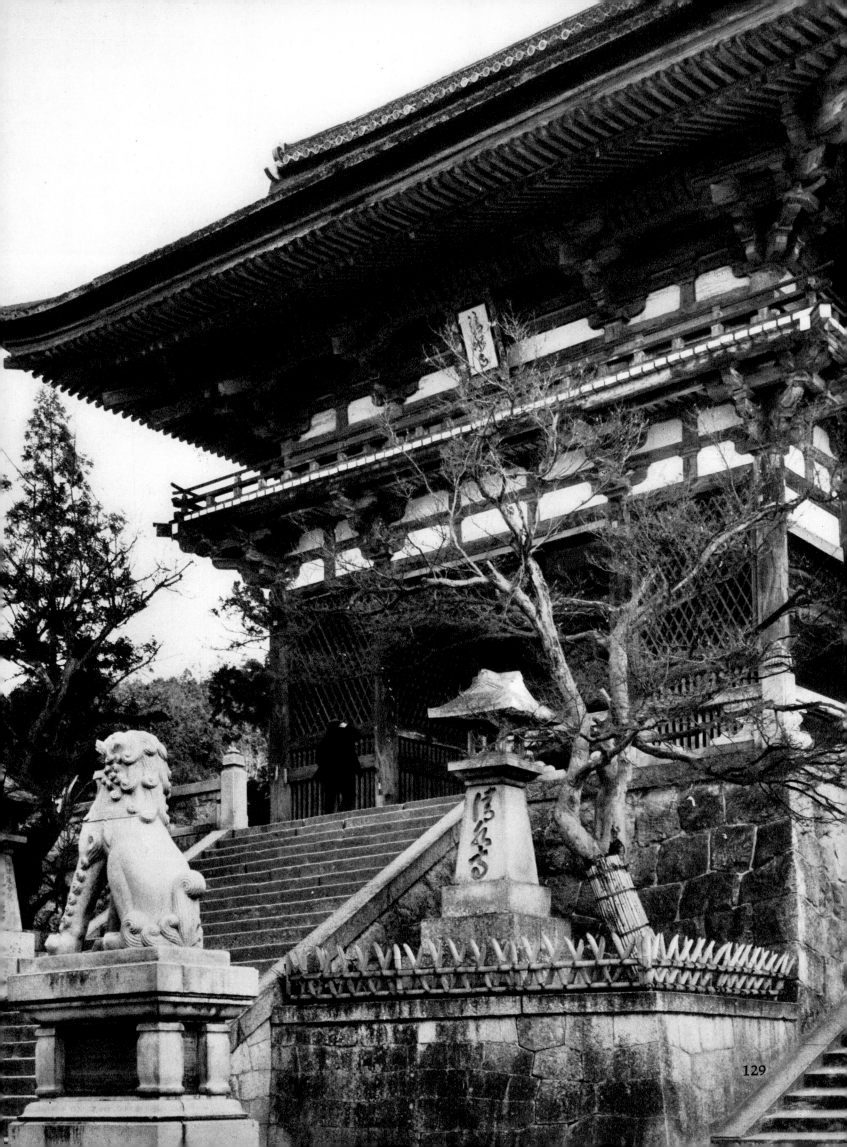

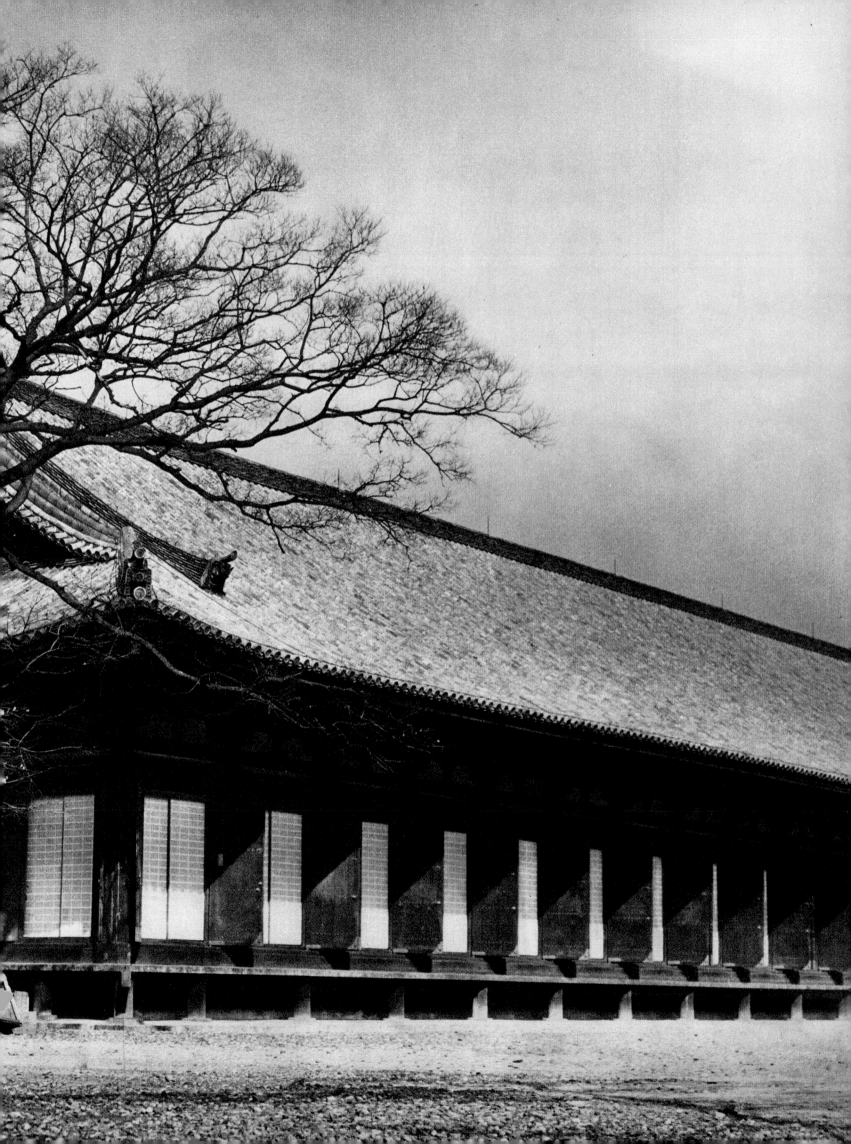

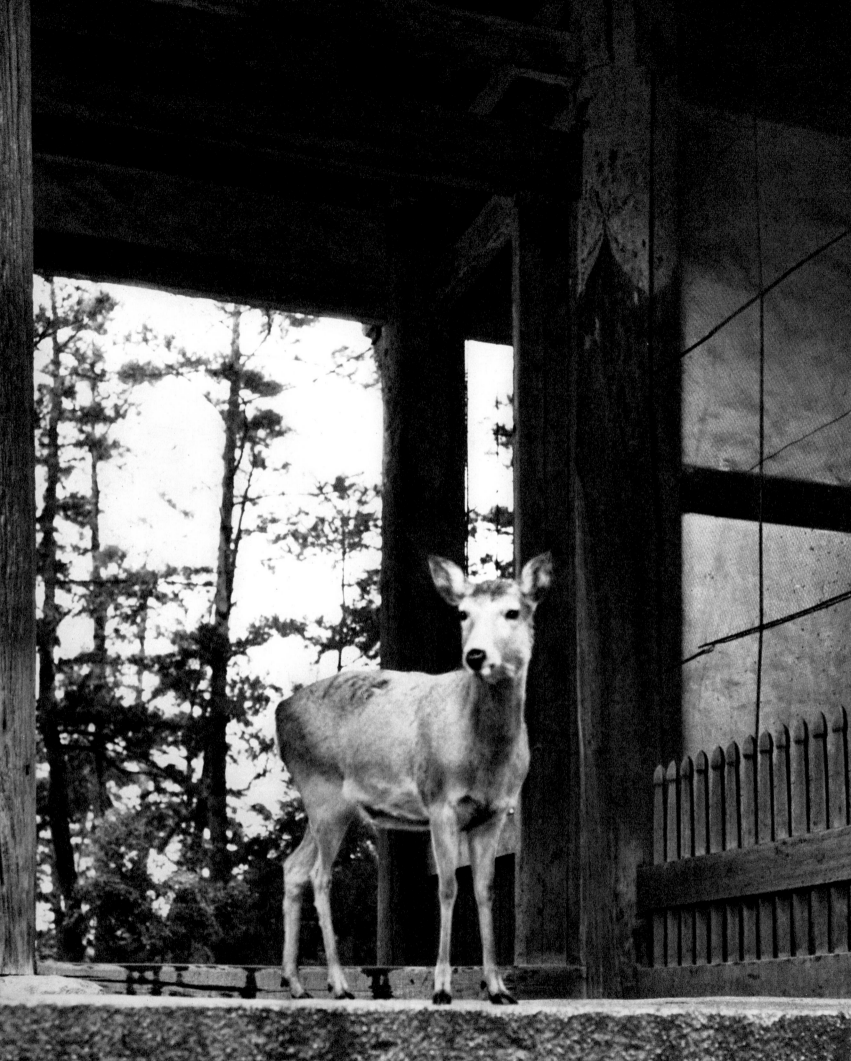

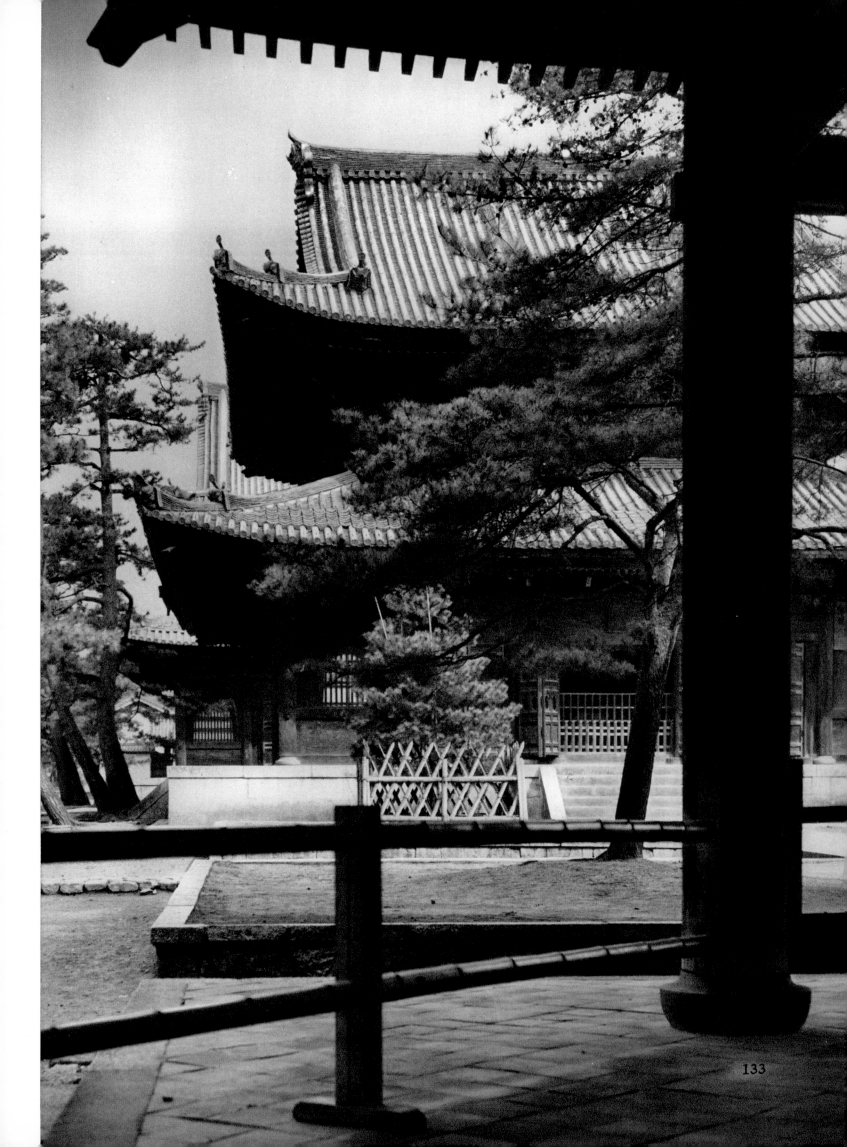

133

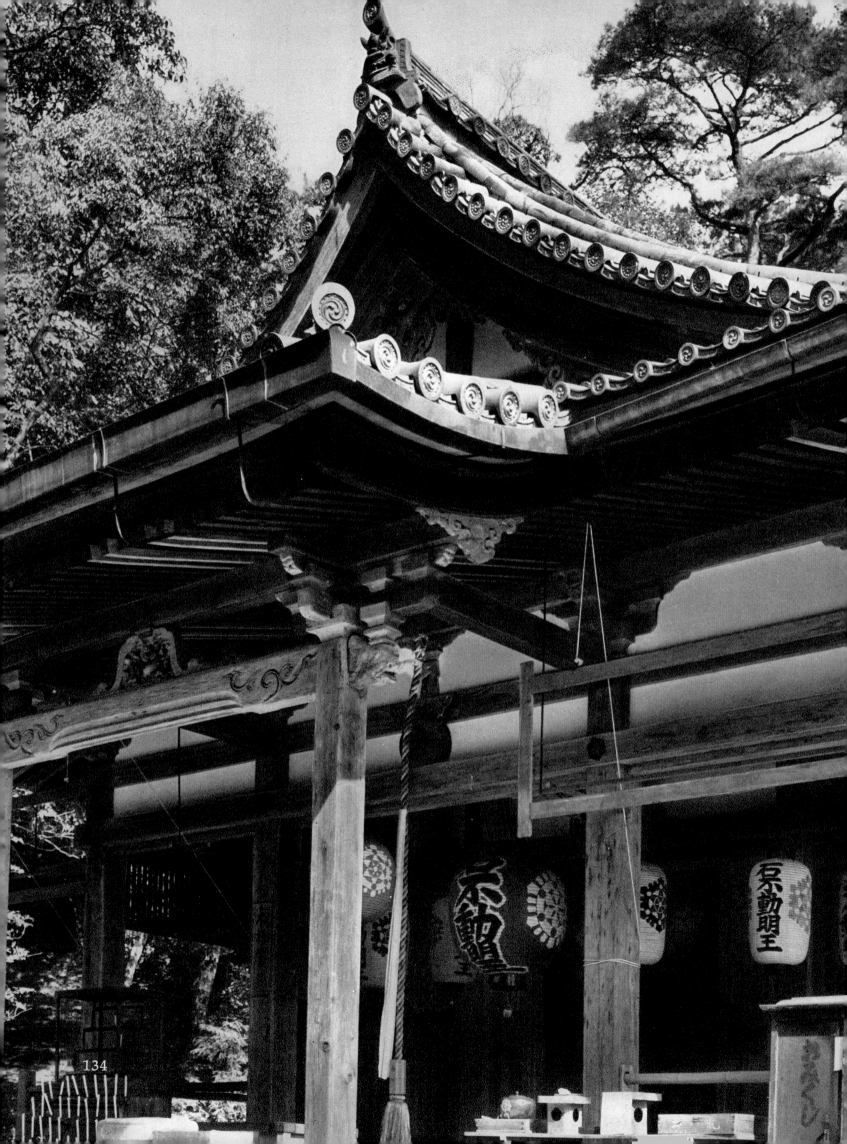

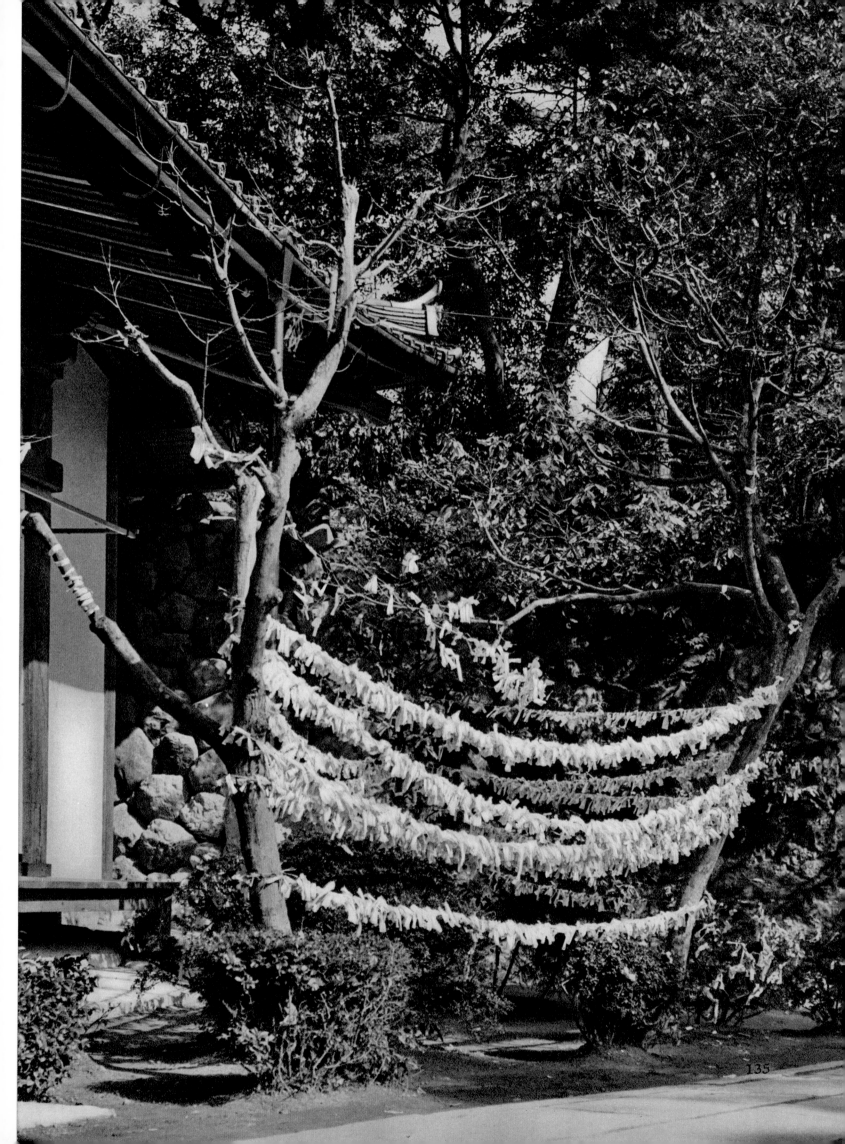

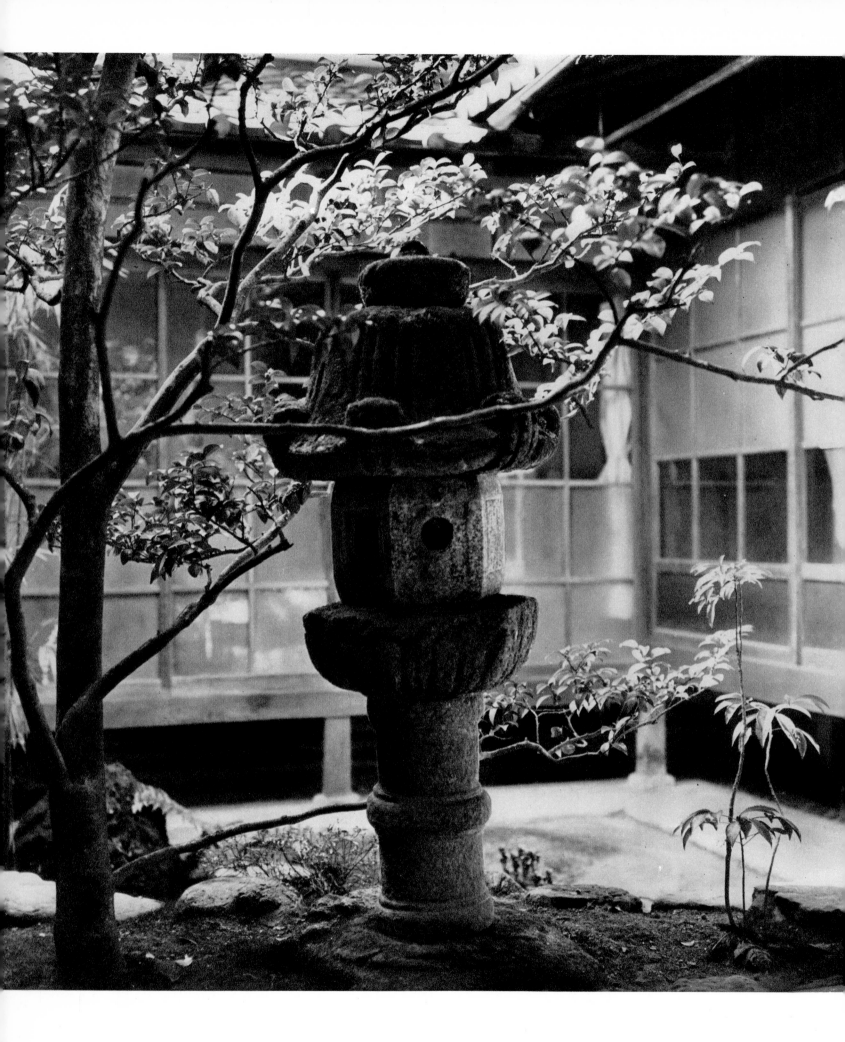

refined it that it became an entirely new work. The age of samurai austerity had ended, but Yoshimitsu now introduced another kind of austerity—an austerity of luxuriance. The Gold Pavilion—it was called "Gold" only because one of the halls was gilded—was his supreme masterpiece.

This villa-temple, half-sacred, half-profane, lies on the edge of a small lake and seems to have been designed so that the building and its reflection should make a perfect whole. Butterfly, petal, a ship's sail: it is all these. Seeing it, you have the feeling that the next gust of wind will send it floating across the lake. Though fragile, it gives an impression of studied power. Its simplicity is disarming, but it is not in the least simple: the proportions were calculated with an imperious refinement. Yoshimitsu demanded nothing less than the most exquisite perfection, and he got what he wanted. He was another Lorenzo de'Medici, establishing a tradition for centuries to come.

Yet if we examine the Gold Pavilion more closely, we discover that its originality derives from many traditions. While the execution is wholly Japanese, and while it betrays the Japanese passion for impermanence—for something seen suddenly, never to be seen again—and therefore could not be mistaken for anything but a Japanese building, yet there are elements in it which derive from the Sung dynasty and from traditions far more ancient than the Sung. A certain amplitude, particularly noticeable in the proportions of the second balcony, seem to derive from the rounded fullness of Sung art. Zen Buddhism, too, has left its influence. Indeed, this new, artfully contrived simplicity owed so much to Zen Buddhism and its doctrines of aesthetic contemplation that there is no telling where its influence begins and where it ends.

When the Zen masters came to Japan, they were welcomed with astonishment and delight. They brought very little that was new; the rituals of sudden enlightenment were already familiar to them. What was new was the body of doctrine, and the authority of the Buddha. Zen became a pervading influence in Japan, intensifying the sensibilities already sharpened to observe a whole world in a flower or a grain of sand. Zen reinforced an attitude of mind that already existed.

Yoshimasa, the grandson of Yoshimitsu, came to the shogunate in 1443. As merciless and mendacious as his grandfather, he led his people to ruin during one of the most disastrous periods of Japanese history. He thought nothing of issuing edicts abolishing the debts of his favorite courtiers, to the ruin of the shopkeepers. He gathered vast wealth in his hands, lived sumptuously, and cared nothing for the sufferings he caused. During a ten-year war fighting reached the capital, and when the rival forces withdrew, forty thousand people were camped in the ruins of Kyoto, which had previously contained half a million people. The chronicles of the time speak of continual revolts, raids for plunder, pestilences. Meanwhile Yoshimasa continued to hold colorful parades and to pamper his wife, who made and unmade laws at her pleasure.

But it sometimes happens that periods of disaster and misrule quicken men's minds. In some mysterious way the spectacle of ruin excites men to think more subtly, more accurately. Despair lends wings to the aesthetic sensibilities and gives the philos-

opher a deeper understanding of the world around him. In terms of lives uselessly lost, the reign of Yoshimasa was one of unmitigated horror; in the history of Japanese art, it was a reign of splendor.

The artists were exploring the nature of refinement to its utmost limit. What was at once exquisitely delicate and exquisitely powerful before became as it were a springboard for further explorations and adventures in the unknown. Search and inquiry in every field of aesthetic judgment became the commonplace of the time. By the light of burning cities the architects built new temples, the artists painted, and the poets sang.

In 1474 Yoshimasa, weary of the discomforts of power, abandoned the shogunate to his son Yoshihisa and for the remaining sixteen years of his life lived a life of elegant self-indulgence, modeling himself on his grandfather. He was even more subtle and imaginative than Yoshimitsu. He, too, built a villa-temple, called the Ginkakuji, the Silver Pavilion. Originally it was to be covered with hammered silver, but this refinement was abandoned, perhaps because it was out of keeping with Zen tradition, which discountenanced any extreme show of wealth or ornamentation.

The Silver Pavilion is much smaller than the Golden Pavilion and has only two stories. It is not a butterfly or a sail; it will not move across its enchanted lake, and it does not live for its reflection in the water. It is more like a leaf that has just fallen. It will stir a little in the wind, and then it will resume its customary place. It is even more subtle, more elegant, more mysteriously appropriate to its setting than the Gold Pavilion. Its beauty lies in the perfection and inevitability of its proportions, the rhythm of the vertical lines giving emphasis to the gentle curve of the broad roofs. According to tradition it was in one of the northeast rooms that the exquisites of Yoshimasa's court first presided over the *cha-no-yu*, or tea ceremony, which was to become a familiar, though infinitely complicated, part of the ritual of Japanese life.

That Yoshimasa originated the tea ceremony or at least gave it his royal sanction and attended its birth, is not surprising. He was the aesthete of aesthetes, pursuing an austere aesthetic ideal to its ultimate limits. He surrounded himself with the great artists of his time and thought no moment of life worth enduring unless it contributed aesthetic pleasure. Significantly the original tearoom was only four and a half mats, scarcely more than nine feet square.

Yoshimasa built up a vast collection of treasures. He collected Sung dynasty paintings, masterpieces of calligraphy, and porcelain. He also collected gardeners, and among them was the master gardener Soami, whom the Japanese regard as the greatest gardener who has ever lived. Soami, like most of the artists of his time, was a monk. For him gardens were acts of contemplation; they were not so much places where a man could meditate as meditations in their own right. He carved out a lake, planted trees, collected rocks from ancient river beds, and so arranged the garden that it possessed a breath of its own, free to meditate, to bless and to smile and to follow its own unspoken thoughts to the end of time.

With the Gold and Silver Pavilions Japanese architecture affirmed the two poles of a continuing tradition. The Silver Pavilion survives in its original form. The Golden

Pavilion suffered the inevitable fate of nearly all Japanese buildings by going up in flames. It had survived for more than five hundred and fifty years when in the summer of 1950 a mad monk set fire to it, in the belief that a building so beautiful did not deserve to exist. At the very top of the pavilion stood a bronze phoenix: the monk should have known that it would rise again.

> Beautie, Truth, and Raritie,
> Grace in all simplicitie,
> Here enclosed, in cinders lie.

> Death is now the Phoenix nest...

Only there was no death, and the phoenix rose again. Even before the cinders were cold, the architects were at work preparing to rebuild it. Five years later, in October 1955, it rose as beautiful as ever.

Soami, the creator of gardens, went on to create that extraordinary adventure in meditation known as the Garden of the Ryoanji monastery temple. It is unlike any gardens known in the West. There are no trees, no plants, no flowers, no grasses. There are no leisurely pathways, and no shade except for that provided by stern walls. There are sand and stones, nothing else. The sand is gravelly white, and the fifteen stones are of many sizes and shapes, cunningly distributed in three groups. Five-two, three-two, three. Seven, five, three. One expects to find some significance in the numbers, but there is none, or at least no one has ever discovered the significance. The gravelly sand is raked, and the rake-marks, swirling round the edges of the stones, or spreading in long level lines, are an intrinsic part of the design; but what the design represents is something that can be known only to the inner mind. There are Japanese who say that it lacks an austere simplicity: Soami has designed a meditation which is almost too luxurious—five stones would have been enough.

The garden of the Ryoanji monastery temple has a haunting quality, as of a dream or a meditation long forgotten and now suddenly resumed. The rocks suggest islands that have just been formed, seafowl which have just alighted, but these are mere hints of hints: something far more disturbing seems to spread out from that engaging pattern, where the haphazard and the inevitable ultimately combine. We tell ourselves—for the mind wanders after certainties—that it may be God's first sketch for the universe, the first tentative blueprint; and then, a moment later, the rocks become mountains emerging from beneath calm seas; a moment later we see the changing outlines of a face of authentic power. Light breaks. Space moves. It changes with every instant, but its mystery is never explained.

The garden was probably created about 1489 and was therefore in existence when Yoshimasa was living out the last years of his life in the Silver Pavilion, built about twenty years before. For nearly seventy-five more years the Ashikaga shoguns continued to misrule, to murder, and to act as though all the wealth of the people could

# *Plates*

*page*

141    Garden at Ryoanji temple, Kyoto.

142    Students on excursion at Ginkakuji temple, Kyoto.

143    Kiyomizu temple, Kyoto.

144    Stone lanterns at Kasuga shrine, Nara.

145    Saplings wrapped in straw sheaves against the winter cold.

146    Garden in Kyoto.

147    Corridor of a shrine, Kyoto.

148    Worshipers entering a Zen temple, Kyoto.

149    Storehouse for the treasure of a Buddhist temple. It is elevated on pilings to keep the contents dry.

150–51    Gardens of the Imperial Palace, Kyoto.

152    Ancient stone lanterns, Nara.

153    Devotee resting on his way to a shrine.

154    Stone lantern with a receptacle for water, at a Zen temple, Kyoto.

155    A wooden bridge in the Imperial Palace Gardens, Kyoto.

156    Another view of the same bridge.

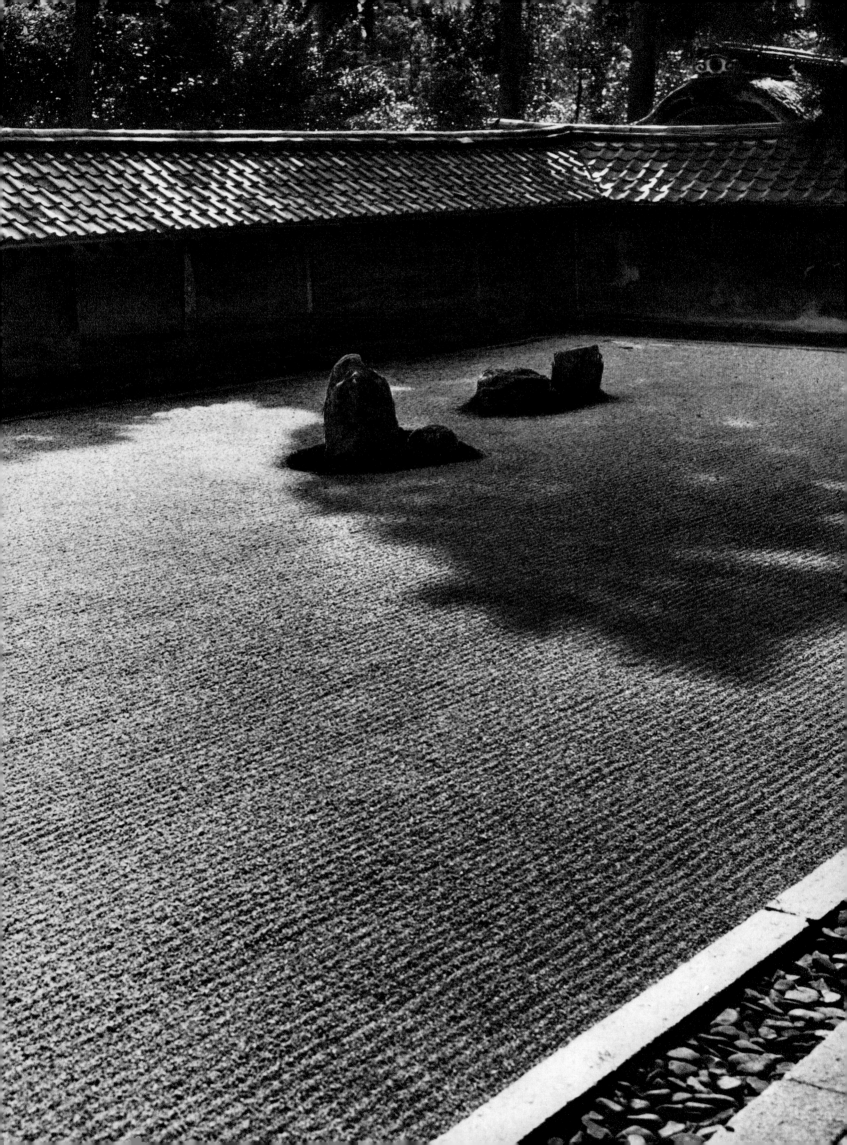

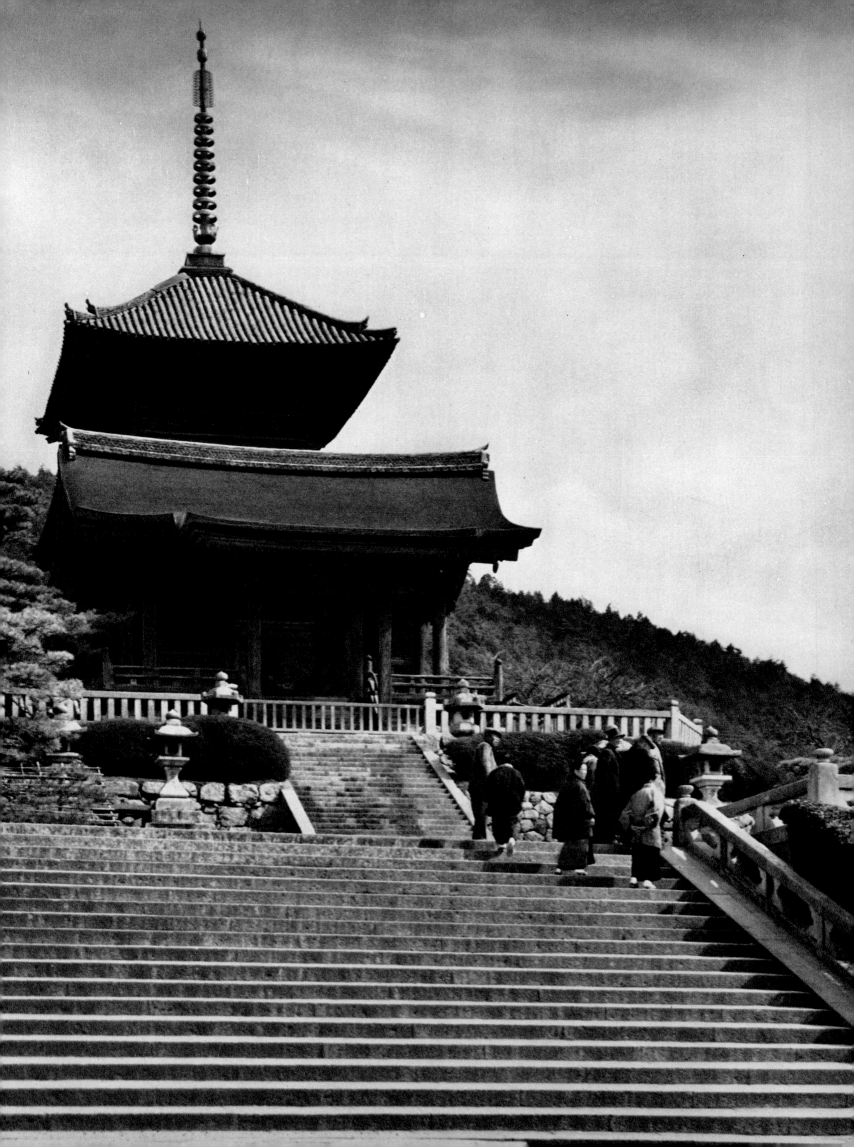

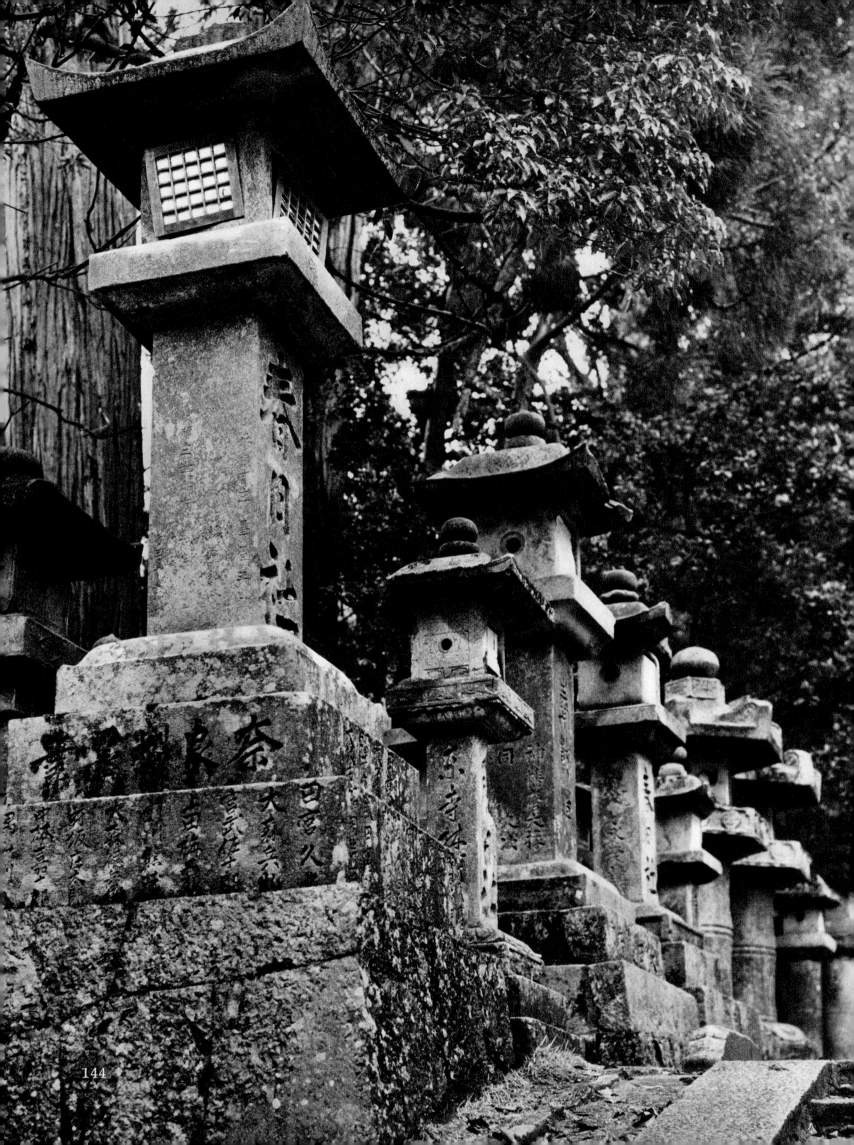

144

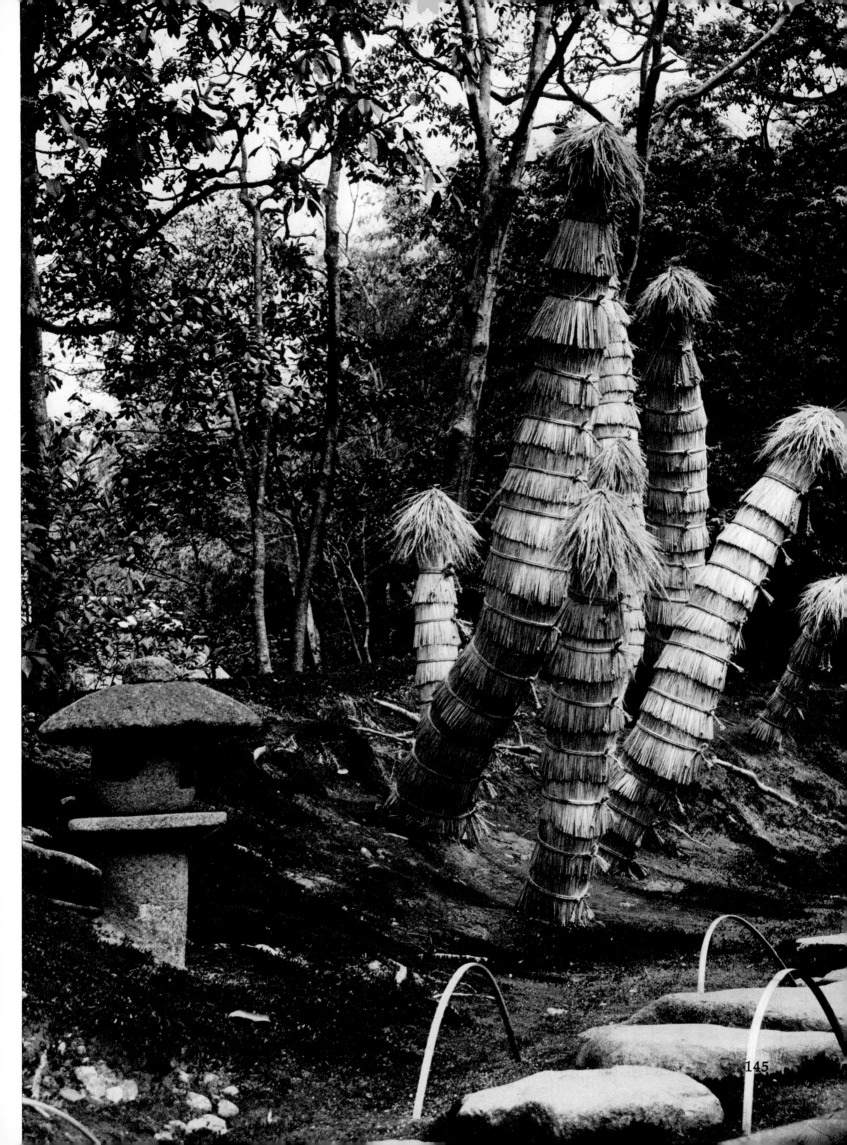

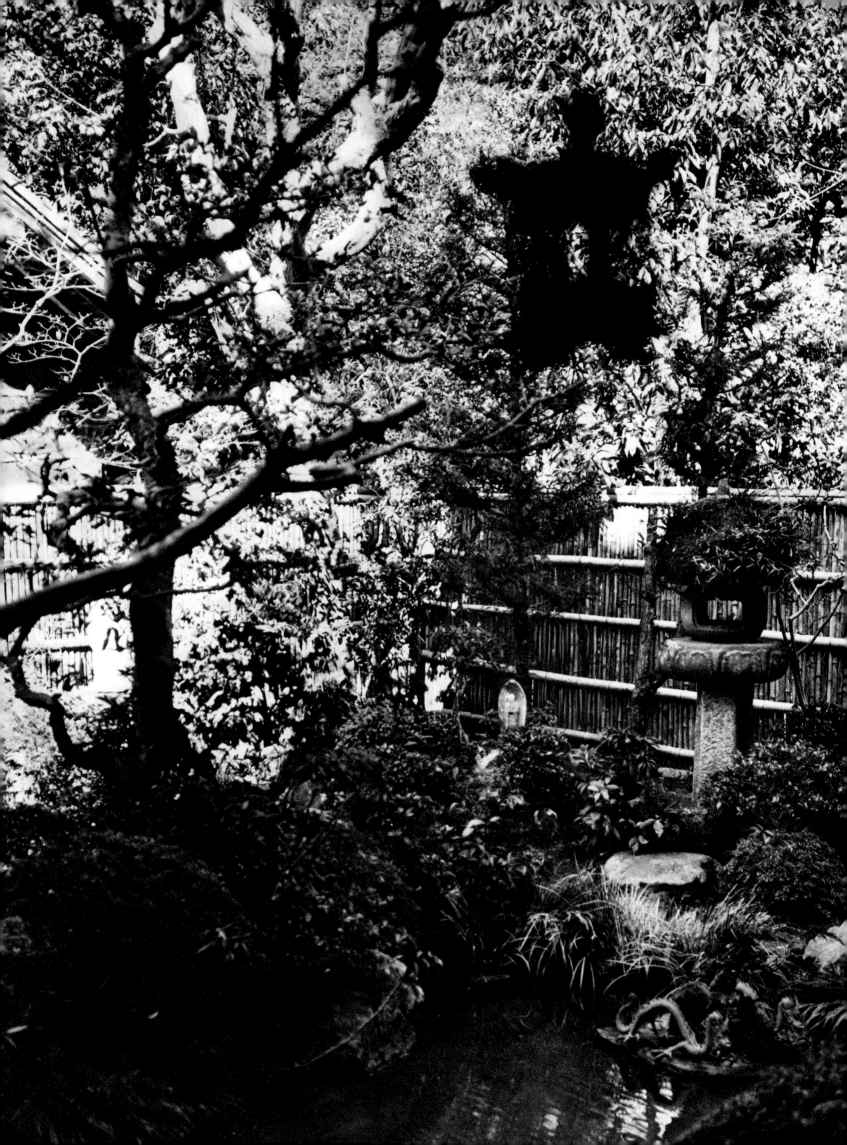

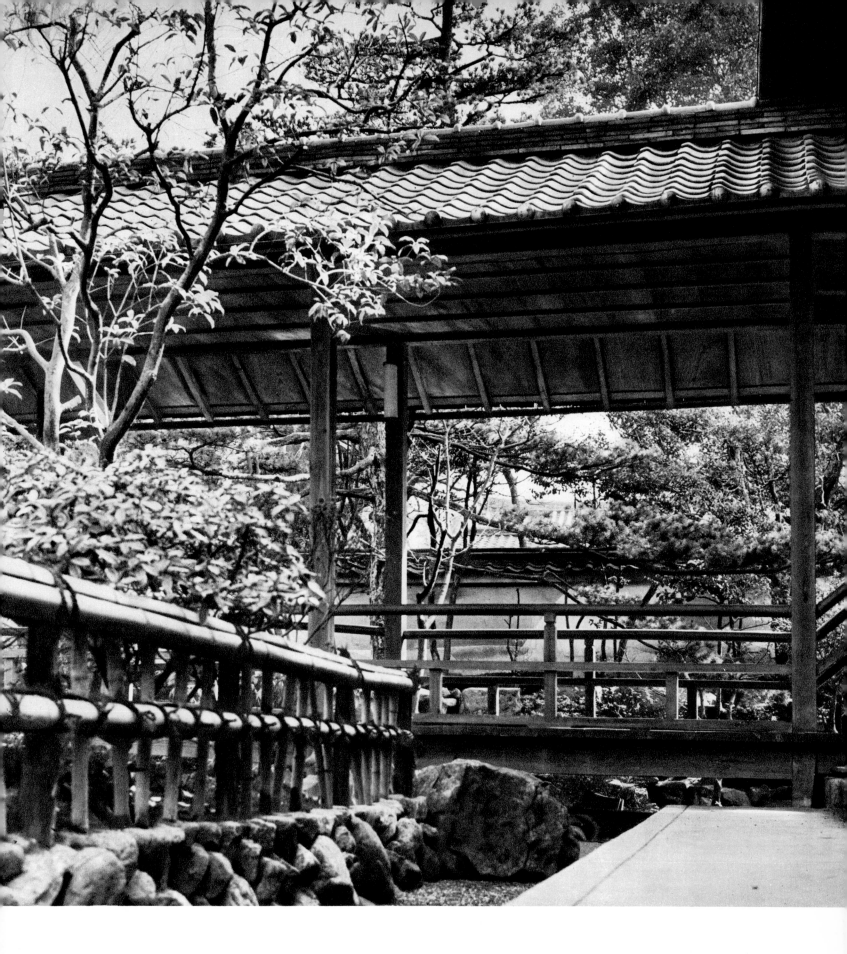

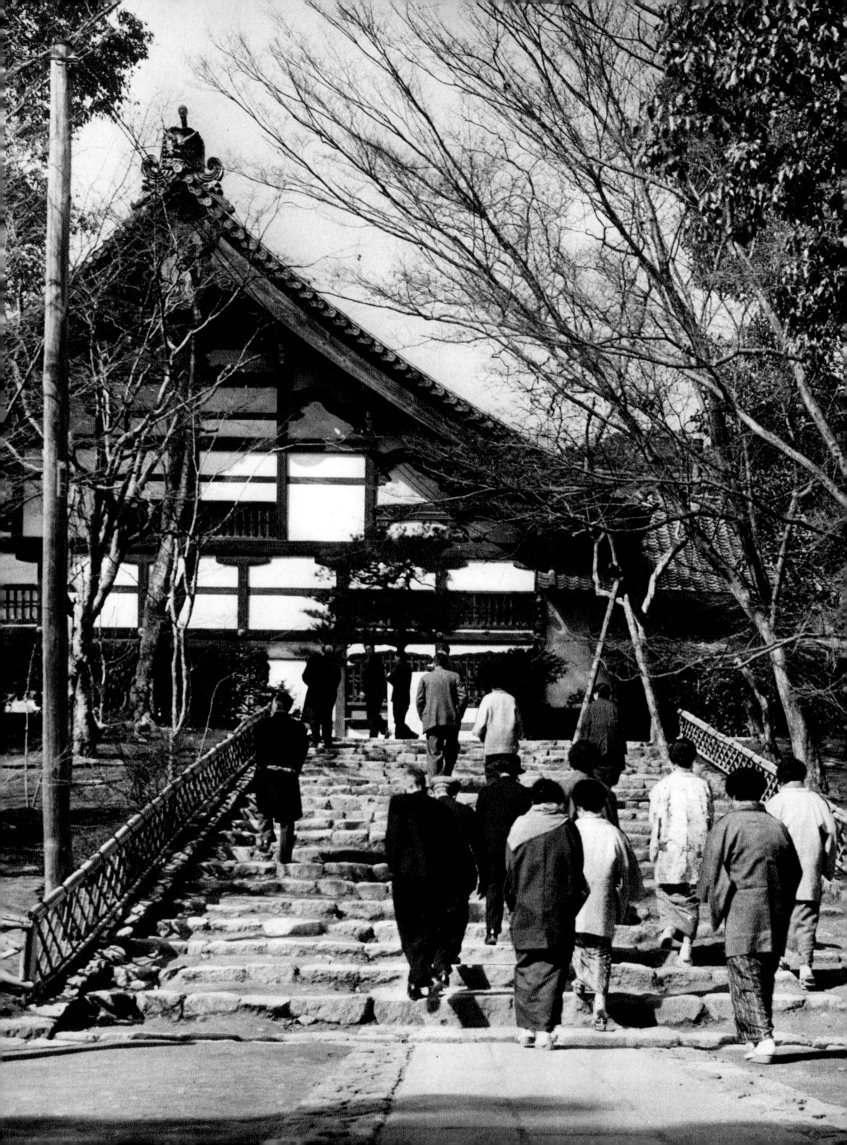

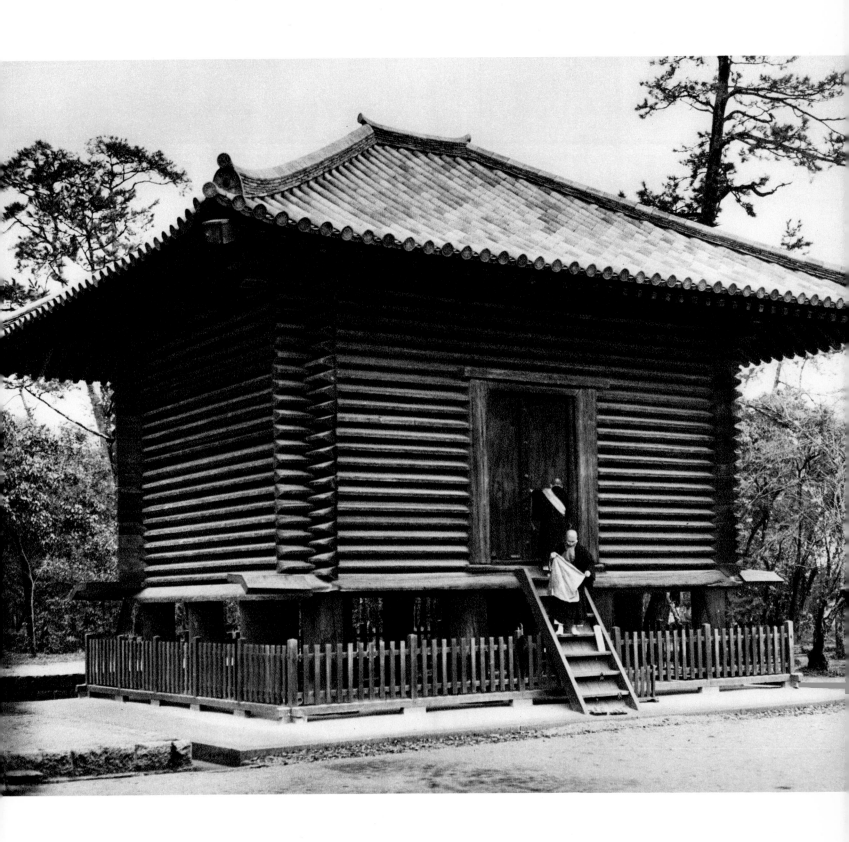

149

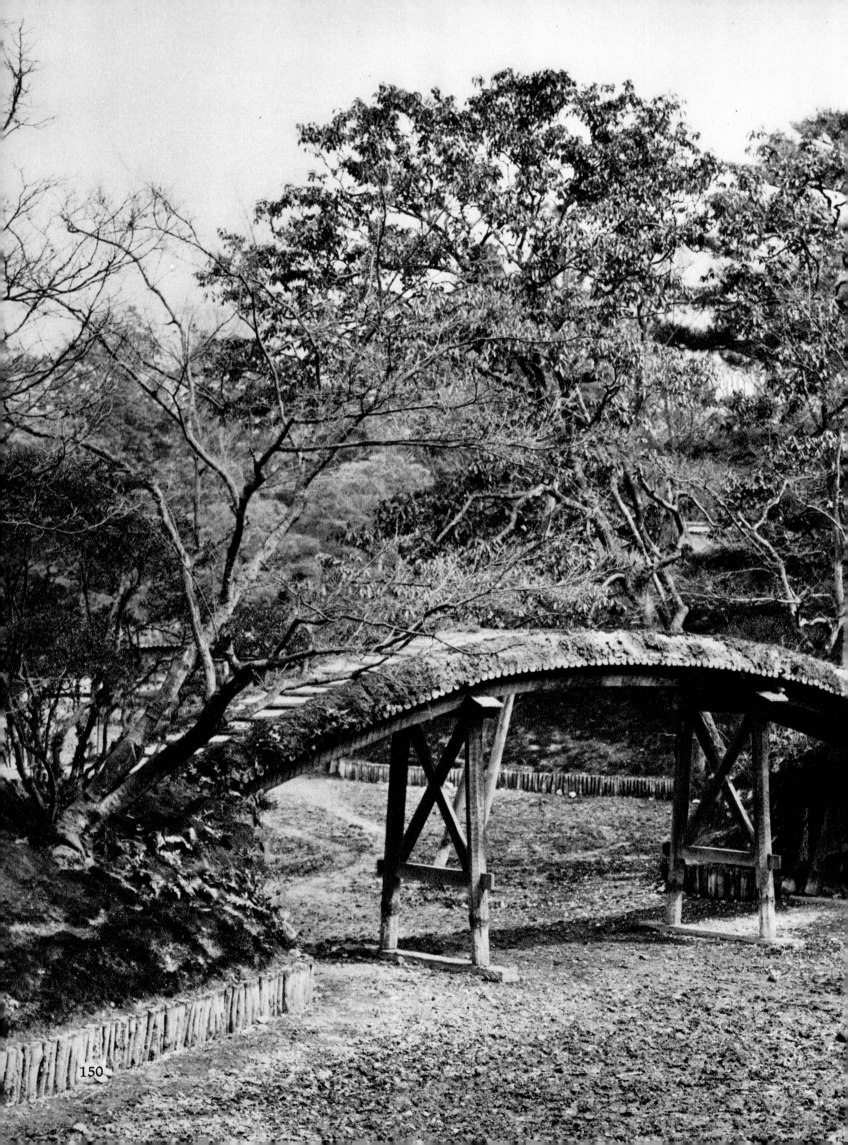

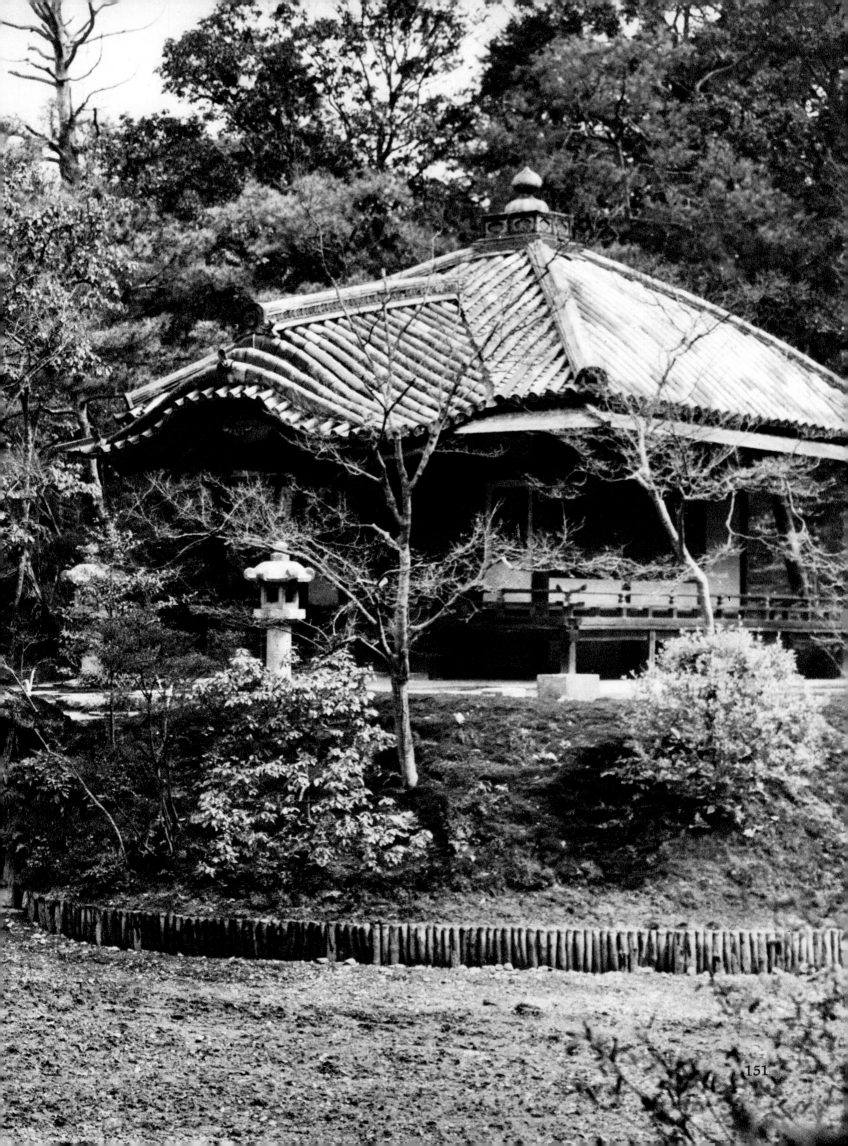

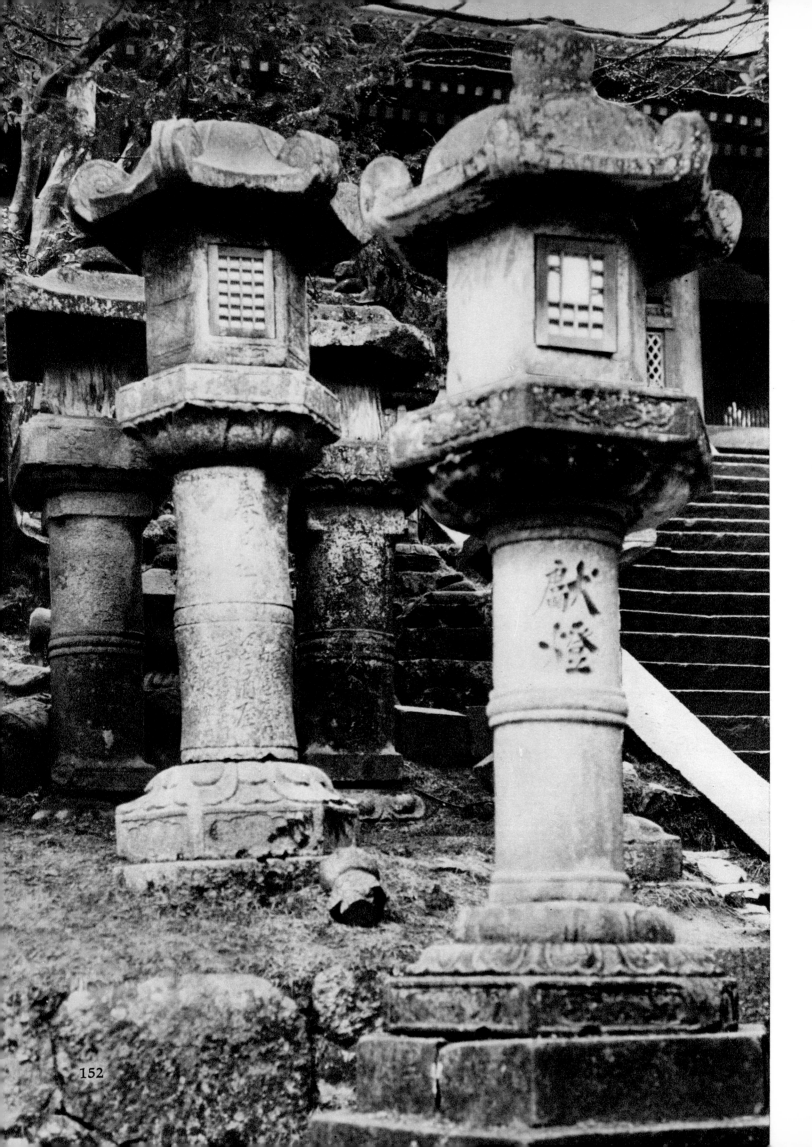

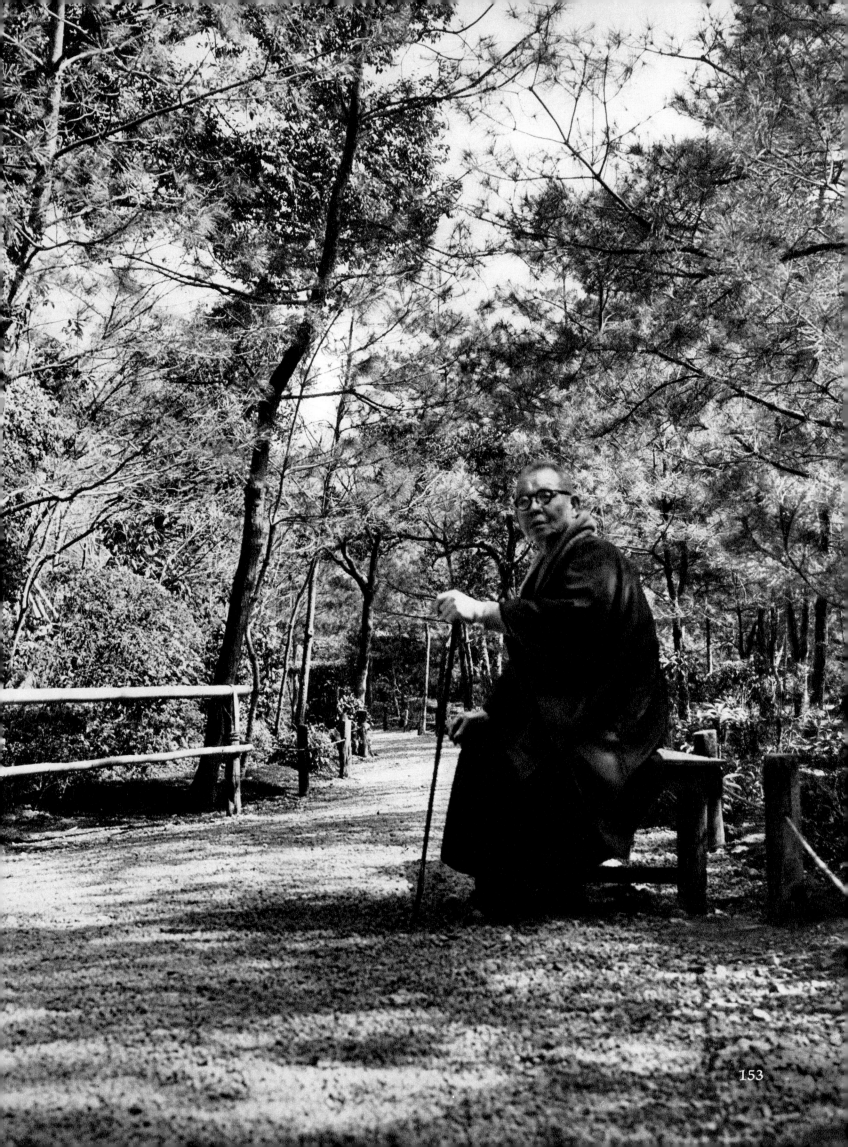

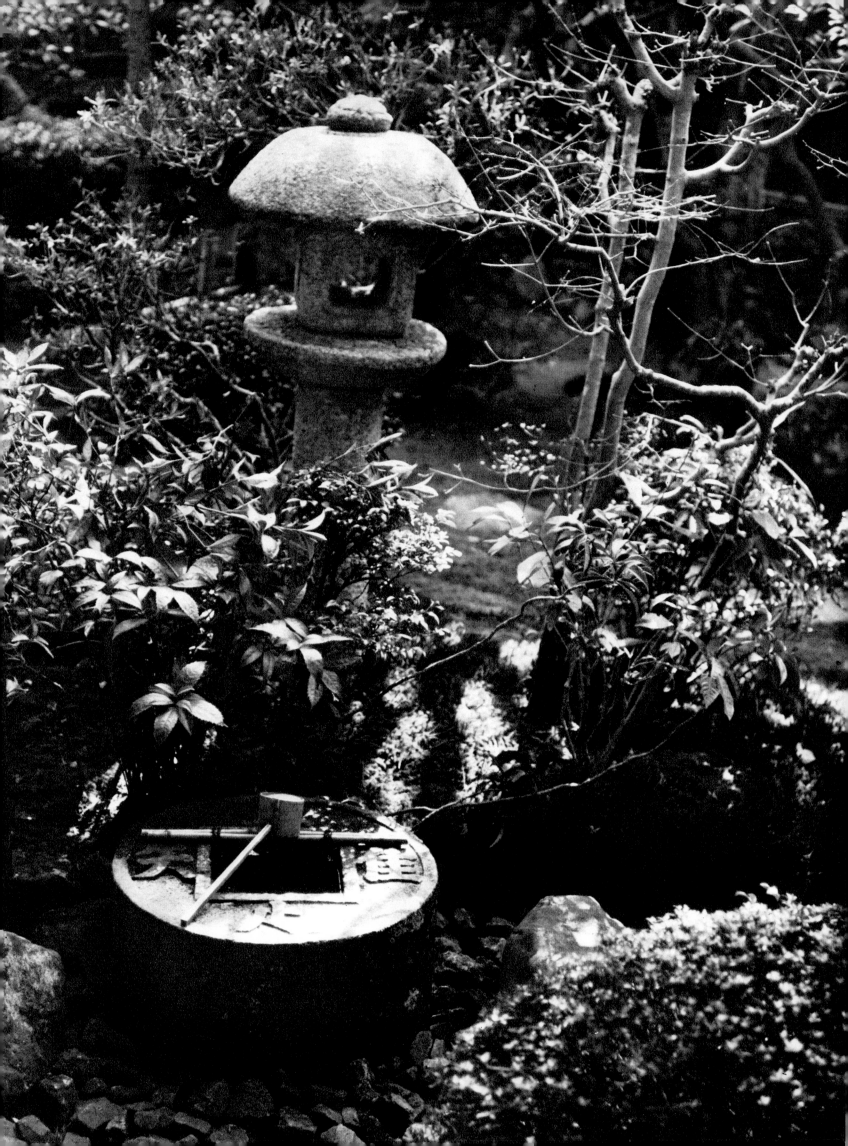

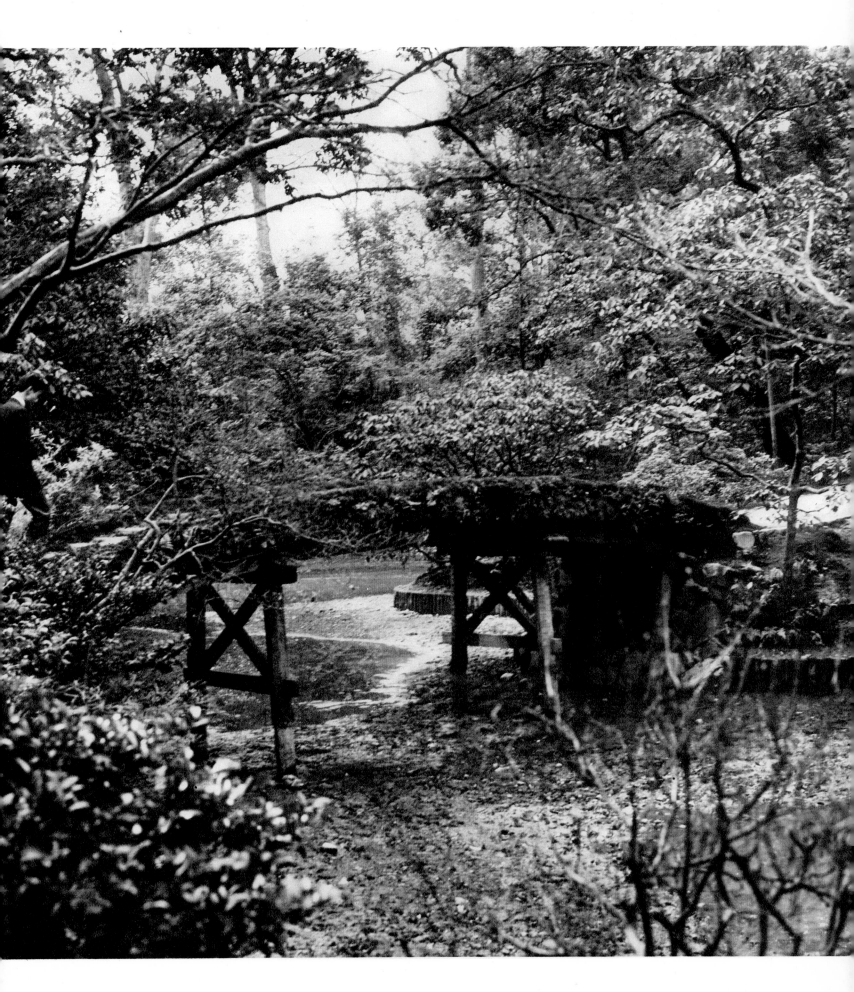

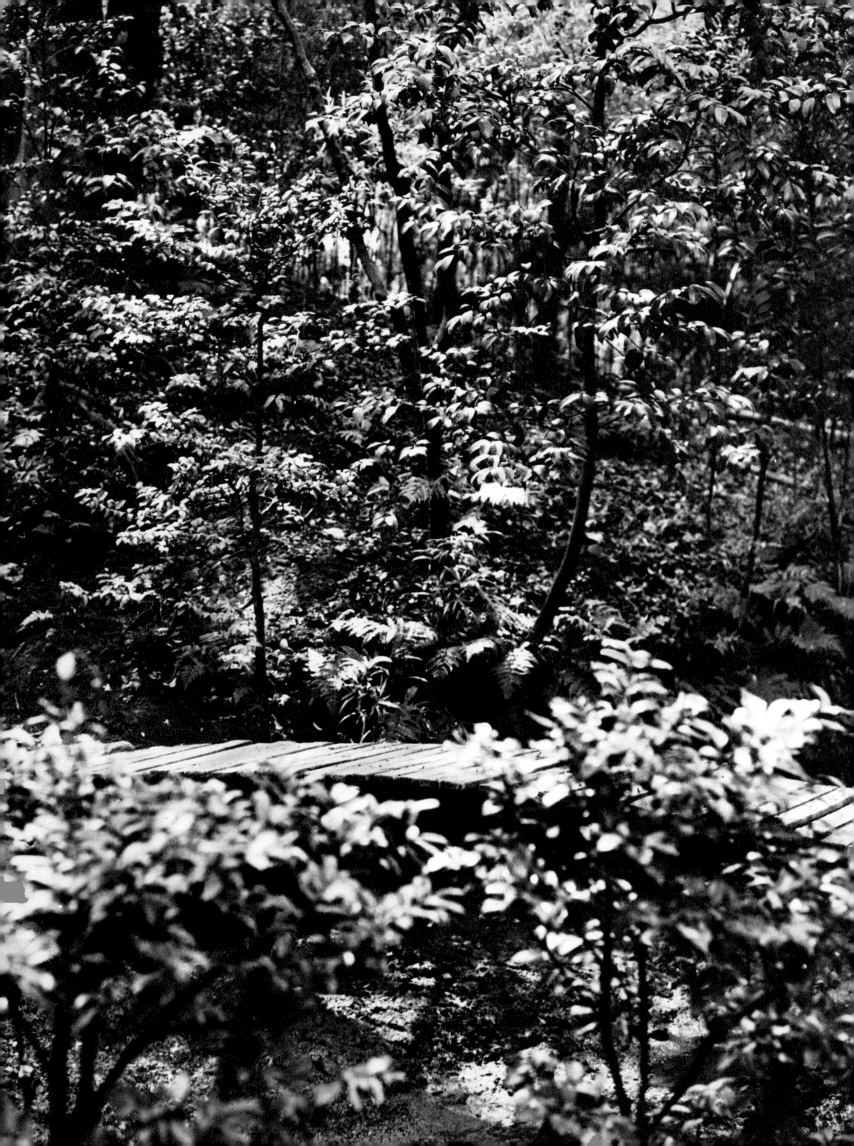

be appropriated for their private amusement. The end came with Nobunaga and Hideyoshi, and then a new chapter in Japanese art began.

Yet the central elements of the Japanese imagination remained unchanged. The curve of a petal or a flame, the various harmonies of the many shades of white, the quietness of space—space as something to be adored for its own sake—all these simple things went to form their delighted awareness of their own artistic accomplishments. They saw the world as though it were made of curved crystal, very bright and very fragile, so fragile indeed that their imaginations played constantly with the thought that any moment it would smash into a thousand splinters, and they took courage from this dangerous fragility. They were a people who lived very close to the edge of things and were rarely afraid.

They were concerned more with the instant than with eternity, more with space than with time. The purity of the Japanese line is a thing of the moment; like the lightning it would vanish and like the lightning return again. But though the moment could be prolonged in poetry and painting, they knew only too well that it could not be prolonged forever; and so they were haunted by the thought of some mysterious power which reigned in the fathomless depth of the universe, eternally recreating the worlds, operating passively through all things. For centuries the Chinese had meditated on this power, calling it the Tao, or the Way, only because they could think of no other name for it:

> Before Heaven and Earth were born
> There was something formless yet complete.
> Silent! Empty!
> Changeless! Depending on nothing!
> Pervading all things! Unending!
> We say it is the Mother of all things under heaven,
> But it has no name.
> We call it the Way.

The Tao came to Japan with the Buddhist invasions; it came in many waves and many disguises, but it was always the same. To the Japanese it was nothing new. Sometimes in their painting they would represent it as a pathway or a small wooden bridge, and there would be no man walking over it. In this way, as you will see, Dorothy Hales Gary finishes her book. At the end there is the pathway, and this is all, and this is everything.

HZT

A 9 HT  wb niged
  15-35
  cu18:1
    20:2
A0 HT  niged
A1 HT  niged, other  sun, stars  (usiged :10-45)
  85                              A17 HT

Gz 141 HT